TETRAPTERIS
methystica
R.E.Schultes

The Lost Amazon

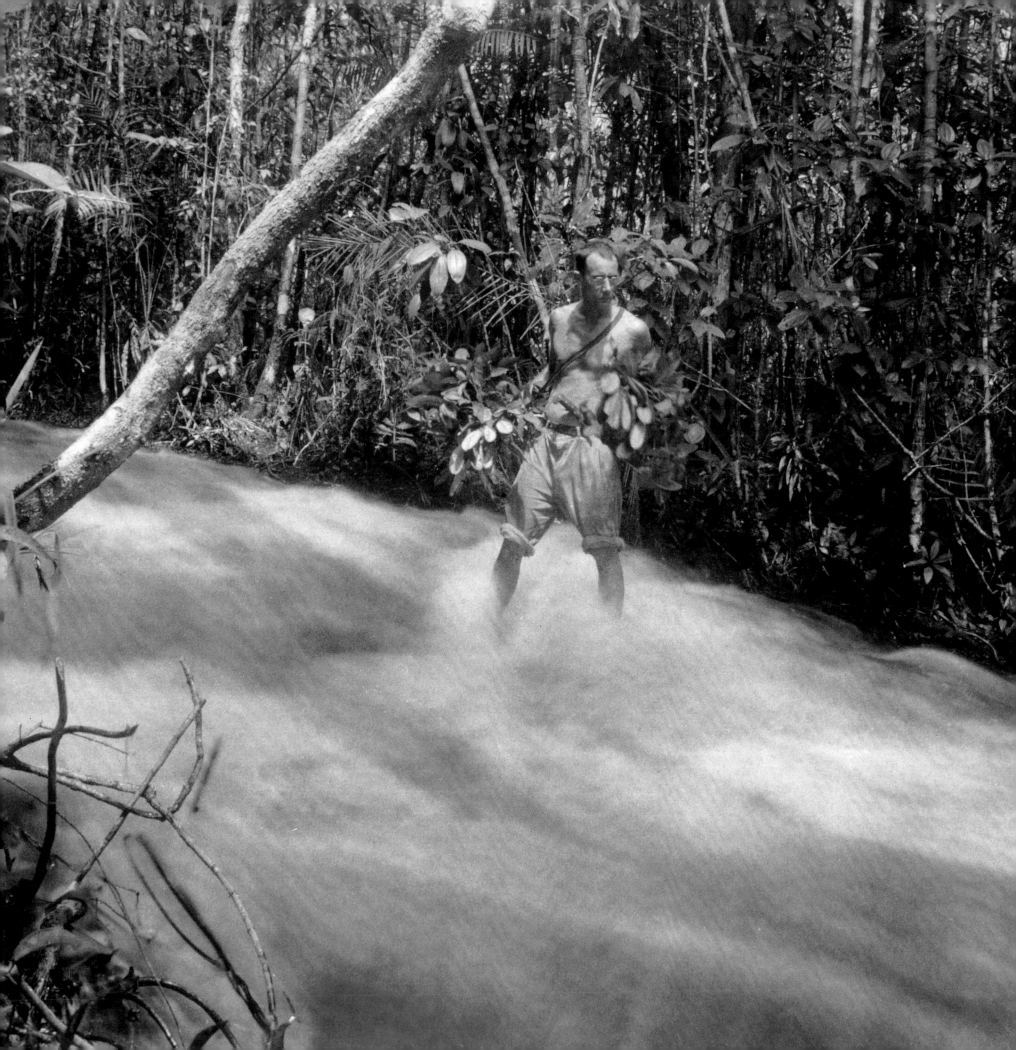

WADE DAVIS

FOREWORD BY ANDREW WEIL, M.D.

AFTERWORD BY CHRIS MURRAY

THE LOST AMAZON

THE PHOTOGRAPHIC JOURNEY
OF RICHARD EVANS SCHULTES

CHRONICLE BOOKS

SAN FRANCISCO

Manufactured in China
by Palace Press International—www.palacepress.com
Designed by Insight Design

Produced by

I N S I G H T ◉ E D I T I O N S

17 Paul Drive, San Rafael, CA 94903
www.insighteditions.com

10 9 8 7 6 5 4 3 2 1

Chronicle Books LLC
85 Second Street
San Francisco, California 94105
www.chroniclebooks.com

CONTENTS

PREFACE

By WADE DAVIS

Plant explorer, scientist, lover of all things Indian and Amazonian, Richard Evans Schultes never presented himself as a photographer. Still, he was quietly proud of his pictures, as he called them. The walls of his fourth-floor aerie at Harvard's Botanical Museum displayed many of his favorites: Yukuna wrestlers from the Miritiparaná, the rock silhouette of the spirit from the chasm of Jirijirimo, Makuna youths peering into the abyss of the cataracts of Yayacopi. Each photograph was framed in wood, carefully labeled, and hung in a manner that served only to enhance the timeless quality of the image. Like the man himself, the photographs appeared as if created in another century, another world.

Schultes was a naive photographer. For him a beautiful image was a photograph of something beautiful. An interesting photograph depicted something of note. He was not one to dwell in nuance or metaphor, and to have had his photographs formally critiqued from an artistic perspective would have amused him no end. But he was, without doubt, an accomplished and inspired photographer. Technically adept at using his medium-format camera, he approached photography with the same meticulous attention to detail that characterized his work with plants.

All of his photographs were taken with a Rolleiflex twin-lens reflex camera, which used compact roll film with 2.25-inch-square negatives. Introduced in 1927, when Schultes was twelve, these cameras had liberated popular photography by leading both professionals and amateurs away from the cumbersome large-format plate cameras that had dominated the field. The twin-lens Rolleiflex was one of the first truly portable cameras, rugged but light, relatively simple to use, and quiet, if not silent, in operation. The Zeiss lens was superb, the optics as finely attuned as those of virtually any camera on the market today.

The design and technical features of the Rolleiflex played an important role in the development of Schultes's style and skill as a photographer. The camera was equipped with a non-interchangeable eighty-millimeter, 2.8 lens. This wide-aperture setting was ideal for the low light conditions of the forest. The limited focal length—effectively, you could not focus the lens within four feet of the subject—implied that all portraits placed the person within his or her environment. One sees the effect created by this imposed distance in many of Schultes's images: the two Makuna boys, for example, lying together in a hammock, and the Kamsá youth in Sibundoy holding in his hand the flower from the jaguar's intoxicant. The photographer is present but not intrusive. Robert Capa famously said that if you do not like your photographs, get closer. With the Rolleiflex, you can't, even if you want to. The camera demands discretion.

The Rolleiflex also had a timer, a ten-second delay, that would have allowed Schultes, with a tripod, to compose an image and then place himself in the shot. A Rolleiflex is not overly complex, but it takes some practice even to align an exposure correctly in the viewfinder. It would not have been possible simply to hand the camera to an Indian companion to take a snapshot. The very best photographs of Schultes—at Yayacopi with the Makuna lads, crossing the forest stream with the botanical specimens in hand, peering like a raptor from the summit of Cerro de la Campana—are almost certainly self-portraits.

Significantly, a person using a Rolleiflex composes the shot by looking into the camera from above. The subject of the photograph appears on a flat ground-glass surface. Thus a three-dimensional

scene is viewed by the photographer as a two-dimensional picture, an image that can be carefully studied and composed before the shutter is released. This was ideal for Schultes's situation. He had a limited supply of film, and it would sometimes be months before it could be developed. The Rolleiflex by its very nature encouraged parsimony, even as it obliged the photographer to be attentive and deliberate in the framing of each image. Schultes learned to be a photographer in the field, and his skill improved over time. The Rolleiflex, in a sense, was his teacher.

The design of the camera also determined how a picture had to be taken. This proved to be of vital significance both artistically and in terms of how the Indians responded to the photographic moment. The Rolleiflex's point of view is not at eye level, as in the case of modern single-lens reflex cameras, but rather at waist height. Schultes stood well over six feet tall. The Amazonian Indians are generally of short stature. Rather than towering over his subjects, he tended to photograph from below, a perspective that enhanced the dramatic presence of the individuals. This aesthetic quality is particularly evident, for example, in his portraits of the Cofán shaman and the stunning image of the Barasana youth at the rock of Nyi.

In a more symbolic sense, the Rolleiflex by definition demanded that the photographer, in composing and exposing an image, literally bow to the subject of the photograph, a gesture that in the setting of the Amazon, with its history of Indians being violated and abused,

transformed the photographic act from one of aggression to one of engagement and humility.

Photography, of course, is not about equipment. The word *photography* is derived from Greek, meaning "to write with light." But the Rolleiflex was an instrument so finely tuned that in the proper hands it became a partner in the creation of art. Schultes understood the fundamentals of the craft. He watched for the soft light of dusk in the Amazon, the twilight moments so fleeting in the tropics. He had an innate eye for composition and, needless to say, fascinating subject material.

The Indians he came to know so well had for the most part had never seen a camera and never been the object of a photographer's zeal. There is an innocence in each of these visual exchanges that tells much about the level of trust Schultes established through his character and work. He was, if nothing else, a good man, honest and true. Having slipped away from the confines of his own world, he experienced through multiple lenses—his eyes, the delicately honed glass of his camera, the visionary realm of the magic plants—an exotic land on the cusp of change. He was the right person in the right place at the right time to accomplish greatness and leave in his wake a remarkable photographic legacy.

Between 1941 and 1953, in twelve years of almost continuous fieldwork in the Northwest Amazon, Schultes took hundreds of photographs, mostly of plants but also of scenes and moments that captured his imagination. These he filed away, placing each negative in a small

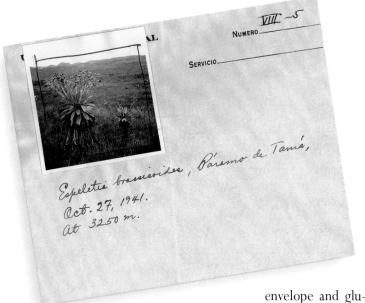

Espeletia brassicoides, Páramo de Tamá,
Oct. 27, 1941.
at 3250 m.

envelope and glu-
ing a two-inch-square print to the
upper left-hand corner on the outside. On the
envelope itself he wrote a short caption and
noted the date the picture was taken. This vast
archive he stored in two metal boot lockers, out
of sight and, in time, out of mind in the base-
ment office of his home in suburban Boston.

I first came upon this collection as I was
writing *One River,* a book that is both a biogra-
phy of Schultes and a celebration of his protégé
Timothy Plowman, a brilliant plant explorer
whose life was tragically cut short by disease.
Without these photographs, I could never have
written the book as I did. It was from the snap-
shots, in particular, that I culled all the small
details of dress and deportment, of appearances
and gestures, of landscape, forest, planes, river-
boats, mission posts, cities, and tribes long
since transformed and laid waste by half a cen-
tury of violent change.

Among these images were many that were
well known to me. I had admired them as framed
prints and seen them published in Schultes's sci-

entific papers or in one of the two quite wonder-
ful illustrated books that he coauthored, *Where
the Gods Reign,* which appeared in 1988, and *Vine
of the Soul,* published in 1992. But most of the
photographs in the collection had never seen the
light of day. As I ferreted through the material,
I was both amazed and perplexed, astonished by
its richness and depth, and confounded by some
of the choices he had made as he edited his work
for publication.

Perhaps predictably, given his nature, he
never published a photograph of himself in the
field. Yet within the collection were dozens of
evocative images of him, elegant self-portraits,
snapshots taken by colleagues, anonymous for
the most part, that in their own way were as
revealing of the time and place as anything in
the archive. Schultes's reflexive modesty and
discretion clouded his other choices as well. He
could never get over his conviction that photo-
graphs were merely illustrations. In both of his
books, but most notably in *Vine of the Soul,* the
finest photographs are lost in a sea of rather me-
diocre images chosen simply to illustrate an ob-
ject or a process: the elaboration, for example,
of a folk preparation. Many of his most beauti-
ful photographs he simply overlooked.

All of this is understandable given the
character and experiences of the man. Like
so many of the great Amazonian explorers—
Wallace, Bates, Spruce, Darwin himself—
Schultes remained, at least in the early years,
shuttered within the constraints of the rational.
It was the only way to stay sane during long
months of solitude and isolation in the forest.

Inevitably, most of his photographs dwell solely on the surface of things.

His very best photographs, by contrast, have a timeless, ethereal, even transcendent quality, as if inspired and envisioned by a completely different person. His own favorite was a portrait of a young Kamsá boy holding the leaves and blossom of a tree known as the jaguar's intoxicant. The boy is dressed in a white woolen poncho with broad stripes. His skin appears soft and unblemished. His thick black hair has been cut with a bowl. His only adornment is a mound of necklaces of small white and dark glass beads. His expression is completely natural. He neither fears the camera nor is concerned about its disapproval. He has the freshness and ease of a photographic subject who has never seen himself in a photograph. Neither sentimental nor condescending, the image is touched with pathos. It is as if in taking the photograph, in freezing that moment of the boy's life, Schultes was both testifying to the youth's vulnerability and mortality and bearing witness to the relentless corrosion of time.

Photography, as Susan Sontag suggests, is a twilight art, an art of elegy. The very act of taking a photograph ensures that the image will in time resonate with nostalgia. But this alone cannot account for the impact of Schultes's most powerful images. Nor can it explain why a man who was not a photographer, and who never thought of himself as one, would nevertheless assemble one of the finest portfolios of his era in these mysterious reaches of the Amazon.

Working only a generation earlier, Edward Curtis had viewed photography as a salvage operation, posing his subjects with the explicit intention of recording the last vestiges of what he viewed as a doomed world. His sepia images fade like the land itself. Even his exterior shots are reminiscent of the painted backdrops of the frontier photographers of the American West who captured and froze Geronimo and Sitting Bull in defeat. By contrast, Schultes's material is alive, unfettered, spontaneous, even pure.

The Amazon that Schultes knew was by no means an innocent land. Indeed, his achievements, as both a botanist and a photographer, are all the more remarkable for the fact that in many areas where he traveled, such as the Putumayo, the Vaupés, and the environs of Leticia, he was living within the long shadow of the rubber atrocities. At El Encanto on the Río Karaparaná and throughout his descent from La Chorrera down the Río Igaraparaná, he was constantly encountering Bora and Witoto elders, both men and women, whose ears, fingers, even hands had been severed in their youth for failure to deliver a quota of rubber. "Cruelty invaded their souls," a Catholic priest told Schultes at La Chorrera, referring to the overseers and rubber traders. "In those years the best that could be said of a white man in the Putumayo was that he didn't kill out of boredom."

Despite this dark history and the tales of murder and rape known to every Indian in the region, Schultes was welcomed wherever he went. He became so trusted that he was able to establish profitable rubber depots both at Soratama and Jinogojé on the Río Apaporis a mere thirty years after the worst of the trade's

ravages. Only for Schultes would the Barasana, Tatuyo, Makuna, Yukuna, and all the other peoples of the Anaconda return to gather the latex known to them as the white blood of the forest.

The great Colombian anthropologist Gerardo Reichel-Dolmatoff saw something wild in Schultes's eyes the first time they met at Jinogojé in July 1952. At first he thought it madness. But almost immediately he realized his mistake. Schultes's obsession with plants and the forest was not that of a fanatic, but of a scholar whose knowledge had become so complete as to slip toward the realm of the mystic.

It is perhaps no accident that so many of Schultes's finest photographs were taken at only four localities, all relatively brief interludes during his many long years in the forest. At Sibundoy, he first experienced the visionary world of the shaman. His three-week sojourn among the Cofán brought him to the finest poison makers of the Amazon, and a culture more profoundly touched by magic plants than any other he would encounter. His experience of the dance of the Kai-ya-ree, a ritual celebration that lasted a mere four days, found him fully embraced by the Yukuna and Tanimuka, and was a fitting preamble to his subsequent journey to the Popeyacá Makuna, whose gesture of engagement and welcome was to paint Schultes with the spots of a jaguar so that he might soar with the shaman into the visionary realm of *yagé*. Aside from these three liminal encounters, there was, of course, the Río Apaporis, Schultes's river of destiny, where lives were lost and new worlds found, and where his journey of discovery truly began.

Ansel Adams described the camera as "an instrument of love and revelation" and said that a great photograph is the "full expression of what one feels about what is being photographed and is, thereby, a true expression of what one feels about life in its entirety."

Henri Cartier-Bresson wrote that great photographs come about in that fraction of a second when the head, heart and eye find perfect alignment in an axis of the spirit. The photographs in this book clearly reveal the precision of Schultes's vision, the breadth of his mind and imagination, the reach of his spirit, and, most important of all, the size of his heart, as expansive and all-embracing as the forest he loved so dearly.

After a long and debilitating illness, Richard Evans Schultes, the greatest plant explorer of the modern era, died in the early morning of April 10, 2001. I learned of his passing later that day in Cambodia when I returned from a walk in the forests of Angkor Wat. At his memorial service some weeks later in Boston, his wife, Dorothy, asked his former students to say a few words. For some reason, I chose of all possibilities to mention how he had persevered in the Amazon despite having succumbed to malaria on more than a dozen occasions. That evening, as I lay in bed, I suffered the first convulsions of what

turned out to be blackwater fever, a particularly nasty and life-threatening strain of malaria. The old professor, I was convinced, was still working his magic. The learning would never stop.

There was always something of the avatar in Schultes. Even as he looked back to those who had inspired him, most notably the nineteenth-century English botanist Richard Spruce, whose seventeen-year sojourn in the Amazon surpassed even his own, he looked forward to those who would inherit his mantle. As a teacher, he understood in his wisdom that the student was as important as the teacher in the lineage of knowledge. His circle of acolytes reached far beyond the walls of Harvard, his academic home for all of his professional life. In a teaching career that spanned decades, he touched and transformed dozens of lives.

It was my good fortune to study with him as both an undergraduate and a graduate student. I learned a great deal in those years, but surprisingly little about the man himself. Although proud of his many botanical discoveries, Schultes was not one to speak of them, and it would never have occurred to him to place his work in a historical context. His capacity for introspection was limited. A man of action and deed, he shunned publicity and was as far removed from the pop culture of his day as a medieval herbalist. His reference points were not of this century.

I came to know and fully appreciate the extraordinary breadth of his achievements only during the years that I spent working on his biography. In writing *One River,* I decided to break up a long and rather dense narrative by inserting dialogue into certain passages, including the strictly biographical chapters covering his early years. Though I obviously was not privy to these conversations, I was extremely careful to ground them in authenticity. I made sure that I knew, for example, that the meeting in question had taken place. I knew the agenda, the personalities, the outcome, even the time so that I might anticipate with some accuracy the tone of light within the room.

For Schultes, these dialogues, and indeed the book itself, took on a sort of magical reality. In his last years, according to his wife, Dorothy, he kept the book on his bedside table, and when he could not sleep at night, he would open it randomly and read of his life. Not long before he died, he took me aside and, pointing to some dialogue in the text, said, "Did I ever tell you what Mrs. Bedard said to me when I first met her in 1943? Look, it's right here!"

I found this both amusing and very touching. Here, after all, was the man who had made my life possible. Now the book had become his life. His life had become my imagination, and my imagination had breathed meaning and content back into the life of an old man who was slowly fading away, as all old men must

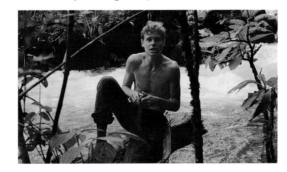

Wade Davis in the Sierra Nevada de Santa Marta, Columbia, 1974. Photo by Timothy Plowman.

inevitably do. It was around this time that I decided to publish a book of his finest photographs, backed in part by excerpts of the text that had brought back his story to him.

Richard Evans Schultes was perhaps the most remarkable person I have ever met. Explorer, mentor, seeker, and scholar: he was all of these things and more. *The Lost Amazon* is a final opportunity to share his story, with the sincere hope that his life and contributions will not be forgotten. He deserves more than simple recognition. He has earned the gratitude of generations of scholars, anthropologists, explorers, and writers whose hearts have been fired by his example.

I would like to acknowledge my good friend Chris Murray. Chris helped edit the archive and brought the project to his partner at Insight Editions, Raoul Goff, and his remarkable design and editorial team at Palace Press International, Robbie Schmidt, Noah Potkin, and Ian Szymkowiak. Deborah Snyder of Synergetic Press, publisher of both of Schultes's illustrated books, kindly provided scans of several images. Cristóbal Cabo generously shared with us the photographic collection of his grandfather, Guillermo Cabo, who traveled with Schultes on two occasions in 1951–52. Maxwell MacKenzie helped me understand the significance of the Rolleiflex camera in Schultes's work. I would also like to acknowledge Bob Bender at Simon & Schuster,

editor of *One River*, from which a portion of the text of this book is drawn. My goal here is not to rewrite the story of Schultes, but rather to complement his photographs in a manner that will add context and meaning, and in so doing enhance the significance of what this remarkable man achieved in both his explorations and his photography. As always, thanks are due to my family, Gail, Tara, and Raina.

Finally, I would like to acknowledge the Schultes family: his children, Neil, Evans, and Alexandra, who trusted us with their father's photographic legacy; and his beloved wife, Dorothy. Not enough has been said or written about this remarkable woman. As liberal as he was conservative, as passionate as he was restrained, she did not sit idly at home while her husband tracked the forest trails. An opera star in Boston, with her own radio show and a following from New York to San Francisco, she toured during World War II with the USO in the Aleutians, flying from Attu to Point Barrow, singing in over 250 concerts in less than eight months. The end of the war found her in Naples, Italy, stationed in the King's Palace. Throughout the late '40s she continued to sing in Austria and Italy, at the Edinburgh Festival, and most frequently with the New York City Opera. Whenever she was in the city, she moonlighted as a vocalist with Phil Spitalny's all-girl band. It helped pay the bills while she waited for Dick to return from the Amazon. She never considered another man. They were finally wed on March 26, 1959. Today, alive and well, she lives just outside Boston.

FOREWORD

By ANDREW WEIL, M.D.

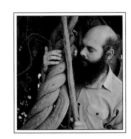

first saw Dick Schultes in September 1960 in the Nash Lecture Hall of the Harvard Botanical Museum. He wore a long white lab coat, and he looked and acted every bit the Harvard professor. Though only forty-five at the time, he appeared rather stiff and stuffy, and his style of lecturing was very formal. Yet he had a twinkle about him that suggested something far livelier.

He felt very familiar to me from the moment I first saw him, as if I had known him before. I sensed a connection with him that held my interest. His face fascinated me. His elegant patrician air, the resonant voice: both seemed so familiar and comfortable. I knew that I wanted to spend time with him. He had this effect on people. For those who fell under his spell, he was the ultimate mentor.

This was my first year at Harvard College and the first day of Biology 104, Plants and Human Affairs, a course I had discovered by thumbing through the course catalog. Intrigued by the title, I went to register at the Botanical Museum and was further intrigued by what I found there: a sort of attic of the university, up four flights of steps, filled with the most amazing ethnobotanical paraphernalia.

Of course, the term *ethnobotany* was yet to be in widespread use.

Biology 104 was an introduction to economic botany, the study of plants of economic importance other than ornamentals. I have to say that, in retrospect, signing up for that course was the best decision of my academic career.

I was a biology major at the time, unsure what direction my career would take. But I knew from the start that I wanted my commitment to be to the Botanical Museum and that I wanted Schultes to be my thesis adviser. When I approached him in 1963, intent on studying the narcotic properties of nutmeg, he went right for the idea and strongly encouraged me to do it.

I think this provides an interesting insight into the man. He famously liked to parade his strong conservative convictions, taking any opportunity, for example, to dismiss FDR as a socialist or the Kennedy clan as rogues. When Harvard erupted as one of the leading centers of the psychedelic revolution, Schultes distanced himself from Timothy Leary and Richard Alpert, and often expressed contempt for the casual use of recreational drugs.

At the same time, he was an astonishing voice of reason when it came to the rights of indigenous peoples to use their sacred plants in ritual context. And he was not at all shy about flaunting his own use of various plant preparations. He openly spoke of his experiences

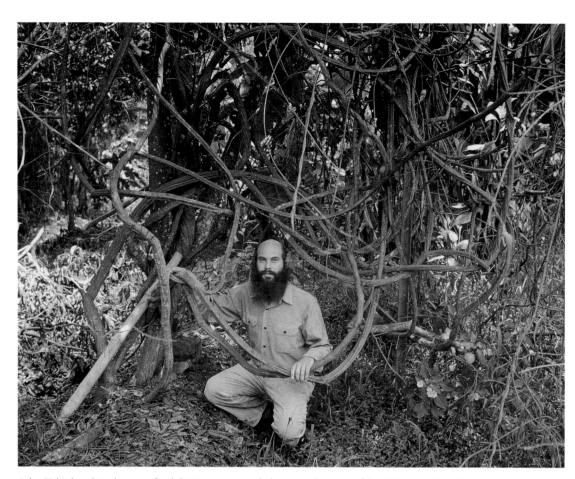

Andrew Weil with a cultivated specimen of yagé, Banisteriopsis caapi, *also known as ayahuasca, vine of the soul. Fusagasugá, Colombia, 1972.*

with peyote and ayahuasca, and he enjoyed telling anyone who would listen about the virtues of coca, most especially the Amazonian powder preparation, *ipadu,* which was his favorite. Years after we had first met, he stayed with me in Tucson when he was lecturing at the University of Arizona. I had just returned from the Amazon and had brought back a can of *ipadu.* I did my best to save some for him, but unfortunately by the time he arrived there wasn't much left. He took one look inside the can and with a wry smile remarked, "There might be enough there to fill a cavity in my tooth."

I have always thought that Schultes's conservative persona was, at least at some level, a bit of a front, and that deep down he was really a freak in the best sense of the word, a proto-psychonaut. It was, to say the least, pretty unusual in the 1930s, '40s, and '50s to be studying hallucinogenic plants. Perhaps the conservative demeanor provided a useful cover.

Certainly he was a different man when he was in the jungle. In 1972, I traveled with him from Bogotá overland to his old haunts in the Putumayo of Colombia. His reputation in the region was astonishing. Everywhere we went, the older people, the padres and shamans, the rubber traders and merchants, treated him with immense respect, as if he was something or someone larger than life. It was wonderful

to be with him and share even a part of that radiant affection, a reverence that I had never before seen expressed for a person. It was all the more remarkable because he was a foreigner. Before I left Bogotá, one of his old Colombian friends and botanical colleagues, Jesus Idrobo, took me aside and told me that if I ever encountered trouble in the lowlands, I had only to mention Schultes's name. "In those regions," Idrobo said very simply, "Schultes is God."

By the time of our travels, Schultes was in his late fifties and already somewhat overweight. But nothing could hold him back in the forest. We were looking for two stimulants, *yoco*, a curious liana that he had found and described in the '40s, and *guayusa*, a tree in the holly family that had been grown in plantations by the Jesuits during colonial times. I remember, in particular, stopping at one point by the roadside on the eastern flank of the Andes just above Mocoa. Suddenly he went charging up this incredibly steep hillside, overgrown with vegetation. I tried to follow and found myself ripped and torn by the thickets. I was in good shape and twenty years younger than Schultes. But he had some extraordinary reserve of energy that was released when he got into a forest. The stuffy Bostonian, the crusty Harvard professor in the starched white lab coat, was nowhere to be found.

Meeting this legendary botanical explorer was one of the truly seminal events in my life. It led to a degree in botany and a long association with him and the Botanical Museum. From 1971–1985 I held an appointment as re-search associate in Ethnopharmacology on his staff, and, although I roamed far and wide from Cambridge, eventually settling in the Sonoran Desert of southern Arizona, I kept in close contact with the museum and with Dick. And I became close friends with many of his other students: Mike Balick, Wade Davis, and the late Tim Plowman.

When I entered Harvard Medical School in 1964, I soon realized how valuable my connection to the world of plants was going to be. Most of my classmates and teachers had little experience with it. Even the pharmacologists knew little of the natural sources of the drugs they studied and taught about. The interest in botanical medicine that Biology 104 and Dick Schultes kindled led me to become an expert on medicinal plants, a practitioner of natural medicine, and a founder of integrative medicine, the new field that emphasizes the natural healing potential of the human organism and makes use of both conventional and alternative treatments.

It has been a long and adventurous road from that morning more than forty years ago in the Nash Lecture Hall to my present position. Dick was there as a teacher, mentor, and friend at many points early in the journey. He gave of himself willingly and generously to anyone who sought his advice and counsel. I miss his wisdom, knowledge, and good humor. I hope that I can mentor students as well as he did. It is a joy to review these photographs and to know that they are preserved for the enjoyment of others, and that through them his work and legend may live on.

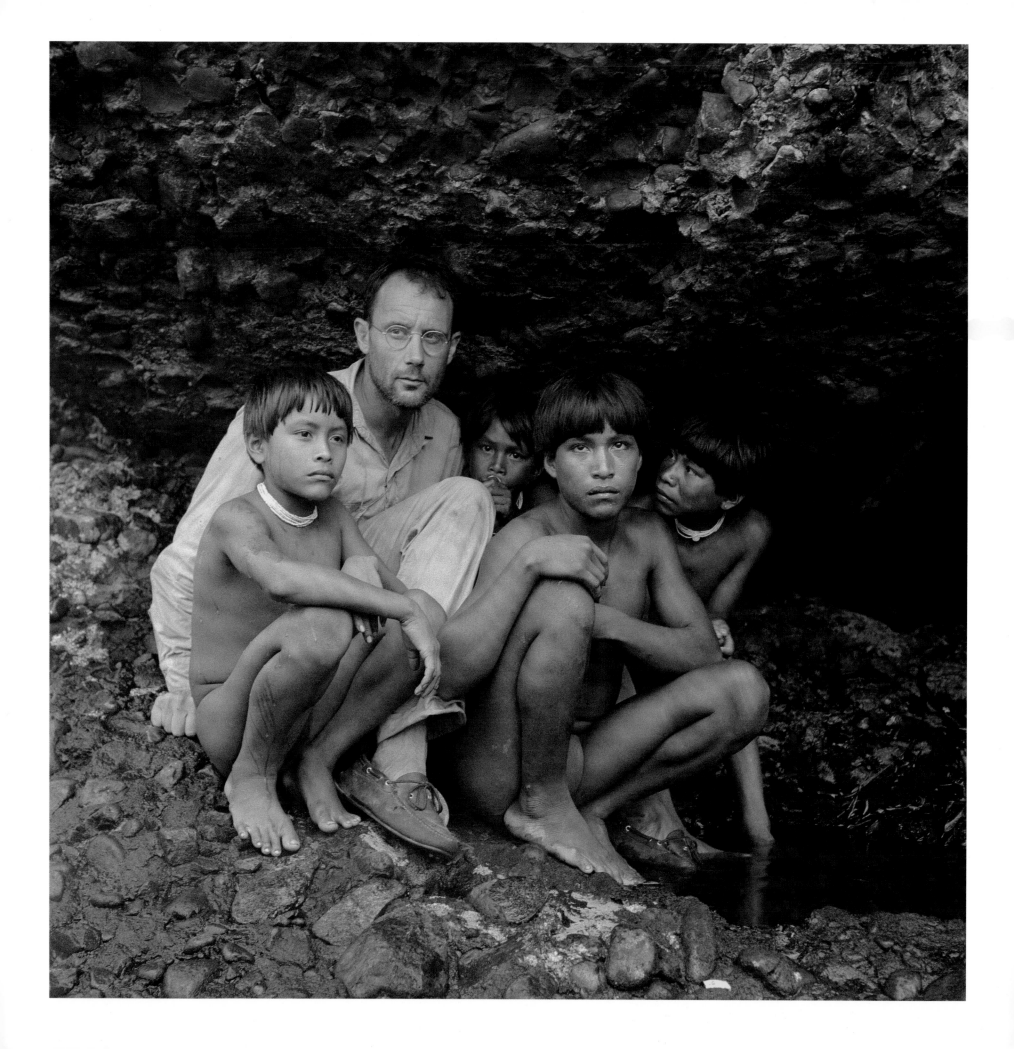

the LOST AMAZON

In the early 1970s, a time of few heroes, one man loomed large over the Harvard campus: Richard Evans Schultes, a kindly professor who shot blowguns in class and at one time kept outside his office door a bucket of peyote buttons, available to his students as an optional laboratory experiment. In time, mountains in South America would bear his name, as would national parks. HRH Prince Philip would call him "the father of ethnobotany." Students like myself knew him as the world's authority on medicinal and hallucinogenic plants, the botanical explorer who had sparked the psychedelic era with his discovery in Mexico in 1938 of *teonanacatl,* the psilocybin mushrooms known to the Aztec as the Flesh of the Gods.

Three years later, after identifying *ololiuqui,* the serpent vine, another long-lost Aztec sacred hallucinogen, Schultes took a semester's leave of absence and disappeared into the Northwest Amazon of Colombia. Engaged in a mission vital to the war effort, with the fate of civilization itself in the balance, he endured unimaginable hardships, including beriberi and twenty-one bouts of malaria, as he pursued one of the most elusive botanical mysteries of the Amazon. Twelve years later he returned, having gone places no outsider had ever been, mapping uncharted rivers and living among previously unknown Indian tribes while collecting some thirty thousand botanical specimens, in-

cluding three hundred species new to science. The greatest Amazonian explorer of the twentieth century, he was a living link to the great naturalists of the Victorian age and to a distant era when the tropical rain forests stood immense, inviolable, a mantle of green stretching across entire continents.

At a time when there was little public interest in the Amazon and virtually no recognition of the importance of ethnobotanical research, Schultes drew to Harvard an extraordinarily eclectic group of students. Andrew Weil, today "America's doctor," got his start by studying the narcotic use of nutmeg by inmates at a maximum-security prison just outside Boston. Dick Martin, another protégé, used to blow sax by night in whorehouse towns up and down the Amazon while by day he explored the flora of an unknown land. One of Schultes's botanical colleagues once complained that Martin was doodling through all his classes in advanced plant taxonomy. Schultes looked into the matter and discovered that his student was taking notes in fluent Japanese. The late Tim Plowman, at the time the world's authority on coca, the source of cocaine and a plant known to the Inca as the Divine Leaf of Immortality, lived in the basement of the Botanical Museum, in an office that had the atmosphere of a gypsy tearoom. His lover was Teza, a beautiful artist who drew illustrations of new species that Tim

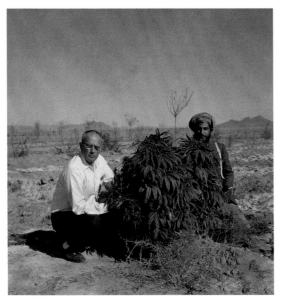

Schultes with Cannabis ruderalis, *Kandahar, Afghanistan, December 1973.*

had discovered. They were the only drawings I have ever seen that captured the feel of wind on paper.

The great professor himself held court on the fourth floor of the museum, in the Nash Lecture Hall, a wooden laboratory draped in bark cloth and cluttered with blowguns, spears, dance masks, and dozens of glass bottles that sparkled with fruits and flowers no longer found in the wild. Oak cabinets elegantly displayed every known narcotic or hallucinogenic plant, together with exotic paraphernalia, opium pipes from Thailand, a mescal-bean necklace from the Kiowa Indians, and a kilogram bar of hashish put on display following one of Schultes's expeditions to Afghanistan. In the midst of enough psychoactive drugs to keep the DEA busy for a year, Schultes would appear, tall and heavyset, dressed conservatively in gray flannels and thick oxfords, with a red Harvard tie habitually worn beneath a white lab coat. His face was round and kindly, his hair cut razor short, his rimless bifocals pressed tightly to his face. He lectured from tattered pages yellow with age, sometimes making amusing blunders that students jokingly dismissed as side effects of his ingestion of so many strange plants.

Throughout the 1960s, as America discovered the drugs that had fascinated Schultes for thirty years, his fame grew. Suddenly, academic papers that had gathered dust for decades were in fierce demand. His 1941 monograph on *ololiuqui,* which had turned out to be a species of morning glory, had been printed on a handset press in the basement of the Botanical Museum.

In the spring and summer of 1967, requests for copies poured into the museum, and florists across the nation experienced a run on packets of morning glory seeds, particularly the varieties named Pearly Gates and Heavenly Blue. Strange people began to make their way to the museum. A former graduate student tells of going to meet Schultes for the first time and finding two other visitors waiting outside his office, one passing the time by standing on his head like a yogi.

For all his achievements, Schultes was an odd choice to become a '60s icon. True, in 1953 he had led William Burroughs into the forests of the Colombian Putumayo and introduced the writer to ayahuasca, the vision vine, the most potent of all Amazonian hallucinogenic preparations. But he also had dismissed Timothy Leary for bastardizing the Greek language by insisting on the term *psychedelic,* when any scholar loyal to the classics knew that the proper orthography was *psychodelic.* His politics were exceedingly conservative. Neither a Democrat nor a Republican, he professed not to believe in the

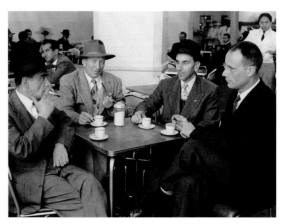

Schultes with Miquel Dumit (to his right), Captain Liebermann, and an unknown associate meeting in Bogotá in March 1951 to plan Soratama, the rubber station to be located on the Río Apaporis.

American Revolution and always voted for Her Majesty Queen Elizabeth II. As an anthropological colleague once remarked, the only way for Schultes to go native would be for him to go to London. A proud Bostonian, he would not use a Kennedy stamp, insisted on calling New York City's Kennedy Airport by its original name, Idlewild, and refused to walk on Boylston Avenue in Cambridge after its name had been officially changed to John F. Kennedy Boulevard. When Jackie Onassis visited the Botanical Museum, then-director Schultes vanished. Rumor had it that he hid in his office closet to avoid having to guide her through the museum's famous exhibit of glass flowers.

These stubborn political convictions, however rigidly held, belied the fundamental decency and generosity of the man. On all issues of personal choice and freedom—sexual orientation, abortion, use of drugs, religion—he was a

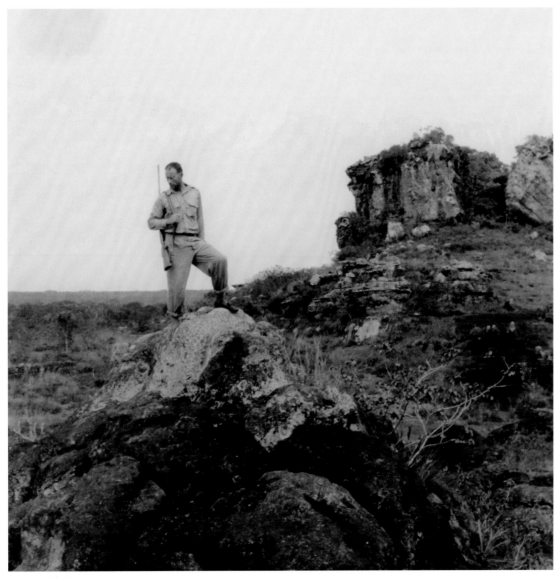

Araracuara, Río Caqueta.

He had led William Burroughs into the forests of the Colombian Putumayo and introduced the writer to ayahuasca, the vision vine, the most potent of all Amazonian hallucinogenic preparations.

complete libertarian. His devotion to struggling students was legendary. For years he traveled around the country using an obscure taxonomic argument to obtain the release of dozens of young people charged with marijuana possession.

The argument went something like this: Marijuana was illegal, but until the law was changed to defeat Schultes's crusade, the actual legal statute prohibited by name only *Cannabis sativa*. Schultes maintained that there were three species of marijuana, including *Cannabis indica* and *Cannabis ruderalis*. As an expert witness, he would testify that there was no way to distinguish the species with forensic material alone.

Neither a Democrat nor a Republican, he professed not to believe in the American Revolution and always voted for Her Majesty Queen Elizabeth II.

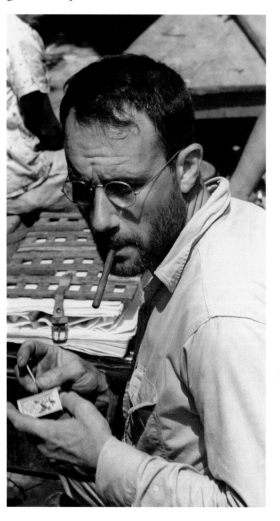

The first time Schultes felt the dull ache of malaria was on the afternoon of May 23, 1942, as he paddled up the Río Caraparaná on his way to El Encanto. It was the height of the rainy season, and both riverbanks were flooded. Still, he had no choice but to make camp and rest until the fever passed. Stringing his hammock above the boggy ground, kindling a fire from moss and bark, he lay in the rain for three days as the paroxysms of chills and night sweats convulsed his body. On the morning of May 27, the fever broke and Schultes awakened to a blue sky, a cool breeze coming off the river and sunlight falling through the forest. Still weak, he rose slowly from his hammock and cautiously made his way down to the river to bathe. He stumbled and fell against the muddy bank. Looking up, he saw a solitary orchid growing on the surface of a half-drowned mossy trunk. He went closer and reached for the delicate inflorescence. The petals and sepals were light blue, the lip somewhat darker with pale veins, and the back and wings of the column were streaked with red. He had never seen such a perfectly pure shade of blue. Teasing a blossom with his finger, Schultes knew that he held in his hand the legendary blue orchid. "Never," he wrote years later, "could a doctor have prescribed a more effective tonic! I had found my friend… I was happy and could almost have believed that destiny had led me in these lowest of days to that one bright jewel of the jungle." Photo by Guillermo Cabo.

That left the burden on the prosecution to prove beyond reasonable doubt that a bag of ground-up flower buds was *Cannabis sativa* and not one of its botanical relatives. Since even botanists could not agree on how many species there were, it was by definition an impossible task. It made for great theater, of course, with Schultes and his longhaired entourage on one side and arrayed against him on the other a team of indignant botanists, often envious of his fame, infuriated by his stand on drugs, and openly contemptuous of his taxonomic position.

In truth, the botanical evidence for Schultes's argument was somewhat dubious. In the heated passions of the times, however, when young students were being jailed for smoking an innocuous herb, none of the academic details were important. What did matter was Schultes's uncanny ability to break open courtrooms and set students free. This, as much as anything else he did, contributed to his mythic reputation on the Harvard campus. Between the extremes of his personality, in the space created by what superficially appeared to be the immense contradictions in his character, there was room for any student to flourish.

The outline of young Dick Schultes's life appeared safe and predictable in the fall of 1933, when he walked through the Johnson Gate as a freshman at Harvard College. The first of his family to attend university, he hoped to become a physician and return to his

neighborhood in East Boston to establish a practice. But he had no idea what awaited him at the Botanical Museum. Taking a job stacking books and filing cards for thirty-five cents an hour, he found himself in the midst of one of the most eclectic libraries in the country. Between the folios of Linnaeus and the herbals of Fuchs and Brunfels were volumes on African ordeal poisons, monographs on distant tribes, and entire shelves dedicated to narcotic plants and stimulants. Intrigued, he enrolled in the museum's basic course in economic botany, Plants and Human Affairs, and promptly found himself distilling alcohol, brewing beer, and drinking copious amounts of both, just as the students had done in lab every year throughout Prohibition.

When the time came to study a curious group of plants classified as the Phantastica, those botanical denizens capable of causing, as the lab manual said, "excitation in the form of visions and hallucinations, often in color," the students were assigned a book report. Hard-pressed by other obligations, Schultes rushed to the back of the room and grabbed the thinnest volume. Its title was *Mescal: The Divine Plant and Its Psychological Effects*. Published in 1928 and written by the German psychiatrist Heinrich Klüver, it was the only monograph then available in English that described the astonishing pharmacological effects of the peyote cactus. Opening the book later that evening in his room back in East Boston, Schultes read throughout the night of visions of orblike brilliance, of stars, of delicate, floating films of color sweeping over the imagination and transforming human consciousness.

Vellozia phantasmagoria, *a new species discovered May 14, 1943, and later named by Schultes. Chiribiquete, Río Apaporis.*

Stunned that a plant could do such things, Schultes approached his professor, the famous orchid specialist Oakes Ames, and asked if he might write about peyote for his undergraduate thesis. Ames agreed, but on the condition that he study the plant in ritual context. Thus, in the summer of 1936, with a small grant provided by Ames himself, Schultes, who at twenty-one had never been west of the Charles River, found himself bouncing over the dusty tracks of Tennessee in a 1928 Studebaker, heading for Oklahoma and the homeland of the Kiowa. There, in sol-

emn nocturnal ceremonies that invariably lasted into the dawn, he ate peyote three and sometimes four times a week. For two months of his young life, time turned into color, thoughts unleashed sounds, gestures became rainbows of light. His teachers were the Kiowa elders Charlie Charcoal, Heap O'Bears, and Mary Buffalo. He entered their lives and thus became a member of the last generation of scholars to know people who had lived the great culture of the plains, a way of life that withered and died within a century of its birth.

Returning to Boston a student transformed, Schultes became an advocate of the rights of the Native American Church. In February 1937, he traveled to Washington to testify successfully against Senate Bill 1399, the latest effort to outlaw the religious practices of the Kiowa. In his undergraduate thesis, he wrote that through the use of peyote the Indians are "able to absorb God's Spirit in the same way that the white Christian absorbs the Spirit by means of sacramental bread and wine." This was a bold idea in the spring of 1937. But for Schultes, it was only the beginning. While still in Washington, working at the Smithsonian, he stumbled upon a critical clue that would propel him into his next adventure, a series of expeditions that would be the envy of Indiana Jones.

In the sixteenth century, Spanish chroniclers in Mexico had written in some detail about an intoxicating preparation derived from mushrooms and known as *teonanacatl*. William Safford, a prominent Smithsonian anthropologist, had summarily dismissed such reports as

fable. In a series of influential academic papers published beginning in 1915, he noted that three centuries of field investigations had yielded no evidence of the existence of narcotic fungi. *Teonanacatl,* he claimed, was not a mushroom but an Aztec name for peyote. Schultes believed the Spanish, but he had no evidence until one morning at the U.S. National Herbarium when he came upon a letter attached to a herbarium specimen of peyote and written by one Blas Pablo Reko of Guadalajara, Mexico. Addressed to the director of the herbarium and dated July 18, 1923, the letter claimed both that Safford was wrong and that psychoactive fungi were still used by the Indians of Oaxaca in their religious feasts. Schultes, who had recently leapt off one Greyhound bus from Tulsa, slipped onto another destined for Mexico City.

In the summer of 1936 Schultes and Weston La Barre headed west in a 1928 Studebaker that Weston had traded for a train ticket. After eight flat tires, a half dozen breakdowns, and ninety-six miles in twelve hours on the dirt roads of Tennessee, driving through clouds of dust and winds so hot they kept the windows tightly shut, they finally made it to Oklahoma. On June 24, 1936, the Anadarko Daily News *announced the arrival of the Harvard–Yale–American Museum Indian Expedition.*

It was July 1938, little more than a year before the outbreak of war in Poland. Mexico was thick with German sympathizers, and Reko, Schultes discovered to his dismay, was one of them. As they traveled south by train to Oaxaca, this Mexican citizen of Slavic blood and Austrian birth boasted of his racial purity

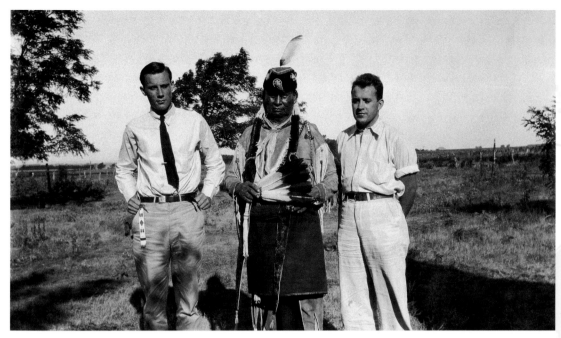

Kiowa Roadman Belo Kozad flanked by twenty-one-year-old Schultes and his companion, Weston La Barre, a graduate student in anthropology at Yale who would go on to write the seminal book The Peyote Cult. *They have just come out of an all-night peyote ceremony. In the heat of the morning, and throughout a long night of chanting, prayers, and ritual vomiting, Schultes evidently has not so much as loosened the red Harvard tie around his neck. One would never know that coursing through his blood is the residue of a sacred plant that has just sent a dozen Kiowa on a mystical journey to their gods.*

and spoke confidently of the Germans' imminent takeover of the world. Schultes suggested that they restrict their conversations to matters botanical. Thus, in a world on the edge of a precipice, with madness the backdrop of the age, Schultes found himself about to enter the mountains of Oaxaca to search for *teonanacatl* with an ardent Nazi as a companion.

To make matters more interesting, a second team of researchers was pursuing the identity of the mysterious plant. The same month that Schultes and Reko reached the small Mazatec Indian village of Huautla, a team of anthropologists arrived, led by a tall, strapping Englishman named Bernard Bevan, a man rumored, Schultes would later discover, to be affiliated with the British Secret Service. With Bevan was Jean Bassett Johnson, an anthropol-

ogy student from Berkeley.

On the night of Saturday, July 16, 1938, Johnson and Bevan became the first outsiders to attend a vigil in which mushrooms were ingested by an old *curandero* as part of a complex healing ceremony. A week later, when Schultes ran into Bevan's party in Huautla, Johnson shared his discovery. He had not taken the sacrament himself, but the mushrooms clearly were the vehicle of transformation that legitimized the divinatory rite. All the prayers and chants, every ritual gesture, were the voices of the mushrooms speaking through the body of the healer.

Neither Johnson nor Bevan had secured specimens that would permit scientific identification of the mushrooms. That breakthrough occurred eleven days later when Schultes and his main contact, a Mazatec merchant by the

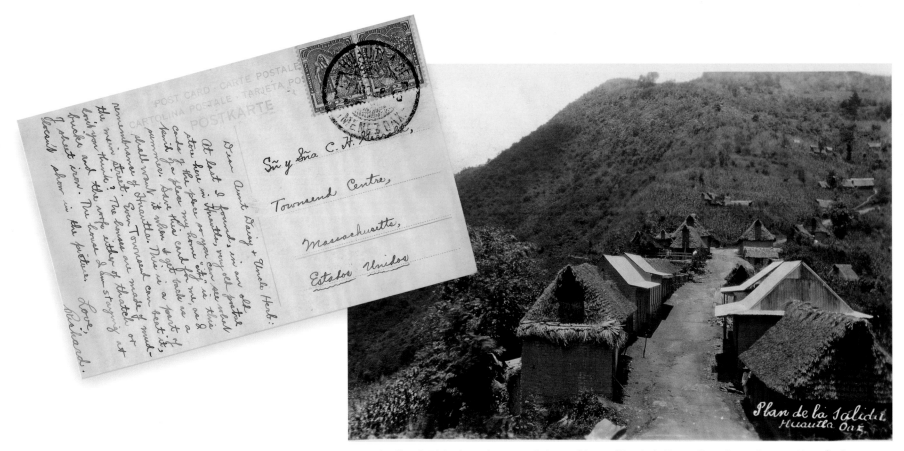

A postcard send home by Schultes showing the main street leading out of the town of Huautla, the Mazatec village in Oaxaca where in 1938 he was first shown specimens of teonanacatl, *the psychoactive mushrooms known as the Flesh of the Gods.*

All the prayers and chants,

every ritual gesture, were

the voices of the mushrooms

speaking through the body of

the healer.

name of José Dorantes, were approached by a thin middle-aged man in threadbare clothes with a face that was all bones and eye sockets. In his hands was a small basket, and within it were a dozen fresh mushrooms. These, Dorantes remarked, were indeed "the Saint Children, the Little Ones Who Spring Forth."

On February 21, 1939, Schultes reported his discovery. Needless to say, in a world moving toward war, a paper entitled "*Plantae Mexican* II: The Identification of *Teonanacatl,* a Narcotic Basidiomycete of the Aztecs" did not enjoy wide circulation. Undeterred, Schultes returned to Oaxaca the following summer and, in a series of arduous expeditions through the rain forests of Chinantla, solved the second of the great mysteries of Aztec ethnobotany.

Ololiuqui, the serpent vine, was a powerfully psychoactive morning glory, closely related to the common garden varieties.

At this point the war intervened, and the thread of the research was not picked up until the early 1950s, when a highly unusual series of events began to unfold. Gordon Wasson, a banker and vice president of J. P. Morgan and Company in New York, and his Russian-born wife, Valentina Pavlovna, were ardent lovers of fungi who had used linguistic evidence to conclude that early humans had worshiped certain mushrooms. In September 1952, just as the Wassons were struggling to prove their assertion, they received a letter from the poet Robert Graves in Majorca, who somehow had stumbled upon Schultes's 1939 paper identifying *teonana-*

catl. Wasson contacted Schultes, who directed him to Oaxaca and a Mazatec *curandera,* María Sabina. It took three years to secure María's confidence, but on the night of June 29, 1955, Wasson and his photographer, Allen Richardson, became the first outsiders actually to ingest the mushrooms in a sacred context.

In his extraordinary account of the experience, Wasson wrote of mushrooms gathered before sunrise in places where mountains are caressed by mysterious winds. Under the influence of María Sabina's prayers, Wasson heard infinitely sweet voices hovering in the dark, saw music assume form, and felt his spirit soar out of his body. With his imagination awash in color, Wasson lay beneath a blanket on the mud floor of María's home as she sang in the beautiful tonal language of the Mazatec:

Woman who thunders am I, woman who sounds am I.
Spider woman am I, hummingbird woman am I...
Eagle woman am I, important eagle woman am I.
Whirling woman of the whirlwind am I,
woman of a sacred enchanted place am I,
Woman of the shooting stars am I.

In the stillness of the night, with the rain falling softly on the thatch roof, this humbled New York banker struggled to find words to describe his "soul shattering experience." They did not exist. Months later, he would write, "We are all confined within the prison walls of our everyday vocabulary. With skill in our choice of words, we may stretch accepted meanings to cover slightly new feelings, but

when a state of mind is utterly distinct, then our words fail. How can you tell a man who has been born blind what it is like to see?"

On May 13, 1957, Wasson published an account of his Oaxaca expedition in *Life* magazine under a snappy title that a young editor hoped would capture the ineffable quality of the experience: "Seeking the Magic Mushrooms." The name stuck, and the article marked a certain watershed in the social history of the United States, the beginning of the psychedelic era. Among those who read it was a young Harvard lecturer named Timothy Leary. In the summer of 1960, Leary would travel to Mexico and ingest the mushrooms in

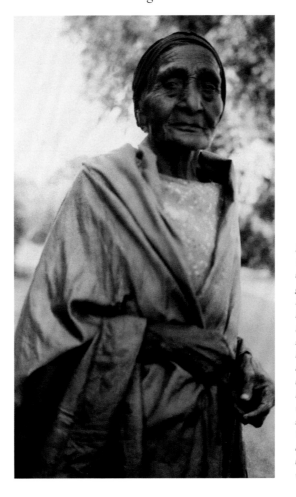

Mary Buffalo, one of Schultes's principal teachers among the Kiowa. Wife of the Keeper of the Ten Medicines, the sacred medicine bundles that date back to the beginning of the world, Mary was also the granddaughter of Onaskyaptak, owner of the Tai-Me, the Sundance Image, the most venerated object of the Kiowa. Her medicine bundle had twelve scalps tied to it, seven of them taken from white settlers. Hers is a face formed by the open prairie, by winter blizzards and summer heat. She appears proud, yet there is a deep sadness in her eyes that suggests that the stoic indifference we have come to associate with Plains Indians is less a characteristic of a people than the result of a century of impossible grief. At eighty-eight her life had spanned the entire modern history of the Kiowa. As a child, she was brought up to believe in the divinity of the sun. As a young girl, she witnessed the return of war parties and made offerings to the Tai-Me at the Sundance. As a woman, she discovered the affliction of defeat and endured famine and disease. She grew old listening to the brooding chants of broken warriors, the silence of a prairie without buffalo.

Schultes in Oaxaca among the Mazatec, 1938.

Cuernavaca. "Like almost everyone else who has had the veil drawn," he would later write, "I came back a changed man."

There remained only one missing link in the chronicle of *teonanacatl* and *ololiuqui:* the isolation of the chemicals responsible for the plants' hallucinogenic effects. First came the mushrooms, sixty-four of which were shipped by Wasson to Albert Hofmann, then director of the natural products department of the Sandoz research laboratories in Basel, Switzerland. Hofmann began by feeding half the sample to his dog. Nothing appeared to happen. So Hofmann himself ate thirty-two mushrooms. Something did happen. The landscape out-

side his laboratory window began to look like Mexico, the face of his colleague overseeing the experiment turned into that of an Aztec priest, and the pencil in his hand became an obsidian blade. After ninety minutes, as Hofmann later wrote, "the rush of abstract motifs...reached such an alarming degree that I feared I would be torn into this whirlpool of form and color and would dissolve."

Such an experience might have unnerved an ordinary scientist, but Hofmann was not of that sort. For more than a decade he had been experimenting with lysergic acid, the fundamental building block of a curious group of chemicals responsible for Saint

Anthony's fire, the mass poisonings that had periodically convulsed European towns since the Middle Ages. Caused by ergot, a fungal parasite of rye crops, these outbreaks killed hundreds and left thousands scarred for life. Many victims lost fingers and toes or had their noses literally rot on their faces. Others experienced horrific hallucinations and went mad. The drug in question acted powerfully to constrict blood vessels—hence the gangrene in the extremities—and it was this medical potential that Hofmann had been investigating in the spring of 1943 when, overwhelmed with vertigo and restlessness, he suddenly had felt compelled to leave his laboratory and go home. Due to the wartime shortages of gas, he had no car, so he set off on what turned out to be one of the most momentous bicycle rides in history. The compound he was making, a trace of which he had accidentally absorbed through his skin, turned out to be the most potent hallucinogenic agent ever discovered: lysergic acid diethylamide-25, LSD for short. On his ride home, Dr. Hofmann went on the world's first acid trip.

So Hofmann was quite prepared for the visual onslaught that resulted from ingesting the mushrooms. In short order he isolated the active ingredients, and in March 1958 he announced the discovery of psilocybin and psilocin, two previously unknown substances that turned out to be very close in structure to serotonin, a compound that plays an vital role in brain chemistry. He then turned to *ololiuqui*. What he found was scarcely believable.

Its active principles were compounds that were already sitting on the shelves of his lab. They differed from LSD only by the replacement of two hydrogen atoms for two ethyl groups. Four years before Hofmann discovered LSD, Richard Evans Schultes had found its analogue in nature, in the seeds of a humble morning glory that was worshiped as a god incarnate by the ancient peoples of central Mexico.

Schultes spent the summer of 1941 in Mexico, touring much of the country as part of an agricultural survey team. When he returned to Boston, he found two job offers waiting for him. A private boys' school just outside Boston needed a biology master. In Washington, D.C., the National Research Council wanted someone to travel to the Northwest Amazon of Colombia and hunt for arrow poisons. Fortunately for science, he chose the latter.

Schultes landed in Bogotá early on a Sunday when the light was soft and translucent, the dust on the road in from the old airport settled from the night's rain, and all the city idle and peaceful in anticipation of midday Mass and empty and endless *paseos* in the countryside. He checked into the Hotel Andina on Avenida Jiménez and tried to contact the Institute of Natural Sciences, which was expecting him. Naturally, the institute was

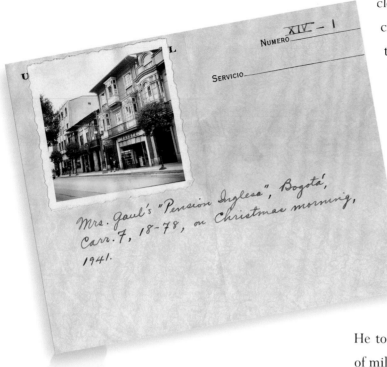

NUMERO ____ XIV - 1

U L

SERVICIO ____

Mrs. Gaul's "Pensión Inglesa", Bogotá, Carr. 7, 18–78, on Christmas morning, 1941.

Mrs. Gaul's Pensión Inglesa, Carr. 7, Calle 18–78, Schultes's first home in Bogotá. Photographed here on Christmas morning, 1941, it was destroyed during the Bogotá riots in April 1948.

closed, so he left his hotel to explore the city that would be his home for the next twelve years. Drifting up and down the broad avenues, he walked past the fountains that then graced the Plaza Bolívar, beneath the austere facade of the Granada Hotel overlooking Santander Park, past the balconies and ornate doorways on Calle Real, and along the deserted alleys that ran up to the foot of Monserrate, the mountaintop shrine that even then was the symbol of the city. A veil of innocence hung over the morning. He took in a band concert, watched a parade of military cadets, and drank fresh juices from street stands that sold *cherimoyas,* guavas, *zapotes, lulos,* and passion fruits of a dozen colors. Bogotá seemed to him a city of priests and organ grinders, bird sellers, gypsies, and the innocently insane living and thriving happily, all dressed in black.

In the afternoon of his first day in the city, he hopped aboard an open-sided trolley, paid a penny, and sat back to see where it would take him. It went south, winding its way toward the outskirts of the city to the munitions factory, where the line ended at the base of a steep hill, lush with vegetation. Schultes got off and followed a group of schoolchildren and a nun up a stone stairway that climbed into a beautiful forest. As he walked through the trees, he noticed a small orchid partially concealed by a cluster of ferns. It was no more than an inch high and unlike anything he had ever seen. He

carefully made a collection, which he pressed between the pages of his passport. Later, he sent it by post to Oakes Ames, who described it as a new species, *Pachiphyllum schultesii.* Thus, on his first day in Colombia, at the edge of the national capital, Schultes had discovered an orchid unknown to science. It was his first botanical collection in Colombia, the first of more than twenty-five thousand that he would make.

Bogotá did not hold him for long. After a brief sojourn in the mountainous reaches of Boyacá, Schultes made his way south to Sibundoy, headwaters of the Río Putumayo and homeland to the Kamsá and Inga Indians. Within a week he would again make botanical history. In a high mountain valley that can be crossed on foot in a day, he counted sixteen hundred individual hallucinogenic trees, the highest concentration of psychoactive plants ever discovered by science. And this was just the beginning. At the approaches to the valley, near Laguna de la Cocha, Schultes made only the second collection of the Tree of the Evil Eagle. In the foothills beyond the town of San Pedro, he first found the hummingbird's flower, *Iochroma fuchsiodes.* In the gardens of *curanderos,* he documented twelve cultivated varieties of tree daturas, including an aberrant form that he later described as a new genus, *Methysticodendron amesianum,* named in honor of his mentor, Oakes Ames. On the Páramo of Tambillo, two thousand feet above the valley to the northeast, he found yet another magic plant, a beautiful shrub with dark, glossy leaves like those of a holly, tubular red flowers tipped in yellow, and

white berries, bright and lustrous. This was *Desfontainia spinosa,* known to the Kamsá as the "intoxicator," a source of dreams and visions employed by shamans from Colombia south as far as Chile. In his first month in the field, before he had even begun to explore the lowlands, Schultes discovered no fewer than four psychoactive plants new to science.

It was not only the hallucinogens that drew his attention. In the fields he found unfamiliar foods: tree tomatoes, taro and *arracacha* roots, new varieties of beans and maize. Working with the healers, he collected flowers used to treat fever, roots employed to kill parasites, herbal treatments for infections, tonics for nerves, and infusions taken to ease childbirth. To dress wounds, the Kamsá chewed selaginella and tobacco, mixed in urine, and plastered the paste over the injury. Ant bites

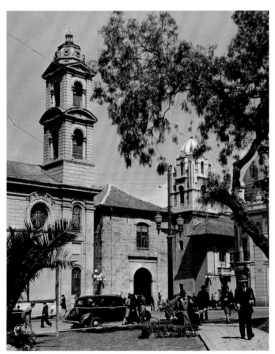

Santander Park, Bogotá, December 1941, with the spire of the San Francisco church. Four stories high, it was as tall as any building in the Colombian capital.

were soothed with a poultice of peperomia, ulcers relieved with the red resin of a plant from the lowlands known as *sangre de drago,* the blood of the dragon.

Yet for Schultes, Sibundoy was but an enticing diversion on his journey to the lowlands. His mission there was to identify the botanical sources of curare, the "flying death," the arrow poison that would later yield d-tubocurarine, a muscle relaxant destined to revolutionize modern medicine. Continuing east from Sibundoy, crossing the Andes by mule, he dropped into the upper Amazon and the homeland of the Ingano. They introduced him to *yoco,* a powerful stimulant taken each morning at dawn to allay hunger. A new species, later named by Schultes, the plant contained caffeine, quite a lot of it, as it turned out. Indeed, in knocking back their morning calabash of *yoco,* the Indians absorbed the equivalent of twenty cups of coffee in a single bolt. They were not, as Schultes later recalled, a people to do things in half measures.

It is perhaps worth pausing for a moment to consider the extraordinarily ambitious sweep of the explorations to which Schultes was about to commit his life. We know little of his feelings at the time. Though not a particularly private man, he was most certainly of a generation not yet prepared to yield itself to analysis. In twelve years in the Amazon, he rarely kept a journal. He had no

time. His collecting notebooks record where he went and when, but they give no insight into his thoughts or emotions. He generally traveled alone or with one native companion, learning early to eschew the cumbersome gear that dragged down so many expeditions of his era. High boots, complicated tents, stools, and portable kitchens were not for him. He wore a pith helmet, khaki trousers and shirt, a kerchief, and, in the low country, leather moccasins saturated with oil purchased by mail order from L. L. Bean back in New England. Rarely

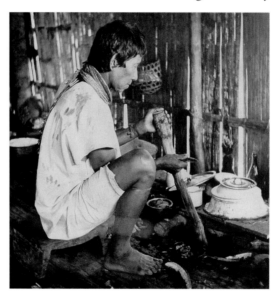

Ingano hunter preparing yoco, *Mocoa, December 1941. The woody liana, though used every day by the Ingano as a stimulant, turned out to be a species new to science, discovered and named by Schultes:* Paullinia yoco.

did he carry a gun. Besides a machete, hammock, and his plant-collecting gear, he brought a camera, a spare set of clothes, and a small medical kit complete with hypodermic syringe and snakebite serum. For food he lived off the land, carrying as emergency rations only a few cans of his beloved Boston baked beans, less for sustenance than to boost his morale when things got rough. For reading he took Virgil,

Ovid, Homer, and a Latin dictionary, as well as the eighteenth-century journals of the Spanish explorers Ruiz and Pavon, which he intended to translate in his spare time.

The region he entered, the Northwest Amazon of Colombia, was and remains the wildest area in South America. The Amazon has fifty thousand miles of navigable rivers, a thousand major tributaries, twenty of which are larger than the Rhine; eleven of these flow more than a thousand miles without a rapid. The Amazonian lowlands of Colombia, by contrast, contain only one major navigable river, the Putumayo; all others are interrupted by rapids and waterfalls. The riverboats that 150 years ago transformed the Amazon in Brazil and Peru into a highway have never been able to penetrate the heart of Colombia.

The land Schultes explored covers over half a million square miles. On a map it is roughly triangular in shape, with a base running from Sibundoy through Iquitos in Peru and then along the Amazon to the Brazilian city of Manaus, with the apex at Puerto Carreño, the point at which Colombia projects into Venezuela and touches the Orinoco River. In Colombia the region is traversed by five major rivers that run east to west on more or less parallel courses before fusing into one massive stream at Manaus, the center of the Amazon basin.

Farthest south is a short section of the Amazon that, rising in the Peruvian Andes, touches Colombia for only eighty miles above the port of Leticia. The one important north-bank tributary is the Río Loretoyacu, home of

the Tikuna Indians. North of the Amazon is the Río Putumayo, with its two major north-bank affluents, the Karaparaná and Igaraparaná, home of the Witoto and Bora Indians. Next is the Río Caquetá, formed by several important rivers, including the Río Miritiparaná, home of the Yukuna and Tanimuka; the Río Yarí, with its unexplored branch the Mesaí; and the poorly known Río Cahuinarí, homeland of several scattered populations of Bora and Witoto. North of the Caquetá is the Río Apaporis, a black-water river 1,350 miles long dissected by spectacular rapids and gorges that have isolated several groups of Indians, the Taiwano on the Río Kananarí and, further downstream on the Río Piraparaná, the Makuna, the Barasana, and the curious Makú, a nomadic people once enslaved by their sedentary and more powerful neighbors. North of the Apaporis is another black-water river, the Río Vaupés. Along the banks of its major affluents, the Papurí and Kuduyari, live the Desana and Cubeo. Finally, northeast of the Vaupés is yet another black-water river, the Guainía, homeland of the Arawakan-speaking Kuripako. The Guainía is the headwaters of the major north-bank tributary of the Amazon, the Río Negro, a massive river that carries more water than either the Congo or the Mississippi.

This, then, was the world into which Schultes disappeared. Hundreds of thousands of square miles of undisturbed rain forest, traversed by thousands of miles of unexplored rivers, the homeland of some thirty unacculturated and often uncontacted Indian tribes

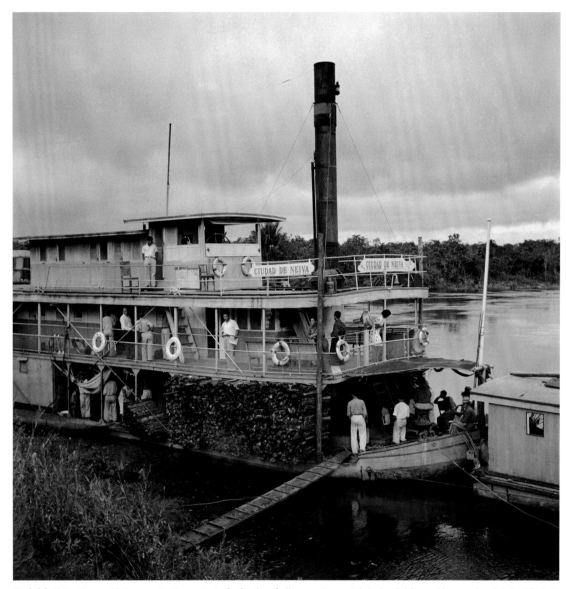

Ciudad de Neiva, Caucaya, Río Putumayo. On May 19, 1942, after four days of collecting at Caucaya, Schultes boarded this wood-burning, three-decked paddlewheeler to travel down the Putumayo to the mouth of the Río Karaparaná. From there he paddled a dugout canoe upriver to El Encanto, and then walked overland to La Chorrera on the Río Igaraparaná. This journey took him through a shadowy world of darkness where he encountered scores of Bora and Witoto Indians who had been crippled and savaged during the rubber boom at the turn of the twentieth century.

representing six distinct language groups and sharing a profound knowledge of forest plants that had never been studied by modern science. Oklahoma and Mexico had been but a prelude. In Colombia he embraced an entire continent, unknown peoples, and a forest that stretched to the Atlantic. It was, as he would write nearly fifty years later, a land where the gods reigned.

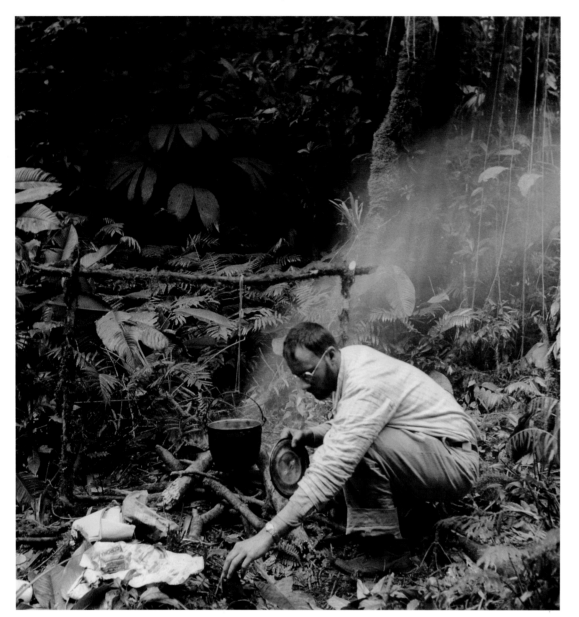

Schultes labeled this photograph "Making coffee, Macarena, Colombia, January, 1951." On the day this photograph was taken, January 23, Schultes would discover a new species of an extremely rare genus of trees found only in Colombia. Perched on the side of a high cliff, it had a dense crown of compound leaves, a long inflorescence, and a striking appearance. He named it Rhytidanthera regalis. *Intermediate between related species found in the northern Andes and one known from the sandstone hills of the Vaupés and Caquetá five hundred miles to the east, it was the missing link that verified his theory that there had been a major migration of Andean plants eastward toward the ancient mountains of the Guiana Highlands. With uncharacteristic pride, Schultes called his find "one of the most significant phytogeographical discoveries of the last two decades."*

THE LOST AMAZON

16

do with curare. The preparation in question was ayahuasca, known also as *yagé,* the vision vine, the vine of the soul, the most celebrated hallucinogen of the Amazon. Schultes naturally knew of the potion. It had been first described in the nineteenth century by his great hero, the indefatigable English plant explorer Richard Spruce. Sacred to all the tribes of the upper Amazon, it is the embodiment of the jaguar, a magical intoxicant capable of freeing the soul, allowing it to wander into mystical encounters with ancestors and animal spirits. Shamans maintain that under its influence collective visions occur and it is possible to communicate across great distances in the forest. When its active ingredient harmaline was first isolated, Colombian scientists called it telepathine. What Schultes encountered took things to an entirely different level.

On February 28, 1942, he collected the woody liana for the first time and recorded the following notes:

"Yagé is taken often by some, infrequently by others. It is a most violent purge and often acts as a vomitive. Extremely bitter. Some say the after effects are an exhilaration and feeling of ease and well-being; others that it is a day of discomfort and headache. The bark of yagé is scraped off and small pieces are heated in water. The water is drunk. People take it alone or in small groups in houses, often with a sick person who is to be cured. The curandero takes yagé to <u>see</u> the proper herb or herbs the sick man needs. Usually taken alone, but in Puerto Limón it is taken sometimes together with the

W hile still with the Ingano, pursuing the mysteries of the flying death on his first expedition below Sibundoy to the lowlands, Schultes made one of the most important and curious discoveries of his career. Ironically, it had nothing to

bark of another vine—the *chagropanga*. It is said to be almost the same leaf, but a harder and stouter vine."

Schultes was not sure what to make of this, but two themes intrigued him. First was the realization that the healer embraced *yagé* as both visionary medium and teacher. The plant made the diagnosis. It was a living being, and the Ingano acknowledged its magical resonance as reflexively as Schultes accepted the axioms of his own science. Yet, at the same time, here was evidence of pure empirical experimentation of a specificity he had never before encountered. In Oklahoma and Mexico, and more recently among the Kamsá of Sibundoy, he had always seen psychoactive plants taken alone, not in any sort of combination. Now his Ingano informants insisted that by manipulating the ingredients of the preparations, in this case by adding a plant known as *chagropanga,* it was possible to change the nature of the experience.

Schultes did not question the word of the Indians. Instead he elected to test their preparation on himself. At Puerto Limón he drank an infusion derived solely from the bark of the *yagé* liana *Banisteriopsis caapi.* The visions that came were blue and purple, slowly undulating waves of color. Then, a few days later, he tried the mixture with *chagropanga*. The effect was electric, reds and golds dazzling in diamonds that turned like dancers on the tips of distant highways. If *yagé* alone felt like the slow turning of the sky, the addition of *chagropanga* caused explosions of passion and dreams that collapsed one into another until finally, in the empty morning, only the birds remained, scarlet and crimson against the rising sun.

What Schultes had stumbled upon was a bit of shamanic alchemy that, in its complexity and sophistication, had no equal in the Amazon. The psychoactive ingredients in the bark of *yagé* are the beta-carbolines harmine and harmaline. Long ago, however, the shamans of the Northwest Amazon discovered that their effects could be dramatically enhanced by the addition of a number of subsidiary plants. This is

For food he lived off the land, carrying as emergency rations only a few cans of his beloved Boston baked beans, less for sustenance than to boost his morale when things got rough.

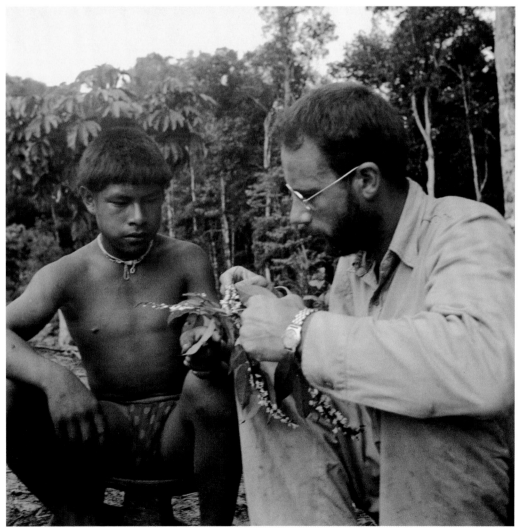

Schultes with Makuna youth, Soratama, 1952.

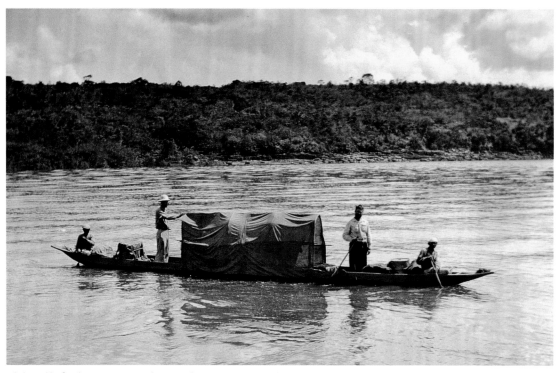

Schultes and his friend Nazzareno Postarino leaving La Chorrera on June 12, 1942, heading down the Río Igaraparaná. Schultes stands in the rear, wearing a pith helmet.

an important characteristic of many traditional preparations, and it is due, in part, to the fact that different chemical compounds in relatively small concentrations may effectively potentiate each other.

In the case of *yagé,* some twenty-one admixtures have been identified to date. Two of these are of particular interest. *Psychotria viridis* is a shrub in the coffee family, the first specimen of which actually was collected by William Burroughs in his Putumayo sojourn in 1953. *Chagropanga,* the admixture that Schultes identified in 1942, is *Diplopterys cabrerana,* a forest liana closely related to *yagé.* Unlike *yagé,* both plants contain tryptamines, powerful psychoactive compounds that when smoked or snuffed induce a very rapid, intense intoxication of short duration, marked by astonishing visual imagery. Taken orally, however, these potent compounds

have no effect, as they are denatured by an enzyme, monoamine oxidase (MAO), found in the human gut. Tryptamines can be taken orally only if combined with an MAO inhibitor. Amazingly, the beta-carbolines found in *yagé* are inhibitors of precisely this sort. Thus, when *yagé* is combined with either admixture plant, the result is a powerful synergistic effect, a biochemical version of the whole that is greater than the sum of its parts. The visions, as the Indians promised Schultes, become brighter, and the blue and purple hues are augmented by the full spectrum of the rainbow.

What astonished Schultes was less the raw effect of the drugs—by this point, after all, he was becoming accustomed to having his consciousness awash in color—than the underlying intellectual question posed by the elaboration of these complex preparations. The

Amazonian flora contains literally tens of thousands of species. How had the Indians learned to identify and combine in this sophisticated manner these morphologically dissimilar plants that possessed such unique and complementary chemical properties? The standard scientific explanation was trial and error. It is a reasonable answer and may well account for certain innovations. But at another level, as Schultes came to realize after spending more time in the forest, it is but a euphemism disguising the fact that botanists have very little idea of how the Indians originally made their discoveries.

The problem with trial and error is that the elaboration of the preparations often involves procedures that are either exceedingly complex or yield products of little or no obvious value. *Yagé* is an inedible, nondescript liana that seldom flowers. True, its bark is bitter, often a clue to medicinal properties, but no more so than that of a hundred other forest vines. An infusion of the bark causes vomiting and severe diarrhea, conditions that would discourage further experimentation. Yet not only did the Indians persist; they became so deft at manipulating various ingredients that individual shamans developed dozens of recipes, each yielding potions of various strengths and nuances to be used for specific ceremonial and ritual purposes.

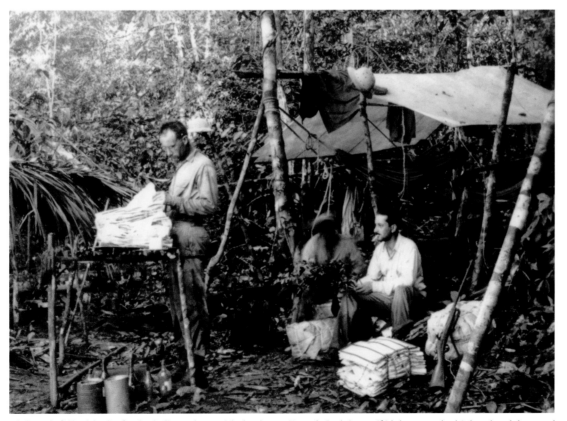

Schultes in the field with his close friend and colleague, the great Colombian botanist Hernando García Barriga. If Schultes connected with Indians through decency and good faith, García Barriga did so with humor. Beyond his dashing appearance—the slicked-back hair and dark eyes, the classic Latin mustache and aquiline nose—he had the look of the consummate trickster. In old age the lines of his face would betray a lifetime of laughter.

...chagropanga caused explosions of passion and dreams that collapsed one into another until finally, in the empty morning, only the birds remained, scarlet and crimson against the rising sun.

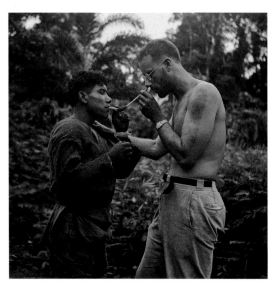

Caño Guacayá, Río Miritiparaná, April 1952. Schultes being administered a dose of Amazonian tobacco.

In the case of the arrow poison, curare, Schultes learned, the bark is rasped and placed in a funnel-shaped leaf suspended between two spears. Cold water is percolated through it, and the drippings collect in a ceramic pot. The dark fluid is slowly heated and brought to a frothy boil, then cooled and later reheated until a thick, viscous scum gradually forms on the surface. This scum is removed and applied to the tips of darts or arrows, which are then carefully dried over the fire. The procedure itself is mundane. What is unusual is the fact that one can drink the poison without being harmed. To be effective, it must enter the blood. The Indians' realization that this orally inactive substance, derived from a small number of forest plants, could kill when administered into the muscle was profound and, like so many of their discoveries, difficult to account for by the concept of trial and error alone.

The Indians naturally had their own explanations, rich cosmological accounts that from their perspective were perfectly logical. Sacred plants that had journeyed up the Milk River in the belly of anacondas, potions prepared by jaguars, the drifting souls of shamans dead since the beginning of time. As a scientist, Schultes did not take these myths literally. But they did suggest to him a certain delicate balance. "These were the ideas," he would write half a century later, "of a people who did not distinguish the supernatural from the pragmatic." The Indians, Schultes realized, believed in the power of plants, accepted the existence of magic, and acknowledged the potency of the spirit. Magical and mystical ideas entered the very texture of their thinking. Their botanical knowledge could not be separated from their metaphysics. Even the way they ordered and labeled their world was fundamentally different.

It was in Sibundoy, en route to the Putumayo, that Schultes first learned that the Indians did not cognitively distinguish the color green from the color blue, for the canopy of the forest was equated with the canopy of the heavens. "For them," a Capuchin priest had explained to him, "the sky is green and the forest is blue." This was a strange concept, and one that lingered in Schultes's imagination as he entered the lowlands. It surfaced when he confronted yet another botanical enigma, the manner in which the Indians classified their plants.

PHOTO ON RIGHT PAGE: *In North America and Europe, the plants are so well known that the discovery of a single new species marks the highlight of a botanist's career. Schultes found over three hundred. Dozens of plants are named for him, even genera. Panama hats, which are actually made in Ecuador, are woven from the fibers of* Schultesiophytum palmata. Schultesianthus *is a genus of nightshades.* Marasmius schultesii *is a mushroom used by Taiwano Indians to treat ear infections. The Makuna use* Justicia schultesii *for sores,* Hiraea schultesii *for conjunctivitis, and* Pourouma schultesii *for ulcers and wounds. The Karijona relieve coughs and chest infections with a tea brewed from the stems and leaves of* Piper schultesii. *The list goes on. So many botanists wanted to name plants for him that they ran out of ways to use his name and had to use his initials. On this cliff in the Vaupés, Schultes found an extremely rare and beautiful plant, a new genus in the African violet family.* Schultesia *had already been used, so the specialist named it* Resia, *for Richard Evans Schultes.*

The Ingano at Puerto Limón, for example, recognized seven kinds of *yagé*. The Siona, a neighboring tribe, had eighteen, which they distinguished on the basis of the strength and color of the visions, the trading history of the plant, and the authority and lineage of the shaman who used it. None of these criteria made sense botanically, and, as far as Schultes could tell, all the plants were referable to one species, *Banisteriopsis caapi*. Yet the Indians could readily differentiate their varieties on sight, even from a considerable

Though trained at the finest botanical institution in America, Schultes, after but a month in the Amazon, felt increasingly like a novice. The Indians knew so much more. He had gone to South America because he had wanted to find the gifts of the rain forest, leaves that heal, fruits and seeds that supply the foods we eat, plants that can transport the individual to realms beyond this dimension. Yet within a month he had learned that, in unveiling indigenous knowledge, his task was not merely to

...shamans developed dozens of
recipes, each yielding potions of
various strengths and nuances to
be used for specific ceremonial and
ritual purposes.

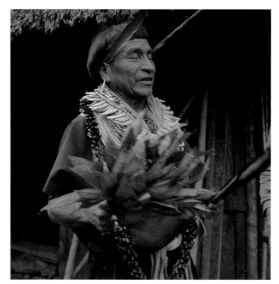

Salvador Chindoy, Kamsá healer, Sibundoy, September 1953.

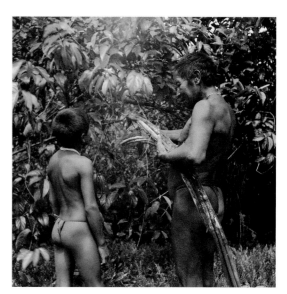

Makuna shaman and young boy collecting the woody stems of yagé, *the vine of the soul. Oo-ña-mé, Río Popeyacá, June 1952.*

distance in the forest. What's more, individuals from different tribes separated by large expanses of forest identified these same varieties with amazing consistency. It was a similar story with *yoco,* the caffeine-containing stimulant. In addition to *yoco blanco* and *colorado,* Schultes collected black *yoco,* jaguar *yoco, yagé-yoco, yoco* of the witches—fourteen categories in all, not one of which could be distinguished based on the rules of his own science.

identify new sources of wealth, but also to understand a new vision of life itself, a profoundly different way of living in a forest. By the time he reached the Cofán, by reputation the finest poison makers in the Northwest Amazon, Schultes was ready to be dazzled by a world of phytochemical wizardry unlike anything he had ever imagined.

Even before his sojourn among the Cofán, before his thousand-mile passage by dugout canoe down the Putumayo, the first of a score of epic river journeys he would undertake, his destiny had been transformed by events half a world away. The outbreak of war with Japan in December 1941 would forever associate him with a plant that meant nothing to the shaman but everything to the fate of civilization.

The Indians called it the weeping tree, and for generations they had slashed its bark, letting its white milk drip onto leaves, where it could be molded by hand into vessels and sheets impermeable to the rain. Thomas Jefferson and Benjamin Franklin found that small cubes of the stuff were ideal for erasing lead pencil notations, and since they believed the plant hailed from the East Indies, the substance became known as India rubber.

Rubber was, in fact, native to the Amazon, but because of an endemic fungal disease, the South American leaf blight, it was not possible to grow it there in plantations. In the early years of the rubber industry, when Brazil controlled the monopoly, this had hardly mattered. Scattered across a forest the size of the continental United States grew some 300 million wild rubber trees. Demand for the product was ravenous. Oldsmobile, the first commercially successful automobile company, sold just 425 cars in 1901. Less than a decade later, the first of 15 million Model Ts rolled off Henry Ford's assembly line. Each vehicle needed rubber, and the only source was the Amazon.

The flash of wealth was mesmerizing. Manaus, situated at the heart of the Brazilian trade, grew in a few years from a seedy riverside village into a thriving city where opulence reached bizarre heights. Rubber barons lit cigars with hundred-dollar banknotes and slaked their horses' thirst with silver buckets of chilled French champagne. Their wives, disdainful of the muddy water of the Amazon, sent their linens to Portugal to be laundered. Prostitutes from Budapest and Tangier,

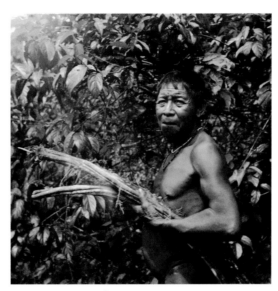

Makuna shaman with yagé. Oo-ña-mé, Río Popeyacá, June 1952.

Moscow and Paris, earned as much as eight thousand dollars for an evening's work, fees often paid in tiaras and jewels; the citizens of Manaus in 1907 were the highest per-capita consumers of diamonds in the world. By 1910, rubber accounted for 40 percent of Brazilian exports, worth, at a conservative estimate, more than 200 million dollars. In Pittsburgh, Andrew Carnegie lamented, "I should have chosen rubber."

The Indians...believed in the power of plants, accepted the existence of magic, and acknowledged the potency of the spirit. Magical and mystical ideas entered the very texture of their thinking.

Rubber barons lit cigars with hundred-dollar banknotes and slaked their horses' thirst with silver buckets of chilled French champagne.

What ultimately ended the party, and not incidentally saved the lives of countless thousands of Amazonian Indians who had been swept into a heinous system of torture and exploitation as rubber tappers, was an act of British imperial policy. In 1877, in a deliberate effort to break the Brazilian monopoly, the English took rubber seeds from the Amazon and introduced them to Southeast Asia. There, in the absence of the blight, plantations could be established. Once these came on line, Asian production soared and the Brazilian rubber boom imploded.

The reversal of fortunes was astonishing. As late as 1910, Brazil still produced roughly half the world's supply. But by 1918, Asian plantations dominated 80 percent of the market. In 1934, when international production for the first time surpassed a million tons, plantations covered eight million acres of the Far East. In South America the industry was dead. Total production for the entire continent was less than ten thousand tons. By 1940, Brazil produced only 1.3 percent of the international rubber supply and the nation had become a net importer of the product she had given to the world.

This was the situation on the morning of December 8, 1941, when Schultes, living in the forests of the upper Putumayo, first learned by radio of the attack on Pearl Harbor. He immediately left overland for Bogotá. By the time he had reached the Colombian capital, the Japanese had attacked Malaya and the Dutch East Indies and taken control of 95 percent of the world's rubber supply. In the last year of

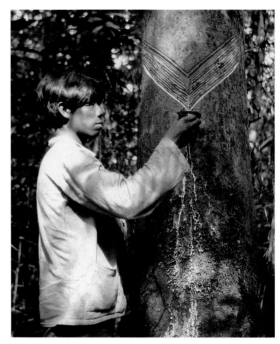

Rubber tapper, Loretoyacu.

peace, the United States had imported more than a million tons of natural rubber. By 1943 imports would dwindle to a mere 55,329 tons.

It was an extraordinary crisis. Every Sherman tank contained twenty tons of steel and half a ton of rubber. Every battleship sunk at Pearl Harbor had more than twenty thousand rubber parts. Rubber was wrapped around every inch of wiring in every factory, home, office, and military installation in the country. There was at the time no viable synthetic alternative. With every conceivable source taken into account, the United States had, at normal rates of consumption, roughly a year's supply. Out of this limited strategic reserve, the nation had to satisfy its own domestic needs as well as those of Britain and her dominions, even as it fueled the largest and most important industrial expansion in history, the arming of the Allied cause.

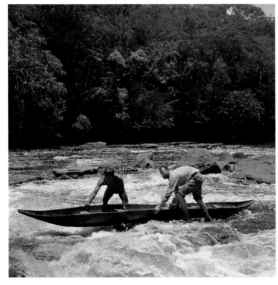

Schultes and friend heading upstream, Caño Paca, Río Piraparaná, October 1943.

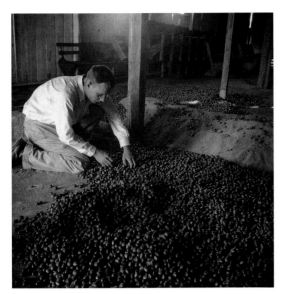

Schultes sorting some of the six hundred thousand rubber seeds he collected and processed for shipment at Leticia, March 1945.

Washington's response was swift and dramatic. Four days after Pearl Harbor, the use of rubber in any product not essential to the war effort was outlawed. The speed limit was dropped to thirty-five miles per hour, not to conserve gas but to reduce wear and tear on tires. Scrap rubber fetched a penny a pound at more than four hundred thousand depots across the country. Even Fala, President Roosevelt's dog, had his toy bones melted down. It was the most extensive recycling campaign in history, and it allowed the Allies to survive 1942. Still, the clock was running down.

The order went out to chemists and engineers to create a new industry. Various chemical substitutes for rubber existed, but none had been perfected. In 1941, the total output of the synthetic industry was just over eight thousand tons, mostly specialty rubbers useless for tires. Thus the nation's survival depended on its ability to manufacture 800,000 tons of a product

that had barely entered the developmental stage, as well as an equal tonnage of its various chemical precursors. American industry had never been called upon to handle such a task, to accomplish so much in such a short time. The engineers had two years. If the synthetic program did not succeed by then, America's capacity to wage war would collapse.

The third initiative was a desperate attempt to obtain latex from any conceivable source. Russian dandelions were planted in forty-one states and three Canadian provinces. Plant explorers were sent to every corner of the free world with the goal of securing raw supplies of latex, and with a far greater challenge. It was their task to find a way to grow rubber in the Americas, with the hope that the nation would never again be in a position to be blackmailed by a foreign power that controlled the Far Eastern plantations.

It was not as if the risks had been unknown before the war. Throughout the early decades of the century, every major rubber company had tried to break the Asian monopoly. Thomas Edison spent his fortune trying to develop goldenrod as a source of latex in the southeastern United States. Firestone took rubber trees to Liberia where the leaf blight did not exist. Goodyear took them to Panama. In 1927, Henry Ford, who by then was making half the automobiles in the world, secured from the Brazilian government a land grant four times the size of Rhode Island and set out to establish rubber plantations in the Amazon. A man unaccustomed to failure—the Ford Motor

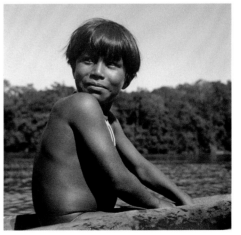

Makuna fisherboy, Río Popeyacá, June 1952.

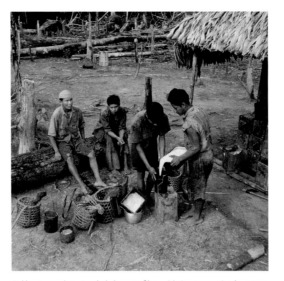

Rubber tappers bringing daily harvest of latex, Río Loretoyacu, October 1944.

Company would produce more industrial output than Italy during World War II—Ford spent millions on his dream, carving out of the jungle an entire modern town with railroads, a deep-water port, and miles of road, as well as schools, a modern hospital, swimming pools, a golf course, and hundreds of brick-and-stucco bungalows for his many employees. Thousands of acres were cleared and planted with the finest of the high-yielding Eastern clones that his agronomists had secured from Malaya and the Dutch East Indies. By 1934, 1.5 million saplings grew at Fordlandia.

All seemed well until the foliage began to form a continuous canopy over the fields. Then the blight struck, moving like a blowtorch through the plantings. An investment of over 20 million dollars was ravaged, but, more ominously, it was discovered that the process of breeding for high yield in Asia had, in fact, produced clones that were especially sensitive to the blight. Thus emerged the nightmare sce-

nario. If the disease ever reached Asia, it could mean the end of the industry.

Out of disaster, however, came hope. Among the thousands of dead and withered trees were a few, mostly wild types from the remote reaches of the Amazon that appeared to demonstrate at least some resistance to the blight. This suggested the possibility that somewhere in the Amazon existed individual rubber trees that both yielded copious amounts of latex and had natural immunity to the disease. It was to find them, a quixotic quest not unlike searching for a needle in a haystack, that Schultes and his small band of explorers were flung into the most remote reaches of the Amazon. At a tremendous cost of lives and treasure, these men would accomplish the impossible.

For Schultes, the real work began in the first weeks of 1943, when he was assigned the daunting task of exploring from its headwaters the Río Apaporis, the most isolated of all the rivers of the Colombian Amazon. The available maps showed the Apaporis only as a broken line etched idly across some fifteen hundred miles of forest, its trajectory unknown, its hazards only imagined. His instructions were to reach the headwaters, home to the Karijona, by reputation a mysterious tribe of cannibals, and then to proceed downriver, surveying the forest to ascertain whether the basin was, as rumored, the mother lode of rubber.

Aerial reconnaissance revealed an unexplored range of flat-topped sandstone mountains at the source, isolated massifs that stand as lonely sentinels, serene and otherworldly, above a narrow river that winds like a serpent through thirty miles of formidable rapids. Then, for three hundred miles, the river moves gently through undisturbed forest until suddenly its somnolence is broken by the great falls and cataracts of Jirijirimo. There the river, perhaps half a mile wide, narrows to a hundred feet, drops seventy feet over a ledge, and enters a chasm nine miles long and fifty feet wide, with towering rock walls on either side. Disappearing into a tunnel of stone, it flows, deep and silent, through a mysterious fault until emerging on a beautiful plain of low forest and savannah spread across dazzling white sands. Below Jirijirimo, there are another four hundred miles of rapids until the Apaporis finally meets the Caquetá. The most dramatic of the rapids is Yayacopi, a wall of rock forty feet high over which flows the entire river. Under no conditions, Schultes had been ordered, was he to travel beyond the cataract of Jirijirimo. To do so would be to court death.

Schultes entered the forest in April 1943, traveling 180 miles up an adjacent river to a portage that led overland to the Apaporis, where he built two canoes that enabled him to explore the headwaters and the ancient sandstone mountains that today bear his name. Massive and remote, veiled in mist and often grotesquely eroded, they seemed to him to echo the dawn of time, rising like giant sculp-

tures left over from some primordial workshop. No botanist had ever seen their flanks, let alone walked the summits where virtually every plant teased him with its novelty.

The journey came, of course, at a cost. The first fatality occurred the night they reached the Apaporis, a young *llanero,* a boy from the eastern plains, swept away in a cataract as he attempted to ford the stream. Injury and death haunted the expedition. A near-fatal

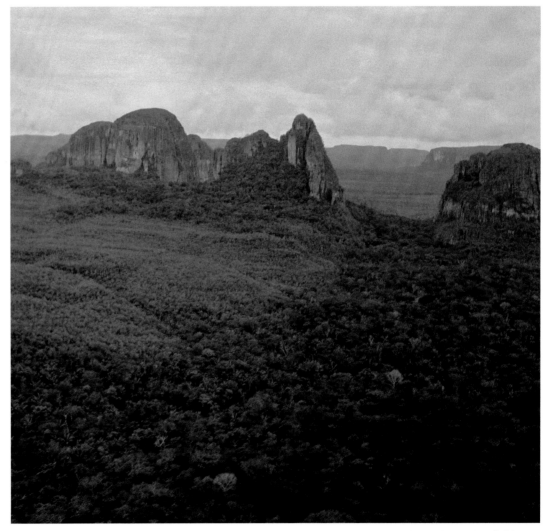

Cerro de la Campana, Río Ajaju. When Schultes began his Río Apaporis explorations in April 1943, the river was the least known and most isolated of all the major waterways of Colombia. Formed by the confluence of the Ajaju and the Macaya, rivers themselves born not on the slopes of the Andes but further to the east, in the midst of the trackless savannahs of Caquetá and Meta, the Apaporis flows through a series of flat-topped sandstone mountains, remnants of the ancient land mass that once rose above the forests of the Guianas, Venezuela, and Colombia.

bout of blood poisoning forced Schultes himself to abandon the drainage at the end of June. When he returned in August, headed this time for the middle section of the Apaporis, he and his crew laid a corduroy track some 36 miles through the jungle and hauled a 3,000-pound wooden boat overland across some 120 creek draws to reach the river. Photographs taken at the time reveal exhausted men straining against a pole bound by rope across the bow of the boat. Their clothing hangs limp with sweat. Many are barefoot. All are filthy, including Schultes, who works beside them, distinguished only by his thick beard, his pith helmet, and a cigar that appears to burn incessantly in his mouth.

It is not clear from the archival records precisely when the authorities at the American embassy declared Schultes missing and presumed lost. Word that the party was overdue reached Bogotá in the first week of October. A military search plane returned from an overflight of the Apaporis without having sighted the expedition. A fortnight passed. The ambassador was about to notify Schultes's parents when a cryptic message arrived from the Colombian Ministry of War. An American claiming to work for the rubber program had turned up at La Pedrera, a military post close to the Brazilian frontier. The Capuchin priests there had put him to work painting the inside of their church blue.

A glance at the map revealed that Schultes was four hundred air miles from where he was expected to be. This meant only one thing. He and his crew had descended the entire length

The chasm at Jirijirimo where the Río Apaporis disappears to flow through a mysterious fault long held to be sacred by the Makuna Indians.

of the Río Apaporis, becoming the first to enter and survive the passage through the cataract of Jirijirimo. For Schultes, who famously maintained that adventures happen only to those incapable of planning an expedition, the falls were a mere impediment to be overcome in the course of his work. His mission was to map the river and hunt for rubber. In seven months, he personally counted 16,713 individual rubber trees. The entire drainage, by his estimate, contained some 17 million viable specimens. Extracting the latex from just the trees within the immediate vicinity of the riverbanks would employ 10,000 men and yield approximately 6.5 million pounds of rubber a year, the largest potential production in all of Colombia. His map of the river is still used today.

Schultes emerged from the Apaporis to find that his fundamental mission had changed. As 1943 came to an end, his superiors were having doubts about the program for which the men were risking their lives. Truth be told, no amount of rubber from the Amazon was going to make the difference. Even at the height of the boom, when as many as five thousand men a week had poured into the basin, total Amazonian production had been only fifty thousand tons a year. The war effort required twice that every month. Increasingly, the rubber men turned their attention to that part of the program that promised to free America from dependence on the East Asian plantations. Schultes, in particular,

was cut loose to explore the Amazon at will, to go wherever his scientific intuition led him, as long as his sights remained focused on the goal of finding high-yielding rubber trees that were resistant to the blight.

Against all odds, he found such trees, solitary specimens growing throughout the homeland of the Tikuna Indians some twenty miles upriver from the Colombian settlement of Leticia. For three tapping seasons, October to December of 1944 through 1946, he made his home there in the forest, in a small hut on the banks of the Río Loretoyacu. Rising each day before dawn, he accompanied the

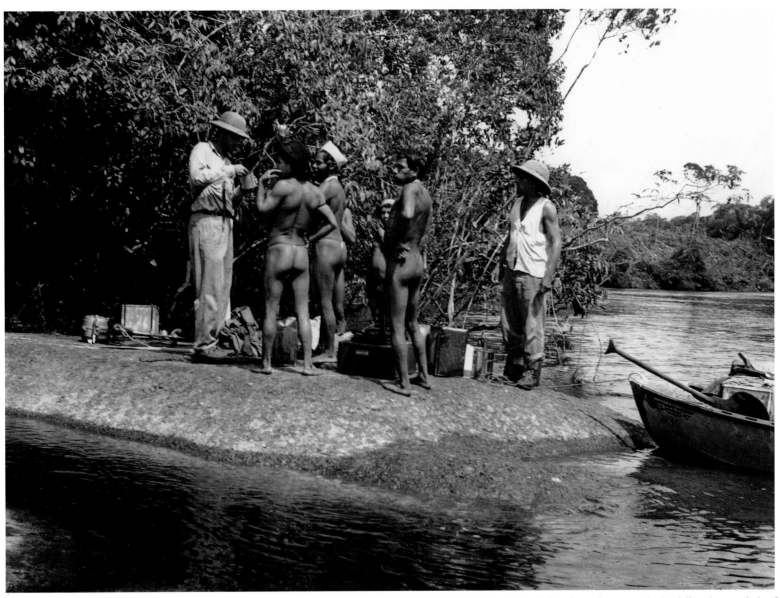

Río Piraparaná, 1943. Schultes sharing coca with his Makuna friends. In the Andes, coca leaves are taken orally and formed into a quid, to which is added an alkaline substance: limestone, powdered seashells, or the prepared ashes of certain plants. In the Amazon, by contrast, the leaves are dried over a fire and pounded in a mortar. Ash is then added, and the mixture is sifted to yield a very fine powder with the consistency of talc. Schultes had a particular fondness for Amazonian coca. According to his good friend, Colombian anthropologist Gerardo Reichel-Dolmatoff, Schultes once pulled out a can of the powder at a Bogotá cocktail party. In measured tones, he explained to anyone who would listen that the preferred ash came from the large palmate leaves of Cecropria sciadophilia, *not the decidedly inferior foliage of* Cecropria peltata. *He, naturally, had the good stuff.*

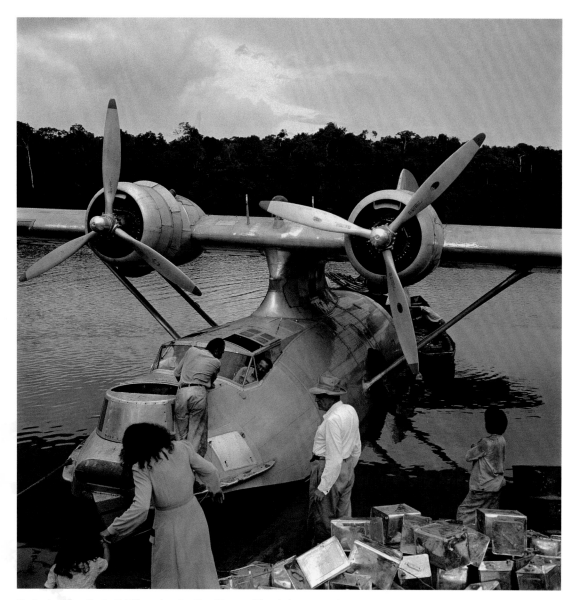

The Catalina. Owned by the Medellín merchant Don Miquel Dumit and flown by his German pilot, Captain Lieberman, the Catalina is pictured delivering supplies to Soratama. At Dumit's behest, Schultes established the rubber station in June 1951 on the banks of the upper Río Apaporis, three hours by paddle above the falls of Jirijirimo. The amphibious Catalina was a marvelous aircraft, capable of carrying a considerable load and able to land and take off from almost any flat stretch of river free of cataracts. For Schultes, it became a lifeline to the outside world, allowing him to travel to ever more remote reaches of the Amazon.

seringueros, the rubber tappers, as they walked their circuits and gathered the latex. The Loretoyacu drainage supported some 120,000 rubber trees. Schultes identified and monitored the production of 6,000 of the very best. Of these, he selected 120 clones to be dispatched to experimental research stations in Costa Rica and throughout the Caribbean. Each spring he orchestrated the collection of over three tons of seed, all together some 600,000 individual seeds, each of which had to be inspected by hand. This was the germ plasm upon which an American plantation industry was to be built.

Between seasons, he was free to wander, south to the lowlands of Bolivia, north through the jungles of the Vaupés, and east to Brazil.

He lived for his work. Every moment not in the forest was a lost dream, a species denied to science, a botanical mystery left unsolved. To understand the source of his drive and ambition, one must appreciate just what kind of botanist he had become.

Most naturalists working in the Amazon must make peace with their ignorance, so complex and remarkable is the diversity of its flora and fauna. When they look at the forest, their eyes fall first on what is known and then seek what is unknown. Schultes was the opposite. He possessed what scientists call the taxonomic eye, an inherent capacity to detect variation at a glance. When he looked at a forest, his gaze reflexively fell on what was novel or unusual. And since he was so familiar with the flora, he could be confident that if a plant was new to him, it was likely to be new to science. For Schultes, such moments of discovery were transcendent. He was once in a small plane that took off from a dirt runway, brushed against the canopy of the forest, and very nearly crashed. A colleague who was with him recalled years later that throughout the entire episode Schultes had sat calmly by a window, oblivious to the screams of the terrified passengers. It turned out that he had spotted a tree, a new species of Cecropia, and had scarcely noticed the crisis. What all this meant was that Schultes could resolve botanical problems in the moment, write descriptions in the field, realign species and genera just by holding a blossom to the light. In the entire history of Amazonian botany, only a handful of scientists have possessed such talent.

Thus for Schultes each journey was like a new morning, full of a day's potential for wonder or disappointment. The reach of his travels, the risks and dangers, the ease and confidence with which he moved into unknown lands, the challenges endured, all mark him as a man from another time. In September 1947, for example, he embarked on what would be a ten-month sojourn exploring the upper reaches of the Río Negro, the greatest tributary of the Amazon, an affluent that were it to exist alone would be the second-largest river on Earth. From the start it was a horrendous expedition; his journal is a litany of boat wrecks, impossible rapids, lost specimens, hunger, death, and disease, including a near-fatal attack of malaria that forced his Indians to carry him prostrate in his hammock off the face of a mountain.

The real crisis would come later, in June 1948, when at the very headwaters of the Río Negro he noticed a tingling sensation in his fingertips. Initially he thought it a consequence of using formaldehyde to preserve his specimens, but within days the sensation had spread to his toes. He realized that, a thousand miles from the nearest city, in the midst of a sterile forest where not a tree was in fruit, he was coming down with beriberi. Caused by a deficiency of vitamin B1, or thiamine, in the diet, the disease is progressive. Early symptoms of lassitude and numbness in the limbs and extremities gradually give way to total degeneration of the nerves, resulting in muscular atrophy, a complete inability to move, and, ultimately, death. The only treatment is thiamine—

massive doses injected repeatedly over time. Schultes was a long way from a pharmacy.

Heading downstream, he reached the Salesian mission at São Gabriel on the evening of June 21. By then his symptoms were pronounced, and it was imperative that he get proper medical attention as soon as possible. One option was to continue down the Río Negro for another six hundred miles to Manaus. The head of the mission, Padre Miquel, suggested another route. By heading up the Río Vaupés, a tributary that flowed into the Negro at São Gabriel, Schultes could reach a portage that would take him overland to the headwaters of a stream that would eventually carry him to Colombia and a remote military outpost where he might secure a flight for Bogotá. The total distance by land and water would be half that of going downriver to Manaus.

Unfortunately, the padre had his geography wrong. It was not a day to the portage; it was five, by which time Schultes's feet were numb and he could walk only with the aid of two sticks. The short portage turned out to be a three-day slog on legs that felt like stumps. Fortunately, he encountered by chance a wandering band of nomadic Indians, the legendary Makú, a tribe he had always wanted to know. Bad luck turned to good as they invited him to attend a nocturnal ritual that involved a mysterious and curious preparation. The effects were unmistakable. "I learned experimentally,"

Schultes later reported, "that it had strong hallucinogenic properties." In fact, the intoxication was as intense as any he had experienced. It lasted all night and into the dawn. His eyes still painted with color, his mind swirling in the cool mist and scent of the forest, his body awkward and clumsy, he made his way to a small clearing where an old man who had danced all night revealed the source of the drug. He recognized immediately that it was a new species in a genus of plants never before known to be psychoactive. He named it *Tetrapterys methysica* and with the help of the shaman gathered herbarium specimens as well as material for chemical analysis. These bulk collections, unfortunately, were lost in the following days when his canoe was spun over in a rapid, but the herbarium specimens survived and later confirmed that in the midst of his darkest hour, with beriberi progressing through his body, Schultes had indeed discovered a new hallucinogen.

His ordeal, however, was only beginning. The Indians carried him overland and on reaching the Colombian watershed left him and his one young *mestizo* companion, Pacho Lopez, alone in a thatch shelter while they returned to get his canoe and the rest of the equipment and supplies. For three days, in the midst of the most terrific rainstorms he would ever experience in the Amazon, he and Pacho waited. At no point did he consider what might happen should the Indians not live up to their promise

PHOTO ON RIGHT PAGE: *The Río Guainía, headwaters of the Río Negro, was a land of hunger, a river of few fish and less game. By the time Schultes reached the Raudal del Sapo, the Frog's Cataract, he had exhausted his emergency rations and was considering breaking into his last supplies—four tins of Boston baked beans he carried wherever he went, less as food than as fetish. After four days on the river, he came upon what appeared to be an apparition, a small dugout canoe paddled by a solitary white woman wearing a straw bonnet. She was an American, Sophia Müller, an evangelist for the New Tribes Mission who had been living for years among the Kuripako at a small outpost known as Sejal. This poor woman was so desperately thin and sickly that Schultes made the ultimate sacrifice. Of his four tins of beans, he left two behind. It proved a hasty decision, for in the following days he would need the food. That evening, June 2, 1948, he first noticed the tingling in his fingertips that foreshadowed the onset of beriberi.*

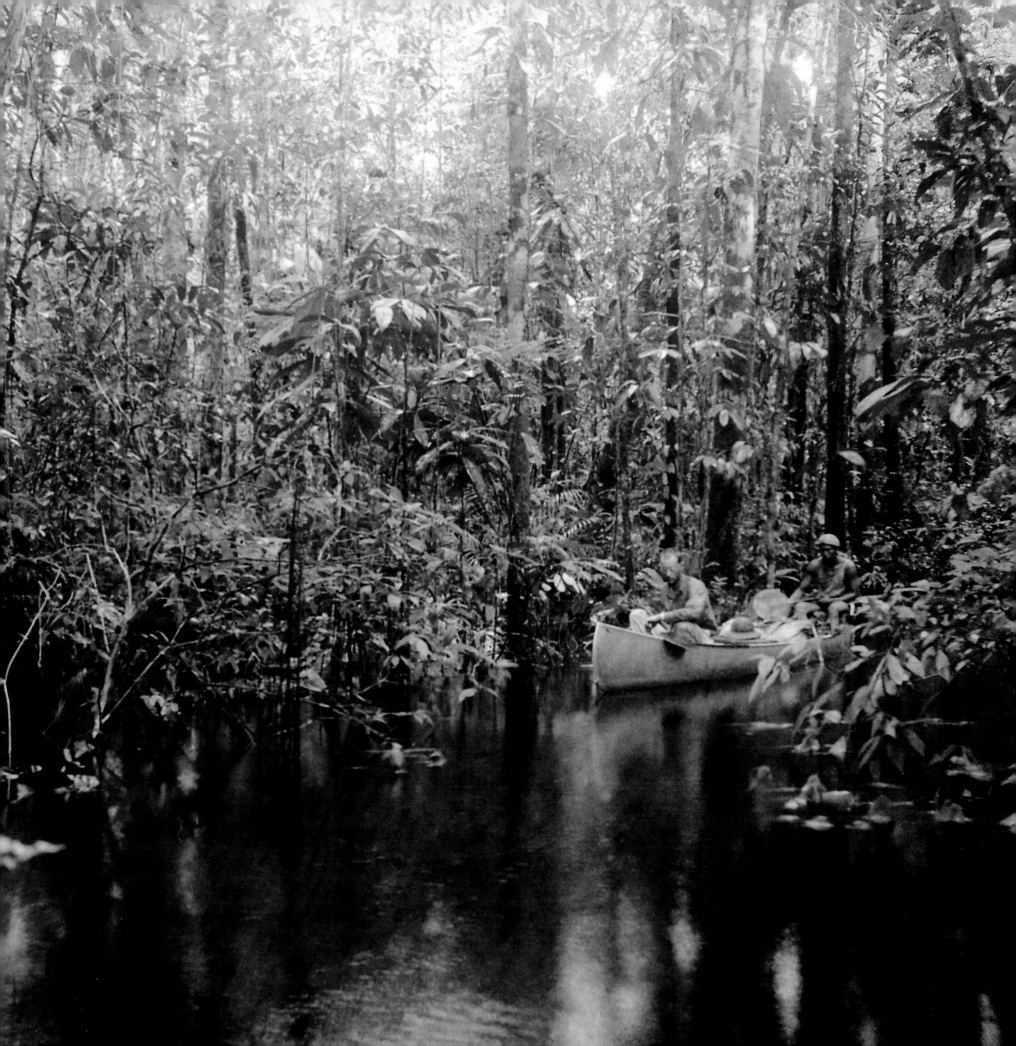

to return. Though he had been with them for less than a week, his trust was absolute.

They did return, and Schultes headed off downriver into Colombia. His food and fuel exhausted, he faced five days of tortuous rapids and portages before reaching the main channel of the Río Caquetá. There, by chance, he encountered a remote patrol of Brazilian soldiers who gave him food and enough gasoline to motor two days upriver to La Pedrera, the Colombian military post he had first visited in 1943 at the end of the Apaporis expedition.

At the landing, before even leaving his canoe, Schultes asked a guard when the next plane was due. The soldier began to laugh. Schultes repeated the question. The soldier still did not believe the question was serious. Civil war had broken out in Colombia during the year that Schultes had been away in the forest. There had not been a military flight to La Pedrera in three months, nor was one expected. Schultes had traveled for nearly a month, enduring extraordinary hardships, only to find himself several hundred miles farther from rescue.

He had no choice but to head downriver. By the time he reached Manaus, after nine days of steady river running, he could no longer walk and had to be carried in a hammock from the docks to the hospital. An ordinary man might have rested for a few days. Not Schultes. On the way up the landing, he noticed a fine riverboat belonging to the American Chicle Company. That night he dispatched young Pacho to make inquiries, and by morning everything had been arranged. Schultes was not about to hang

around Manaus nursing himself with injections. He got hold of a syringe, learned how to use it, and bought a large supply of thiamine. Within three days of arriving in Manaus, he was back on the river and headed for the Río Madeira, the second-largest tributary of the Amazon after the Río Negro. Three years before, when he had come down the Madeira from Bolivia, low water had prevented him from reaching a remote savannah, home to a rare endemic species. He was not about to let beriberi get in the way of a chance to secure flowering specimens of an unknown plant.

With the end of World War II, the rubber crisis passed. Schultes, though still employed and fully funded by the government, became an almost ghostlike figure to the bureaucrats, a legendary botanist perpetually off on some extreme expedition, pursuing some botanical mystery that few of them could appreciate or understand. All of this suited him fine. Left alone, he was free to wander. In 1950, the entire frontier region of Colombia and Brazil, lands bounded to the north by the Río Guaviare and to the south by the Caquetá, was as remote and wild as any place on earth. Yet Schultes came to know it literally like the back of his hand. On one occasion in 1958, he flew from Bogotá to Mitú, a small trading post in the heart of the Northwest Amazon. As the Catalina dropped out of the Andes, it came

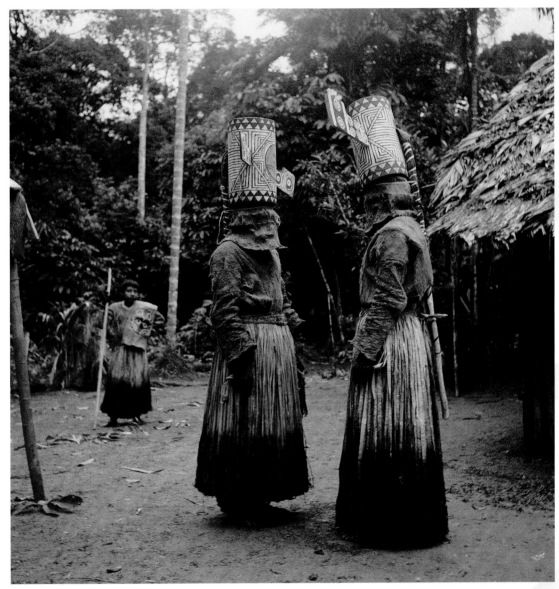

*Caño Guacayá, Río Miritiparaná. In April 1952, Schultes traveled to the homeland of the Yukuna, an Arawakan people inhabiting the Miritiparaná, a remote **tributary** of the Caquetá born in the lightly forested uplands south of the Río Apaporis. Three hundred miles long, the Miritiparaná begins as a shallow transparent **stream flowing** over a bed of pure white sand, and then tumbles through seven major rapids. Doubling in size at the confluence of the Guacayá, its principal affluent, **the river** flows south, entering the Caquetá twenty-five miles above the Colombian military post of La Pedrera. He arrived among the Yukuna on the eve of the Kai-ya-ree, a four-day annual celebration that gives form through dance and ritual masks to all the forces of nature. In this photograph, Yukuna dancers at the Kai-ya-ree wear the masks of the sun.*

upon a blanket of cloud stretching south as far as the pilots could see. They flew on, hoping for a break in the cover. After two hours, well beyond radio contact, they were lost, with neither fuel to return to Bogotá nor any means of locating their position. In desperation, they called Schultes to the copilot's seat. With fuel running low, he told them to fly south. Suddenly a small break in the clouds appeared. The pilot dove through it and leveled off the forest. They could have been anywhere. Schultes looked around, recognized a bend in a river, and directed the astonished pilots, flying at treetop level, on to Mitú.

lost amazon

An ordinary man might
have rested for a few days.
Not Schultes.

Within that immense forest he came to know not just the plants, but also the people who understood them best. From the Cubeo, he learned of *ipadu,* the powdered coca taken each day and throughout the night around the men's circle in the flickering light of the long-houses. The Yukuna tied magic herbs to his arms and taught him to wrestle; the Tanimuka dressed him in bark cloth and ritual masks, transforming his spirit into that of an animal to dance the Kai-ya-ree, the mythical story of the birth of the world. The Makuna actually took him to the geographic point of origin, a sacred rock where the primordial anaconda had come to Earth from the Milky Way. Among the Tukano, he became the first outsider to inhale the Semen of the Sun, a psychoactive powder acquired at the first dawn when the daughter of the Sun had scratched her father's penis and ground the dried secretions into snuff. It turned out to be yet another new hallucinogen, derived from the blood-red resin of a forest tree previously unknown to science.

The key to Schultes's success lay both in the respect that he displayed for the Indians and in the time that he was able to live with them. Whereas most botanical expeditions, both in his day and since, would be measured in weeks, perhaps months, Schultes spent years in the most remote reaches of the forest. In early 1952, for example, he established a small rubber station on the Río Piraparaná, just above the Apaporis confluence. He named the camp Jinogojé: in Makuna, "Cave of the Anaconda." For the next eighteen months, virtually all of his explorations

were within a one-hundred-mile radius of the station. Though he never lingered long in any particular Indian community, his movements and reputation resonated throughout the entire region, drawing men and women of a half dozen tribes—Tanimuka, Barasana, Makuna, Tatuyo, Yukuna—to his base at Jinogojé.

A window onto this world is provided by a letter written by Gerardo Reichel-Dolmatoff just before the great Colombian anthropolo-gist's death in 1994. On July 10, 1952, Reichel-Dolmatoff, who would become one of Schultes's closest friends, flew into Jinogojé as part of a five-man delegation from the Colombian Ministry of Education. Also on board the am-phibious Catalina was Enrique Gomez, son of then-President Laureano Gomez, as well as a young journalist by the name of Belisario Betancur, who would himself become president of Colombia some thirty years later. Indeed, it would be Betancur who in 1983 would present Schultes with the Cruz de Boyacá, Colombia's highest civilian honor and one that had never before been awarded to a foreign naturalist. At the time, Reichel-Dolmatoff was making his first trip to the Amazon. He describes his ini-tial encounter with Schultes:

"A steady rain was falling and the dank smell of forest was in the air. The people sur-rounded us....Most of them had malaria-worn faces; wiry little mestizos clad in tatters shook hands with us; in the background were some Indians, most of them naked, some with trousers. A tall stranger, gaunt and bearded, dressed in crumpled khaki, but unmistakably

American, walked up to me and said: 'I am Richard Evans Schultes.'"

That evening after dinner the anthropologist and the botanist spoke long into the night, a wide-ranging conversation that drifted from plants and natural history to botanical terminology, Greek etymologies, the Latin classics. At one point, Reichel-Dolmatoff mentioned Richard Spruce, the modest yet legendary English botanist who spent seventeen years alone in the Amazon in the mid-nineteenth century. With a jerk of his head, Schultes stared at his guest and said in a toneless voice, "He is my hero." The comment surprised Reichel-Dolmatoff. This was not idle sentiment; it was the raw invocation of lineage.

"There was something in his expression," Reichel-Dolmatoff would recall, "in his eyes that alerted me. The next day I noticed the same expression on his face. We had gone a few miles upriver and now were standing on the riverbank and in front of us, on the other side, the forest was rising like a wall. We looked in silence and then Schultes said, as if speaking to himself, 'I know every tree, every single tree one can see from here.' He was standing very quiet, eyes wide open, with up-drawn eyebrows. 'That man's a fanatic,' I thought, but immediately I corrected myself; no, that was not the word. He had not been talking about trees; it wasn't about trees at all. The forest meant something else to him; the forest was a mediator. And sometimes I wonder what the forest came to mean to those Victorian naturalists, to Wallace, Spruce, Bates. And to the Victorian deep inside Richard Evans Schultes."

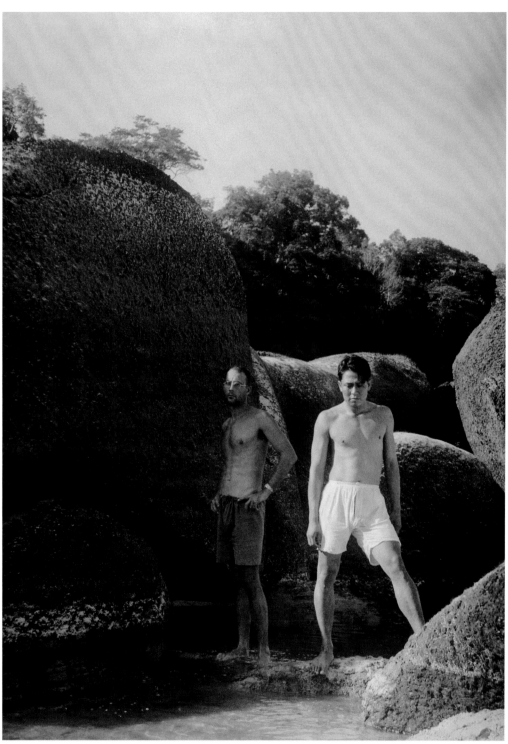

Schultes and his close friend and assistant Pacho Lopez, Río Negro, 1947. Schultes met Francisco "Pacho" Lopez living on the Loretoyacu in the fall of 1944. The son of a Miraña mother and a white balatero, Pacho had come to find work in Leticia. He and Schultes were a perfect match. A brilliant youth of seventeen with a passion for plants, Pacho could climb any tree, follow any path, find food in the midst of a swamp. Hardworking, strong, and honest, he lived by his intuitions and never complained. More than once he would save Schultes's life. It was Pacho who carried Schultes off the dock in Manaus when he succumbed to malaria and beriberi. After their seventeen-month sojourn on the upper Río Negro, Schultes returned briefly to Boston. It was there, seven months later, that he received the terrible news that Pacho had died on July 6, 1949, of tuberculosis, contracted during their time on the Río Negro. Pacho was only twenty-two. For five years they had been inseparable, and for Schultes, losing Pacho was like losing a son and a brother.

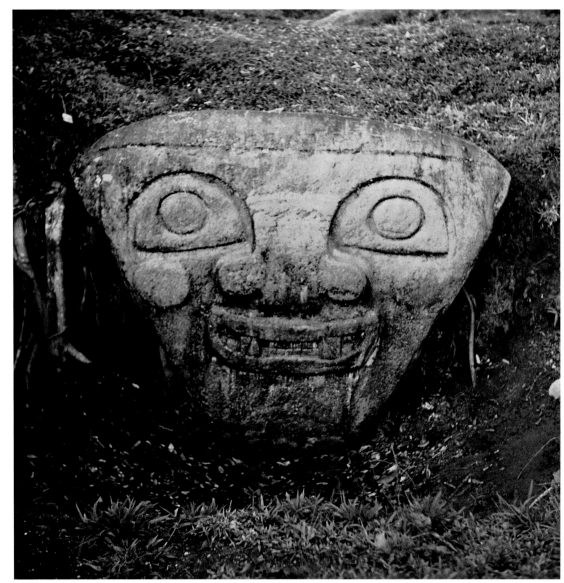

On New Year's Eve 1942, the day this photograph was taken, Schultes was visiting San Agustín, an ancient site overlooking the ravine of the upper Magdalena. As he wandered the hillsides on either side of the river, he encountered, standing over burial sites and sarcophagi, some five hundred anthropomorphic statues. In aspect and scale, these megaliths rival those of Easter Island, but their symbolism is rooted in the forests of the Amazon. Carved sometime during the first millennium A.D., though possibly much earlier, by a people we know little about, they depict animals and demons, eagles with fangs, felines copulating with men, faces emerging from the tails of snakes. In many instances the figures have cheeks bulging with stylized quids of coca. Schultes recognized these as some of the oldest representations of the plant, and the earliest evidence of its sacred role in the lost civilizations of the northern Andes.

For Reichel-Dolmatoff, who would go on to become the world's foremost authority on the ethnology of the Vaupés, the chance encounter at Jinogojé was a pivotal moment. The Indians spoke of the Piraparaná, a river "where their people lived in painted long houses and where hardly ever a foreigner had been seen." Schultes too had mentioned the river, and "although his quiet voice and sober-minded descriptions were unromantic, there was something that captivated me... The Indians and Richard Schultes, each in their own way, had shown me a new dimension. I left Jinogojé with the conviction that this had been a liminal spot on my way."

Schultes, of course, had his own plans for the Piraparaná, but they would have to wait. He was feeling poorly, and when, on July 13, the delegation left for Mitú and Bogotá, he went along, sitting beside Reichel-Dolmatoff behind the pilot. Overloaded with rubber, the Catalina struggled to leave the water. The forest loomed ahead. There was a moment of panic. The hatch was flung open, and Indians dumped bale after bale of rubber as the plane ricocheted over the surface before finally rising sharply over the rocks and barely clearing the edge of the canopy. Reichel-Dolmatoff settled back to catch his breath. "Schultes," he later wrote, "had remained in full control, holding on to his field notes and presses." In fact, Schultes hardly noticed the crisis. His head pounded, and he was beginning to sense the convulsions of yet another attack of malaria, this time so severe that it would leave him prostrate in Bogotá for nearly a month.

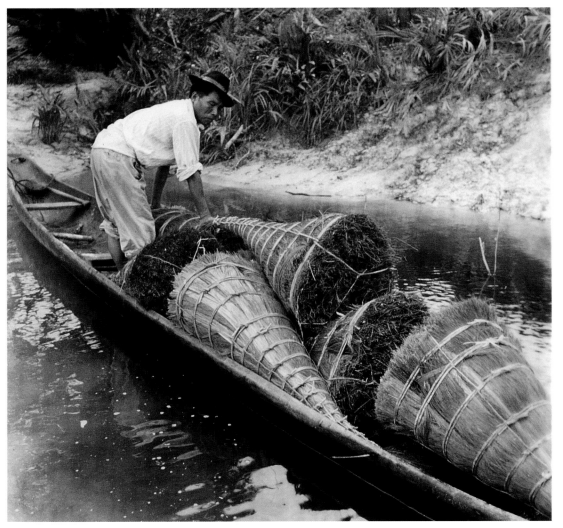

Transporting piassaba fiber, Río Guainía, Vaupés. The piassaba palm thrives only on the white sands of the open savannahs of the upper Río Negro. Though mostly used for brushes and brooms, piassaba was so highly valued that men risked their lives to transport it from the headwaters a thousand miles or more in dugout canoes through impossible rapids to the markets of Manaus.

"The forest meant something else to him; the forest was a mediator."

The Journey Begins

In the summer of 1936, at the age of 21, Schultes traveled to Oklahoma to live among the Kiowa and study their ritual use of peyote. He participated in the nocturnal ceremonies, ingesting the plant on many occasions, sharing with the Kiowa the journeys that led them to their gods.

The Roadman took four peyote buttons from a leather bag and placed them before the altar, a raised crescent of earth that enveloped a small fire kindled at the center of the tipi. The Cedarman repeated the gesture and then circulated the bag in a clockwise direction. Taking a bundle of sage in his hands, the Roadman knelt before the fire and rubbed his entire body with the leaves. Others did the same, and the scent of crushed sage and juniper mingled with the blue veil of tobacco smoke that hovered just above the worshipers. As the men reached into the smoke with their fans, the Roadman added more juniper to the fire. He took his staff in one hand and his rattle in the other, and slowly described four circles in the smoke.

"Eat these, and remember that they are sweet," Charlie said as he passed the leather bag to his left.

Schultes withdrew four peyote buttons and placed the bag on the ground in front of the Drummer. The texture of the dried plant was that of brittle leather. Once in his mouth, it was several minutes before the flesh softened and the first waves of nauseating bitterness swept over his senses. He swallowed hard.

The Roadman held a sprig of sage and his staff before the altar. He closed his eyes and, shaking his rattle, began in a high nasal tone to sing the Hayätinayo, the Opening Song that heralds the spirit of Father Peyote.

*Hei yana hi ya na nei
Hei yana hi ya na nei
Hei yana hi yoi na nei, hei yana ha yoi na hei nei
Hei yana hi nei na dok' igo ba ko onta
Hei nei yo wah*

*May the Gods bless me,
help me, and give me power and understanding.*

The Drummer motioned to the altar with his drumstick, pulling smoke from the fire over the drum. Then began the sound that would continue intermittently until dawn, a single drumstick struck on wet buckskin. The beats came so fast that they merged into a steady, almost electronic hum, exactly the tone of the auditory hallucinations that soon would be echoing around Schultes's mind.

It was forty minutes or more before Schultes felt the first effects of the plant. An unpleasant nausea was soon overcome by a whimsical sensation in the periphery of his field of view, an intuitive sense of space, a cushion between himself and everything else in the tipi. There followed a fleeting moment of pure clarity, an almost crystalline awareness of the appropriateness of where he was and what he was doing. He looked at Charlie Charcoal, whose eyes had changed to sparkling beads, whose face was flushed in gentle undulations that were slowly growing in intensity. Schultes blinked. The music had stopped. The Roadman was handing his staff to the man on his left; the Drummer was passing his drum to the Roadman. Each man in turn was drumming for the one singing. The songs ran together. Schultes found himself paying the utmost attention to every sound, and each one burst into another thought that washed over him with immense feelings of good will. All around him there were old men praying, tears running down their cheeks, voices tender with emotion, bodies swaying in adoration, hands reaching out for Father Peyote. He tried to move. Charlie stopped him.

"Never step between the fire and a man praying," he cautioned. Schultes began quietly to laugh. The shadows on the tipi wall were so much larger than the men beneath them. It was as if a gallery of spirits were dancing.

A pouch of tobacco came his way. His fingers fumbled over the moist brown strands. The scent was as rich as memory. He crushed oak leaves between his fingers. He took a peyote button in his hand. He shut his eyes and experienced warm flushing sensations and a sound that seemed to link his body to the earth. There was the sense of the feel of the earth, the dry desert soil passing through his fingers, the stars at midday, the smell of cactus and sage, the feel of dry leaves through hands. When he once again opened his eyes, the men were slowing fusing one into another, and every movement shot pulsating bolts of color, diamonds turning into tunnels, windows into waves, oceans into rain. He lifted his hand before his eyes and was amazed to see a trail of light from his thigh to his fingers. Everything was reduced to sensation. His heart. His hair like straw. His jaw moving up and down, chewing more peyote. The men around him ate it constantly. He watched their faces, and the taste in his mouth changed. It was no longer bitter and sour. If the desert itself had a flavor, this was it.

Time turned into color. Every thought unleashed a sound, every gesture a rainbow of light. Schultes tried to concentrate, to follow a single train of thought, but found it was impossible. Resisting the wild flow of his thoughts was physically painful. There was another cloud of smoke as the Roadman placed more juniper on the fire. He seemed so calm, so outwardly untouched by the peyote. The Fireman went about his work, sweeping the floor of the tipi, tossing the cigarette butts into the fire, tending the flames, drawing the ashes into the shape of the Waterbird. Sometime close to midnight, the Fireman placed a bucket of water close to the fire while the Roadman sang the Yáhiyano, the first of the Midnight Water songs…

The singing and drumming continued almost constantly, for there were twenty or more worshipers and each had four songs to chant. The amount of peyote consumed varied, with some men eating as many as forty buttons. Schultes had eaten ten or twelve; it angered him that he didn't know. In the middle of the night, well after the Midnight Water ritual, there was a healing. The patient was an old woman, a cousin of Mary Buffalo, and thus it fell to Charlie Charcoal to chew the peyote for her. The Roadman placed the partially masticated buttons in her mouth and with his hands slowly worked her jaw. He bared the upper part of her chest and, taking a burning ember between his teeth, blew sparks over her skin four times. Then, accepting the bucket from the Water Bearer, he sprayed water onto her face and chest, all the while tracing the form of a cross in the air and whispering soft invocations to the spirits.

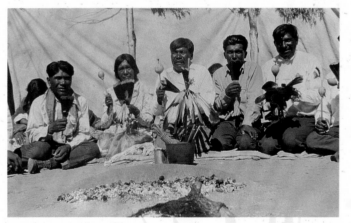

The altar is the moon, the mountain where Peyote Woman found the first plants. The narrow groove running along the length of the altar symbolizes the road one must follow to obtain peyote knowledge. The ashes of the fire spread in the shape of a wing in an arc parallel to the altar. In the morning, the canvas will be pulled away from the tipi, and the wind will disperse the ashes of the Thunderbird.

A sudden wave of nausea took Schultes out of the tipi. Once clear of a small group of women huddled around the fire, he stumbled against a tree and retched as he never had before, deep spasms that were less painful and disturbing than peculiar. Though the peyote had begun to run its course and the wild imagery was already receding into memory, his mind and body remained apart. He was watching his body vomit. He looked up. The dawn was slipping through a pearl-gray sky. The branches of the oak trees spread like veins. Birds were beginning to stir. Behind him in the tipi, he heard the Roadman singing the first words of the Wakahó, the Daylight Song for the Morning Water.

Adapted from *One River: Explorations and Discoveries in the Amazon Rain Forest*.

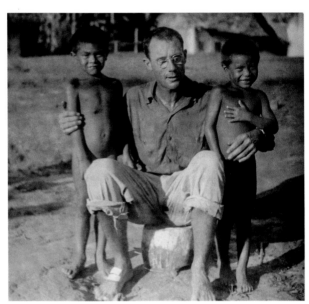

Schultes and young friends.

Only natural rubber
can withstand the rapid
transition from the freezing
temperatures of high
altitude to the sudden
heat of touchdown on the
runway.

Throughout all these years, Schultes assumed that the dream for which he and his fellow plant explorers had risked their lives was about to be realized. He knew that by war's end horticultural breakthroughs had solved all the technical problems involved in establishing high-yielding, disease-resistant rubber plantations at home in the Americas. It was only a matter of time, investment, and follow-through.

But he had no idea of the machinations in play in Washington. In 1952, the rubber program, which had always been the responsibility of the U.S. Department of Agriculture, was taken over by the State Department. The order went out that rubber was not for Latin America, and the research program was shut down. The agricultural research stations were taken over, the files seized, and the clonal gardens, which preserved the invaluable germ plasm of an entire continent, were abandoned and in time allowed to be cut to the ground.

Recently declassified documents in the U.S. National Archives reveal the process by which the decision to destroy the rubber effort was made. What emerges is less evidence of a conspiracy than an egregious example of bureaucratic idiocy and folly. That, together with blind faith in the future of synthetic rubber. For the engineers had, indeed, done the impossible. In 1941, natural rubber accounted for 99 percent of American consumption. By 1945 petrochemical plants supplied a serviceable substitute that satisfied 85 percent of domestic need. At a cost of 673 million dollars, the United States had pulled off

one of the most outstanding scientific achievements of all time. Synthetic rubber had won the war, and most assumed that in time natural plantations would be reduced to a footnote of history. Synthetics were the future. The investment had been enormous; the infrastructure was in place; the plants had to be used or they would corrode. America could control the process from start to finish. And, of course, there were more votes in Texas and Louisiana, where the new petrochemical industry was based, than in Costa Rica and Colombia. In the fall of 1953, when the rubber program was canceled, federal officials declared brashly that natural rubber had had its day and was no longer of strategic importance.

As it turned out, they were wrong. Technical improvements in synthetic rubber had peaked out by the early 1950s, and two unexpected developments since then have left us more dependent on natural rubber than ever before. First came the widespread adoption around 1970 of the radial tire, which requires natural rubber in its sidewall for strength. As the demand on a tire increases, so does the importance of natural rubber. A pickup truck's tire is 50 percent natural. The enormous tires of industrial machines are 90 percent natural. So are the truck tires that today carry half of America's freight. Every semi rolling down an interstate in 2004 does so on rubber scraped from a tree.

The tires of every commercial and military aircraft, from the 747 to the B-2 bomber and the space shuttle, are made almost entirely of natural rubber. There is no viable substitute, no product that can match its resilience and

tensile strength, its resistance to abrasion and impact. Only natural rubber can withstand the rapid transition from the freezing temperatures of high altitude to the sudden heat of touchdown on the runway.

Each year the United States alone spends nearly a billion dollars importing natural rubber. Annual worldwide consumption exceeds 6 million tons, 85 percent of which comes from Southeast Asian plantations, 19 million acres all together, derived for the most part from the original seed stock introduced more than a century ago by the British. It is only an accident of biology that has kept the region free of the South American leaf blight. The wall of the fungal spore is too thin to survive an ocean voyage. But in the age of jet travel, it could be readily introduced, which is why rubber-growing countries such as Malaysia have never allowed direct commercial airline connections from any nation in the Western Hemisphere known to harbor the blight. But eventually every plant disease gets everywhere.

Decades ago, scientists warned of the danger of the leaf blight being deliberately introduced into the plantations. "None of the planting material used in establishing millions of acres of plantations in the east has any appreciable degree of resistance to the disease," wrote Schultes's friend and colleague Loren Polhamous, a leading rubber authority at the USDA throughout the wartime years. Fundamentally, the situation has not changed. Even today a single act of biological terrorism, the systematic introduction of fungal spores

so small as to be readily concealed in a shoe, could wipe out the plantations, shutting down production of natural rubber for at least a decade. It is difficult to think of any other raw material that is as vital and vulnerable.

The decision to end the rubber work was made in the miasma of ignorance, lack of accountability, and arrogance for which modern bureaucracies have become renowned. As an act of folly, it has few equals in botanical history. After a century, the threat of South American leaf blight and the vulnerability of the Far East plantations continue to hang like a Damoclean sword over the neck of the industrial world. Had the rubber program continued, one can be almost certain that today there would be healthy, blight-resistant plantations growing close to home in the Americas. Had that happened, many of the trees would have been the descendants of wild seeds gathered years before by a solitary explorer in the forests of the Amazon. Instead, his dream of twelve years was wiped out by the stroke of a pen.

The end of the rubber program was a great disappointment to Schultes and confirmed his long-standing conviction that most bureaucrats were fools. But it did not make him a bitter man. He simply returned to Harvard and devoted increasingly more of his time to those who would carry on his work. His own research, of course, continued and in time generated no fewer than

496 scientific papers, 10 books, and, it must be told, one *Golden Guide to the Hallucinogens*. But it was really as a professor that he found his calling.

He was a true mentor, a catalyst of dreams. His own achievements were legendary, and merely to move in his shadow was to aspire to greatness. The very force of his personality gave form and substance to the most esoteric of ethnobotanical pursuits. At any one time he had students flung all across Latin America, seeking new fruits in the forest, obscure oil palms in the swamps of the Orinoco, rare tuber crops in the high Andes. Under his guidance, it somehow made perfect sense to be lost in the canyons of western Mexico hunting for new varieties of peyote, miserably wet and cold in the southern Andes searching for mutant forms of the Tree of the Evil Eagle, or hidden away in the basement of the Botanical Museum figuring out the best way to ingest the venom of a toad rumored to have been used as a ritual intoxicant by the ancient Olmec.

By the time I met him, in the fall of 1973, it had been some years since he had been capable of active fieldwork. I found him at his desk in his fourth-floor aerie at the Botanical Museum. I was twenty at the time. We had never met, and he knew nothing of my past. I introduced myself as an undergraduate student from British Columbia. The adjective *British* caught his attention. I said that I wanted to go to the Amazon and collect plants, just as he had done so many years before. At the time I knew little of South America and less about plants. Asking nothing about my credentials, he peered across a stack of dried herbarium specimens and, as calmly as if I had asked for directions to the local library, said, "Well, when would you like to go?" A fortnight later I left for South America, where I remained during that first sojourn for fifteen months.

Just before leaving Cambridge on that trip, I stopped by his office, hoping to pick up a few tips or at least some guidance that might allow me to placate my parents. He had three vital pieces of advice. First, I was to avoid high leather boots, as all the snakes strike at the neck. Second, he recommended that I bring a pith helmet, because in twelve years he had worn one and never lost his bifocals. Third, he insisted that I not come back from the forest without having tried ayahuasca, the vision vine. Then he handed me two letters of introduction that, as it turned out, might as well have come from God, such was his reputation throughout Colombia and beyond. And so I went, as others had, and did what I could to honor his trust. And, of course, I did try ayahuasca, not to mention several other curious preparations, but that is another story.

Savannah of Yapobodá, Río Kuduyari, Vaupés, 1946.

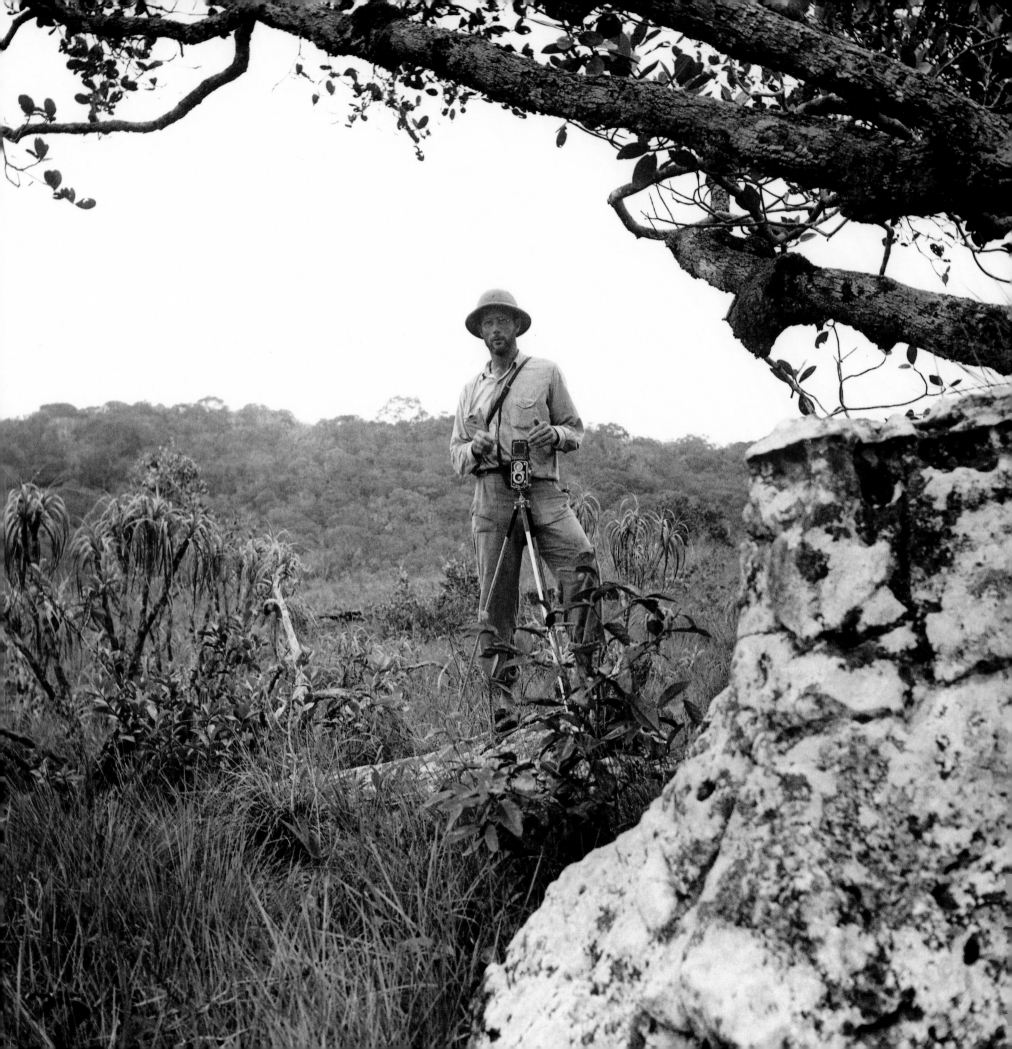

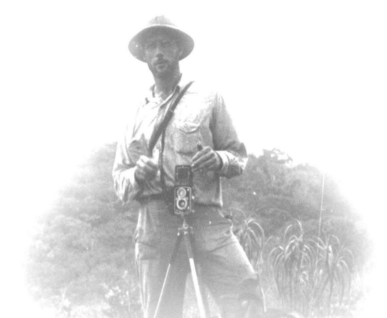

The PHOTOGRAPHIC JOURNEY of
RICHARD EVANS SCHULTES

COFÁN POLING UPSTREAM, QUEBRADA HORMIGA, APRIL 1942

Isolated at the foot of the mountains, the Cofán spoke a language that, with its strange pattern of glottal stops, was related to no other living tongue. The word *Cofán* itself had no meaning in the language. It was simply the term that traders and the early Spanish missionaries had used to describe the tribe. Some believed that it was derived from the word *ofanda,* a term in the Sucumbíos dialect for the wood of the blowgun, a reference perhaps to their notorious reputation as poison makers. Their word for themselves was *a'i,* meaning simply "the people." They were by reputation the finest poison makers in the Amazon.

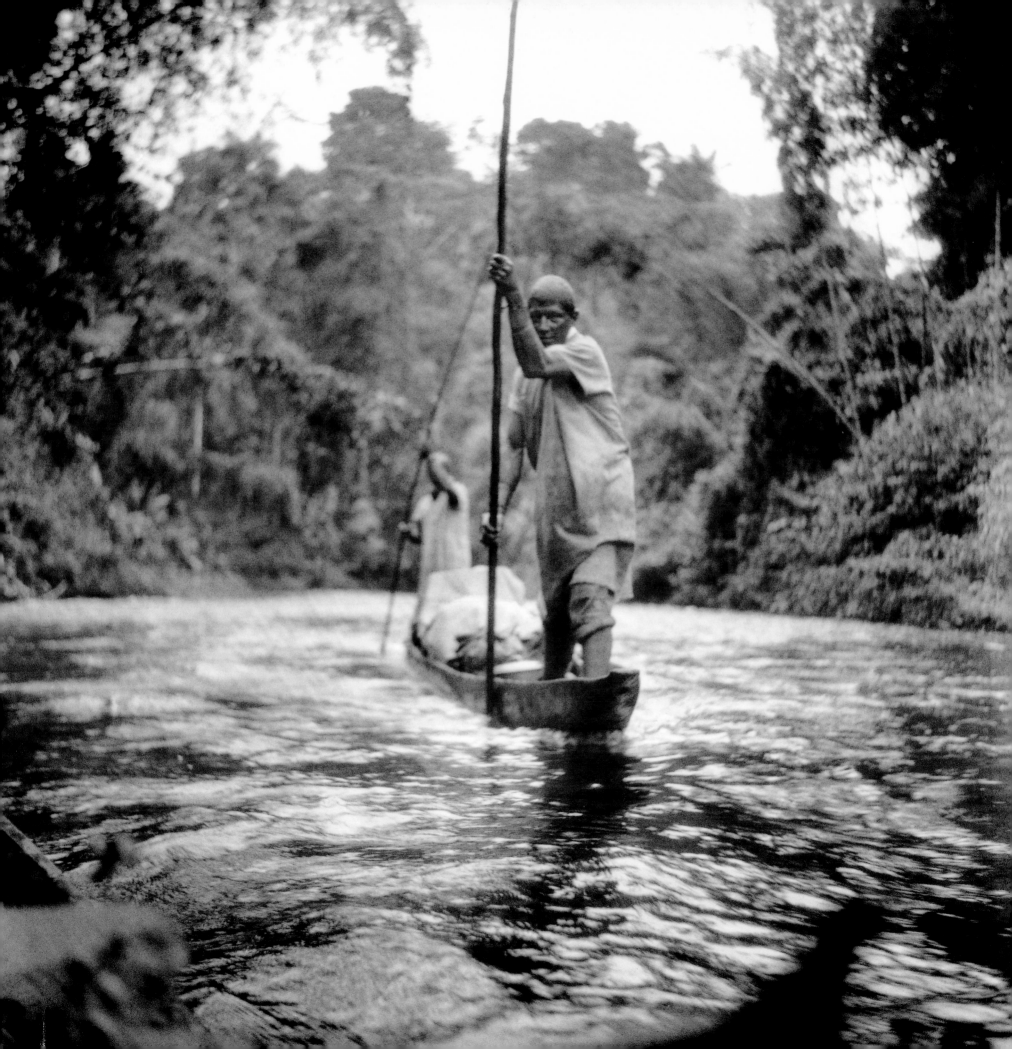

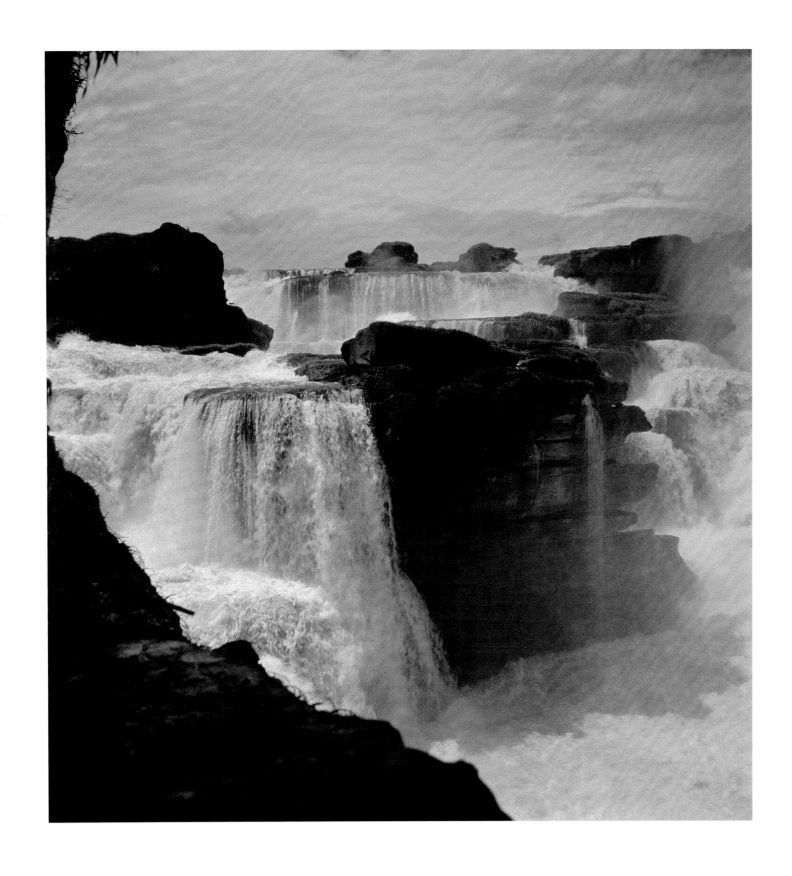

THE ENTRY FALLS AT JIRIJIRIMO, RÍO APAPORIS, SEPTEMBER 1943

Scouting the first rapids of Jirijirimo, Schultes climbed down over giant boulders and saw to his amazement the hardiest of plants, an algal-like growth clinging to the rocks in the midst of seething cauldrons of whitewater. It was an astonishing adaptation. In time he would learn that the leaves of this river weed flush out at the very height of the rainy season, when the river runs hardest. A member of the *Podostemaceae*, a family of strictly aquatic species, this plant flowers and sets fruit on an annual cycle designed by nature to take advantage of the full sweep of the floodwaters. Almost a decade later, Schultes would return and collect the plant with the Makuna, who called it *moo-á* and reduced it to ash to make salt. For the time being, however, he could only admire its wild beauty and imagine what other wonders awaited him downstream. ∽

MAKUNA SHAMAN LIGHTING THE TORCH
THAT HERALDS THE BEGINNING OF THE YAGÉ CEREMONY,
RÍO POPEYACÁ, JUNE 1952

After a month on the Miritiparaná, during which time he danced in the Kai-ya-ree, Schultes elected to return to the rubber station of Jinogojé. The simplest route was to retrace his steps across the Guacayá portage to the lower Apaporis. Schultes went the opposite direction, up the Miritiparaná and overland through miles of forest to the headwaters of yet another major river, the Popeyacá. He reached the Makuna settlements on June 4. Traders had cautioned him to be wary of the Popeyacá Makuna, a people said to be notoriously deceitful and dangerous. Schultes scoffed at the warning. "The Makuna are not treacherous," he wrote, "but when called upon to match the treachery and guile of an unwanted intruder, they are equal to the task of defending their homes and families with treachery." His way of establishing rapport was to take *yagé,* which he did on his first evening in the longhouse, or *maloca,* sitting patiently as the shaman stained his hands red and painted red dots on his face to facilitate the jaguar transformation. They attached rattles to his ankles, presented him with a shaman's wand, and taught him to play panpipes as the shaman sang the mythological history of the world. The clear notes carried over the forest, Schultes recalled, and he came to realize for the first time that the shaman's breath had a creative power of its own. The paintings on the facade of the *maloca* were the same images as those carved into petroglyphs by the ancients, and these were the same as what he saw an hour after the shaman had cleaned the ritual vessel with a scarlet feather and poured him a dose of the drug. This photograph was taken just before he came under the influence the of the sacred plant. ∂

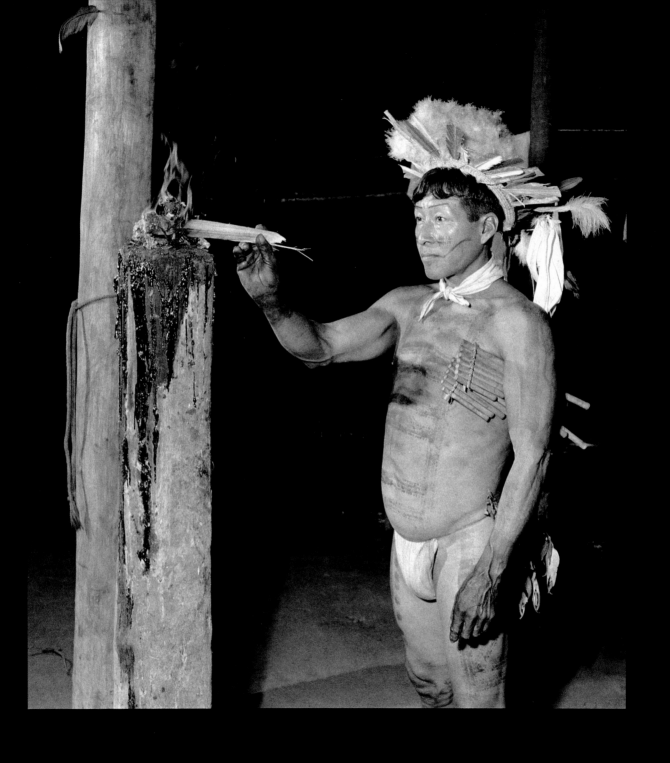

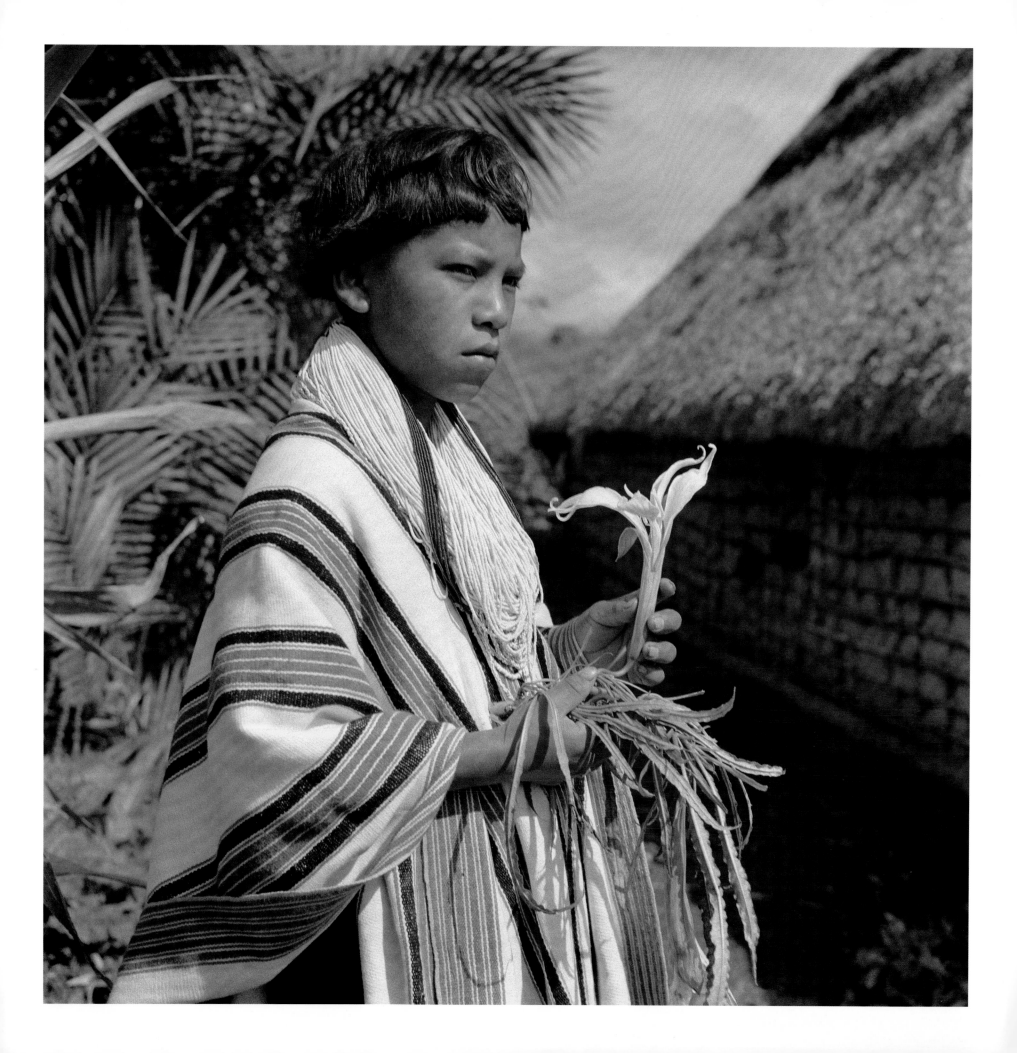

KAMSÁ YOUTH WITH THE BLOSSOM OF CULEBRA BORRACHERA, SIBUNDOY, JUNE 1953

The tree daturas are among the most dangerous and toxic of all psychoactive plants. They contain tropane alkaloids that, though useful in the treatment of asthma, can in higher dosage induce a frightening state of psychotic delirium marked by burning thirst, nightmarish visions, a sensation of flight, and ultimately stupor and death. As true cultivars, these plants are always found in association with human habitation, in the domain of the shamanic healer. Years of artificial selection have produced numerous varieties, including this curious form known to the Kamsá as either the jaguar's intoxicant or *culebra borrachera,* the "drunken snake." When Schultes first encountered the plant in 1941, he thought it so unusual that he recognized it as a new genus, which he named *Methysticodendron amesianum* in honor of his Harvard professor Oakes Ames.

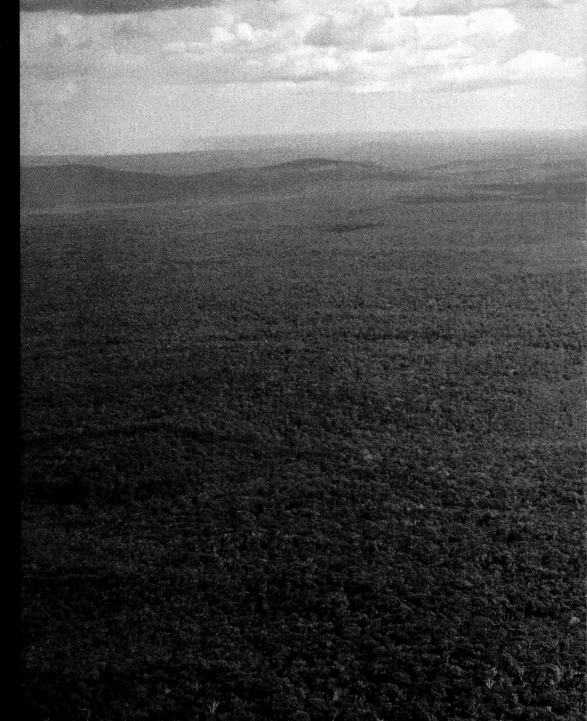

TATUYO LONGHOUSE,
RÍO PIRAPARANÁ, VAUPÉS

From the air the streams fall away and grow into rivers, and
the rivers spread like serpents through a silent and unchanging
forest. The Tatuyo and Barasana liken *yagé* to a river, a journey
that takes one above the land and below the water, to the most
remote reaches of the earth, where the animal masters live and
lightning is waiting to be born. To drink *yagé*, anthropologist
Gerardo Reichel-Dolmatoff wrote, is to return to the cosmic
uterus and be reborn. It is to tear through the placenta of or-
dinary perception and enter realms where death can be known
and life traced through sensation to the primordial source of all
existence. When shamans speak of facing down the jaguar, it is
because they really do.

COFÁN SHAMAN, PORVENIR, RÍO PUTUMAYO, APRIL 1942

The world has many layers, all of them inhabited by people, animals, spirits. The shaman alone mediates between these realms. *Yagé* allows him to do it. It takes him there. It gives him the clothing of the jaguar, and once in flight, he and the jaguar become one. ❧

Overleaf: RIO KARURÚ, VAUPES

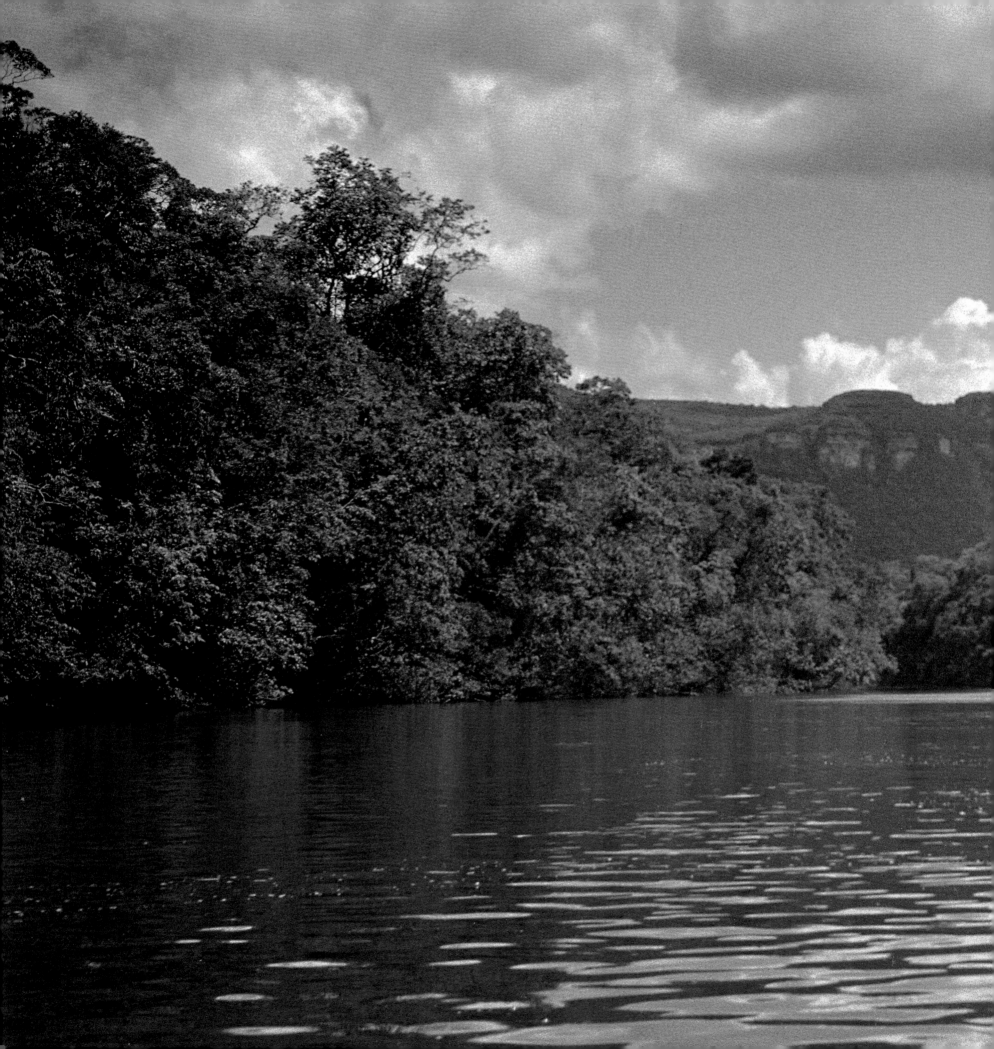

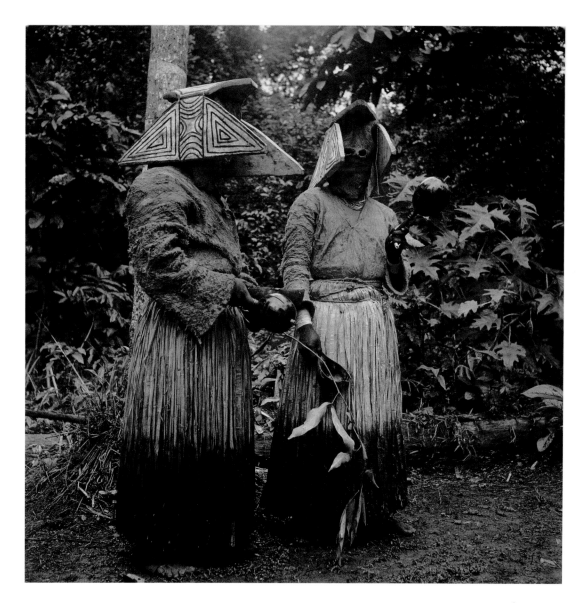

THE DANCE OF THE BUTTERFLY, CAÑO GUACAYÁ,
RÍO MIRITIPARANÁ, APRIL 1952

There are more than thirty separate dances at the Kai-ya-ree, each with a different mask representing an animal of the forest. The dance of the butterfly is slow, even languid. To Schultes it evoked the easy grace of the blue iridescent morpho as it floats aimlessly along a forest trail.

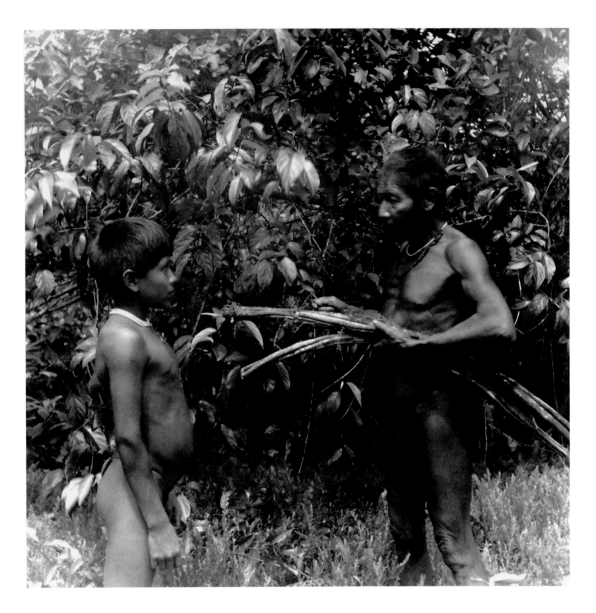

MAKUNA SHAMAN AND YOUNG BOY COLLECTING THE WOODY
STEMS OF YAGÉ, THE VINE OF THE SOUL, OO-ÑA-MÉ,
RÍO POPEYACÁ, JUNE 1952

Yagé, known also as ayahuasca or *caapi,* is the vision vine, the vine of the soul, the most curious and celebrated hallucinogenic plant of the Amazon. The drug is prepared by pounding the woody stem of a liana and boiling it with various admixtures. The Indians see the plant as a magical intoxicant that can free the soul, allowing it to wander into mystical encounters with ancestors and animal spirits. Some users maintain that collective visions occur, and that under its influence it is possible to communicate across great distances in the forest. When its active ingredient harmaline was first isolated, Colombian scientists called it telepathine. ༄

VICTORIA AMAZONICA

The giant lily, *Victoria amazonica,* with its enormous leaves capable of supporting the weight of a small child, grows in side channels and standing bodies of water throughout much of the Amazonian floodplain. When the flower buds are ready to open, they rise above the surface of the water, and, precisely at sunset, triggered by the failing light, the flower blooms at a speed that can be seen with the naked eye. The brilliant white petals stand erect, and the flower's fragrance, which has been growing stronger since early afternoon, reaches its peak of intensity. At the same time, the metabolic processes that generate the odor raise the temperature of the central cavity of the blossom by precisely eleven degrees Celsius (twenty degrees Fahrenheit) above whatever the ambient temperature happens to be. The combination of color, scent, and heat attracts a swarm of beetles that converge on the center of the flower.

At sunset, as temperatures cool, the flower begins to close, trapping the beetles with a single night's supply of food in the starchy appendages of the carpel. Around two in the morning, the petals begin to turn pink. By dawn the flowers are completely closed, and they remain so for most of the day. In early afternoon, the outer sepals and petals alone open. By now a deep shade of reddish purple, they warn other beetles to stay away. Last night's beetles, however, remain trapped in the inner cavity of the blossom. Then, just before dusk, the male anthers of the flower release pollen, and the beetles, sticky with the juice of the flower and once again hungry, are finally allowed to go. In their haste to find yet another opening bloom with its generous offering of food, the beetles dash by the anthers and become covered with pollen, which they then carry to another flower. This sophisticated pollination mechanism is, in its complexity, not unusual for the plants of the Amazon. ⌒

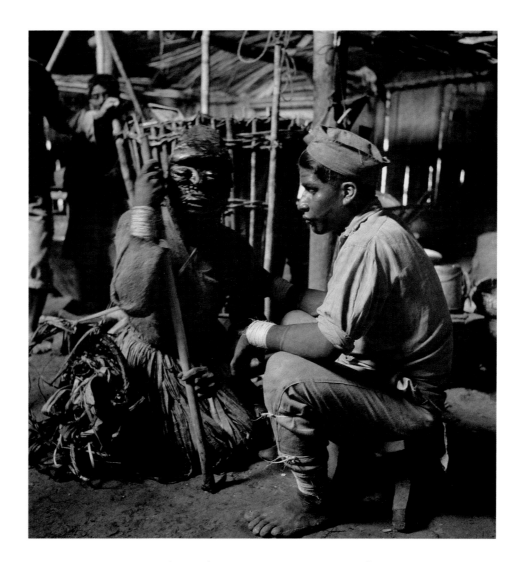

CAÑO GUACAYÁ, RÍO MIRITIPARANÁ, APRIL 1952

The spirit mask of Wagti rests momentarily in a Yukuna longhouse during the dance ritual of the Kai-ya-ree.

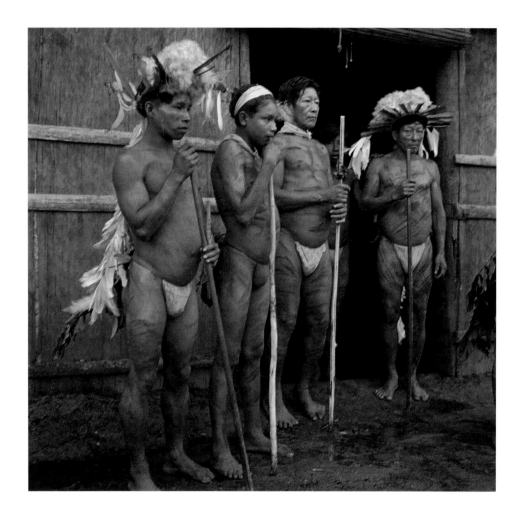

CELEBRATION OF SHAMANIC INITIATIONS
AMONG THE CUBEO, RÍO KUBIYÚ

When the shamanic training is complete, the teacher presents the successful initiates to the community. Adorned in feathered coronas and body paint, they carry the beads and rattles with which they will practice their sacred art of healing. For three days the entire community celebrates with music and dance and the ingestion of tobacco and *yagé.* ᴄ⟩

HEADWATERS OF THE RÍO PUTUMAYO

Sibundoy emerges from the clouds, a strange and beautiful world hidden in the midst of mountains. The floor of the valley is emerald green, lush and fertile, and seen from a distance the towns and hamlets that lie scattered along the flanks of the mountains appear toylike and fragile. The entire valley covers just one hundred square miles, and but for a chance of geography the place would still be a lake. The land is almost perfectly flat, its surface disturbed only by the glint of unknown streams and the many rivulets that drain into the basin from the surrounding mountains. To the north and east, the Ríos San Pedro and San Francisco cut deeply into the mountains, extending the bottom lands. Other rivers flow in from the west and south, coalescing in a shallow lake surrounded by marsh and a tangle of vegetation, remnants of the forest that once covered the valley. Out of the marsh flows a small river, little more than a brook, that crosses the plain and then plunges through an abrupt notch in the southeast corner of the valley. This is the headwaters of the Río Putumayo. The water that soaks the *páramo,* the clouds that burst over the valley to the south, and the veil of rain that obscures the high ridges of the mountains on all sides eventually join with tens of thousands of narrow streams falling out of the Andes and into the Amazon. ᧿

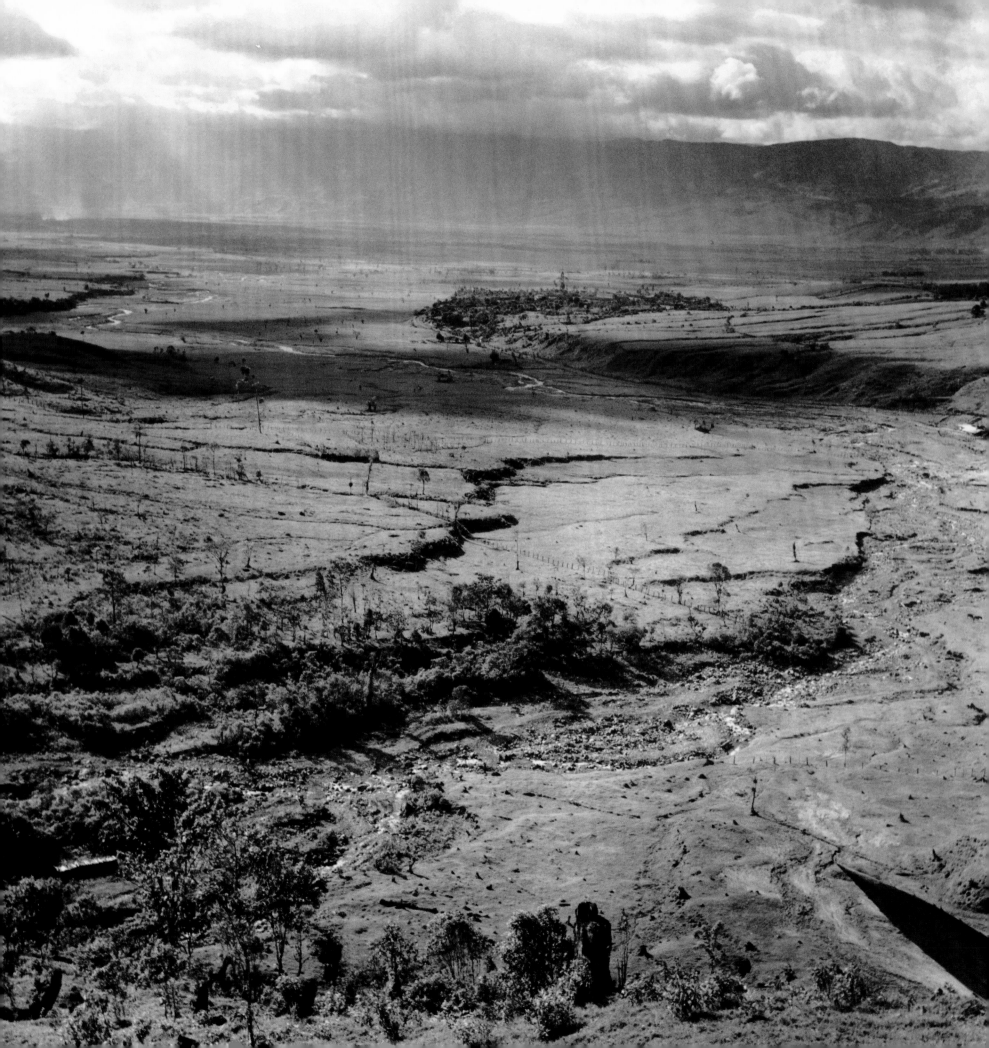

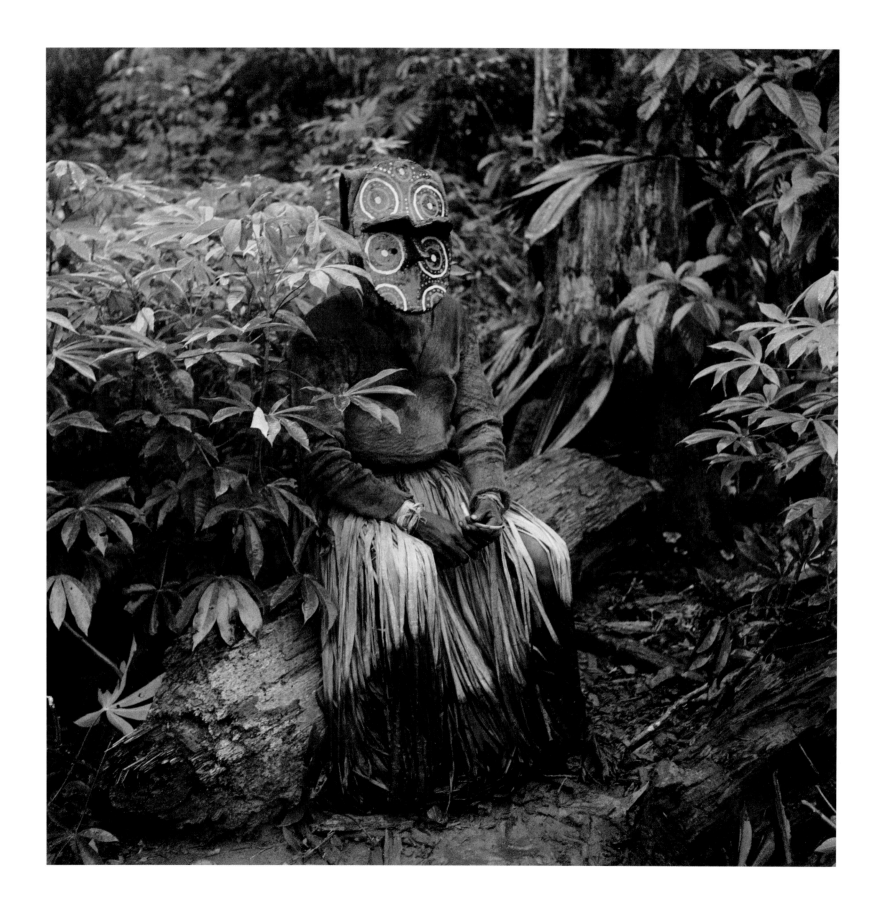

CAÑO GUACAYÁ, RÍO MIRITIPARANÁ, APRIL 1952

This spirit mask, according to Schultes, is believed by the Yukuna to embody all the forces of darkness or evil in the universe. It is the first mask to be honored at the Kai-ya-ree, and its dance is the longest of the four-day ceremony. Schultes described the singing as monotonous, pentatonic but beautiful. The sounds that emerge from beneath the masks have a haunting tone, as if conceived to invoke all the forces of creation. ❧

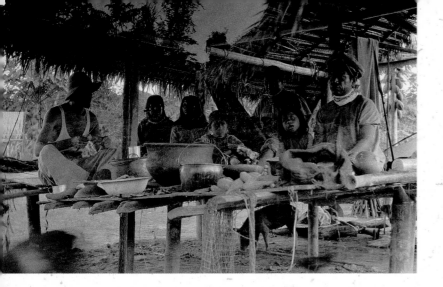

Among *the* Cofán

The Cofán shaman was an old man, and he wore a *cushma* of bright-blue trading cloth that fell as a mantle well below his knees. Mounds of colored beads hung around his neck, and necklaces of seeds and shells, jaguar teeth and boar tusks, were draped in concentric rings down to the middle of his chest. His face was broad, his eyebrows plucked and painted, his lips dyed indigo, his wide and flattened nose decorated with a blue macaw feather that ran through the septum. Across his forehead and on both cheeks were intricate patterns of lines and dots painted in orange and blue, motifs like visions.

There were bamboo tubes and feathers in his earlobes. His hair had been shaved short and allowed to grow to a uniform length that tickled the tips of his ears. On his head was a magnificent feathered headdress with an iridescent band of turquoise hummingbird feathers, a circle of red and white toucan breasts, and a corona of green parrot feathers that created a strange halo effect as he moved. Emerging from the top of the headdress was a fan of five scarlet macaw feathers. Two long bandoliers of jungle seeds crossed his chest, his wrists were bound with iguana skins and leaves, and great manes of scented palm fiber hung from his upper arms. A long train of parrot feathers fell over his back.

The shaman, whose Spanish name was Miguel, invited Schultes to sit beside him on the floor of the hut. A woman approached with a calabash of *chicha*. She knelt before the men, dipped her fingers into the liquid to remove some

coarse fibers, and then graciously offered him the bowl. Like the men, she was beautiful. She wore necklaces and feathers, patterns of color on her face.

After a few rounds of the sweet, mildly alcoholic *chicha*, the stiff posturing of the old man softened, and he spoke a few words in Spanish. Gifts were exchanged, and after a suitable interlude Schultes brought up the purpose of his journey, his desire to learn about the medicines of the forest. The shaman was not suspicious; in fact, he acted as if a visit by a student of plants was the most reasonable idea he had ever heard from a white man.

The following morning, March 30, 1942, the launch departed early as planned, leaving Schultes to complete his collections and eventually make his way back downriver. Schultes saw off the crew at the landing and then left immediately for the forest with the shaman, Miguel. To understand what happened next, one must have some sense of the historical moment. The Cofán, living alone on the upper reaches of the Sucumbíos, on the Colombian-Ecuadorian frontier at the foot of the eastern flank of the Andes, had had little contact with the outside world. The few whites they had met, mostly missionaries, soldiers, rubber tappers, and the odd explorer, had generally viewed their society and their forest with fear and contempt. Only a decade earlier, the Capuchin priest Gaspar de Pinell had with perfect sanctimony described a sojourn in a land where "tall trees covered with growths and funereal mosses create a crypt so saddening that to the trav-

Cofán fisherman placing the stems of the timbó *liana into the water, April 1942.*

eler it appears like walking through a tunnel of ghosts and witches. There, far from civilization and surrounded by Indians who could at any moment kill and serve us up as tender morsels in one of their macabre feasts, we spent spiritually blissful days."

The British army officer and explorer Thomas Whiffen, whose book Schultes had read, wrote that the forest was "innately malevolent, a horrible, most evil-disposed enemy. The air is heavy with the fumes of fallen vegetation slowly steaming to decay. The gentle Indian, peaceful and loving, is a fiction of perfervid imaginations only. The Indians are innately cruel." To live for a year among them, he noted, was to become "nauseated by their bestiality." In offering advice to future travelers, he suggested that exploratory parties be limited to no more than twenty-five individuals. "On this principle," he wrote, "it will be seen that the smaller the quantity of baggage carried, the greater will be the number of rifles available for the security of the expedition."

Schultes was alone and unarmed. He was a botanist who respected the Cofán knowledge of plants and revered their forest. He described the Cofán leaders as "friendly, helpful, intelligent, trustworthy and dedicated." In a prose that is today archaic

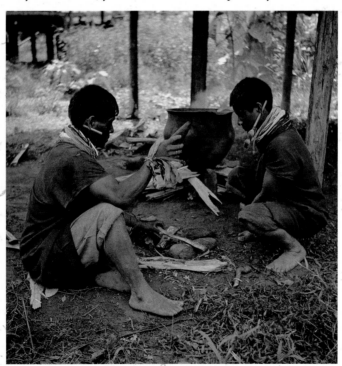

Cofán men preparing curare. Conejo, Río Sucumbíos, April 1942.

in tone, but thoroughly modern in sentiment, he noted that "the naturalist, interested in plants and animals, both close to the Indian's preoccupations, usually is immediately accepted with excessive collaborative attention. These leaders are gentlemen, and all that is required to bring out their gentle manliness is reciprocal gentle manliness. Until the unsavory veneer of western culture surreptitiously introduces the greed, deception and exploitation that so often accompanies the good of ways foreign to these men of the forests, they preserve characteristics that must only be looked upon with envy by modern civilized societies."

These convictions, once translated into gesture and repartee, immediately distinguished Schultes from any other outsider the Cofán had known. They understood his passion for plants, appreciated his patience, and responded enthusiastically to his curiosity. In ethnobotany he had the perfect conduit to culture.

For the first three days, Schultes and Miguel followed the same quiet rhythm, slow mornings spent harvesting plants, afternoons on riverbanks concocting preparations, evenings in the shelter of the shaman's home preparing the specimens and recording on paper knowledge that the Cofán had passed on by word of mouth for generations. Within a week they had worked the forests of the floodplain, wading through inundated palm swamps and exploring the streams by canoe. In two days they walked overland to the Río Tetuye, following the traditional route to the Río Aguarico in Ecuador. Never had Schultes made collections of such significance.

Over the course of two

hundred years of research, plant explorers in South America, beginning with Humboldt and Bonpland, have identified only twenty-one species of the genus *Strychnos* used as arrow poisons. In one week on the Sucumbíos, Schultes found eight of these, each believed by the Cofán to have unique chemical and magical powers. He also collected *Chondrodendron iquitanum,* as well as two species of *Abuta,* a related genus in the moonseed family. He also described for the first time the use of *Schoenobiblus peruvianus,* a plant known to the Cofán as *shira"chu sehe"pa,* a poison used exclusively for hunting birds.

It was not just curare that drew his attention. He collected dozens of folk remedies, stimulants and hallucinogens, fish poisons and wild fruits. But more than the collections, it was the opportunity to be with a people who manipulated plants with such dexterity that changed forever his perceptions about ethnobotany. Psychoactive and toxic plants touched every aspect of the lives of the Cofán. At dawn men and women went to the river to bathe, rinsing their mouths with water, preparing their palates for the morning dose of *yoco*. There followed an hour of ritual grooming as each adult made ready for the day, plucking facial hair, painting intricate designs onto the skin, and donning the elaborate costumes that mimicked the dress of the spirit beings encountered during *yagé* intoxications. En route to the fields or forest, the men carried a paste of fermented banana that, when mixed with water, could be whipped into a frothy alcoholic beverage. They pounded the leaves of shrubs, the bark of lianas, the roots of small trees, and placed the pulp in streams, later gathering stunned fish in great baskets woven from the fiber of palms. To make curare, they manipulated a dozen recipes, producing poisons of various strengths. Every man possessed his own repertoire, and there were specific poisons for each animal and bird of the forest. Returning to the settlement in the late afternoon, the men joined the women and children in the evening meal, sharing the events of the day as they imbibed more *chicha,* and smoked cigars the size of a child's arm.

In Cofán, the word for *medicine* and *poison* is the same, for just as curare-tipped darts bring death to an animal, so

medicinal plants bring death to evil spirits that cause misfortune and disease. Thus, in a manner that made perfect sense to the shaman, Schultes moved from the study of curare to an examination of the art of healing, which inevitably led him to *yagé*. For the Cofán, he learned, disease is caused by magic arrows cast into the victim's flesh by the avenging souls of malevolent sorcerers. The duty of the shaman is to free his own soul to wander so that he might find and remove these forces of darkness. It is *yagé* that allows him to

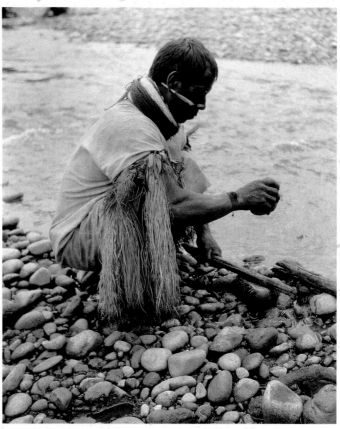

Cofán fisherman pounding the stems of the timbó *liana, a fish poison,* Lonchocarpus nicou. *Río Sucumbios, April 1942. Schultes was interested in all biodynamic plants. He often quoted the Greek scholar Paracelsus, who said that the difference between a poison, a drug, and a medicine is dosage. On his first complete day of botanizing in the Amazon, he discovered a new species of fish poison,* Serjania piscetorum. *Known to the Ingano as* sacha barbasco, *it was one of four fish poisons collected that first morning. The other three, all members of the Spurge family, remain unidentified to this day. Placed in slow-moving bodies of water, these poisons interfere with respiration in the gills of the fish. The fish float to the surface and are readily gathered. In time he would identify more than thirty species employed as fish poisons by the Indians of the Northwest Amazon. Many contain enormous concentrations of rotenone. Thus, in uncovering their identity, Schultes stumbled upon the source of the most commonly used biodegradable insecticide available to the modern world.*

soar away. The image of flight is invoked in the colors of the corona, the train of feathers winglike on the shaman's back. The feathers, the shaman explained, are the memories of birds that can be seen only on *yagé*. They are the masters, the patrons of ecstatic intoxication.

For the Cofán, Schultes discovered, *yagé* is far more than a shamanic tool; it is the source of wisdom itself, the ultimate medium of knowledge for the entire society. To drink *yagé* is to learn. It is the vehicle by which each person acquires power and direct experience of the divine. The teachers are the *yagé* people, the elegant beings of the spirit realm, the dwelling place of the shaman grandfathers. Expressing themselves only in song, the *yagé* people give each and every Cofán an image, a song, and a vision that become the inspiration for the designs painted onto the skin. No two Cofán share the same motif or the same song. There are as many sacred melodies as there are people, and with the death of a person, his song disappears.

When Schultes asked the shaman how often the people drank *yagé,* his response suggested that the question had no meaning. During illness, of course, and in the wake of a death. In times of need or hardship. At certain passages in life. When a young boy of six has his initial haircut, or when he kills for the first time. And naturally, the shaman suggested, a youth drinks *yagé* at puberty, when his nose and ears are pierced and he obtains the right to wear the tail feathers of the macaw. As a young man, he may drink it at his leisure to improve his hunting technique or simply to flaunt his physical prowess. The message that Schultes received was that the Cofán took *yagé* whenever they felt like it. At least once a week, and no doubt on any occasion that warranted it. Such as the eve of his own departure from the village. With the people dancing, the men facing the women in long lines moving forward and then backward, turning from side to side, the dancers stamping the ground lightly in

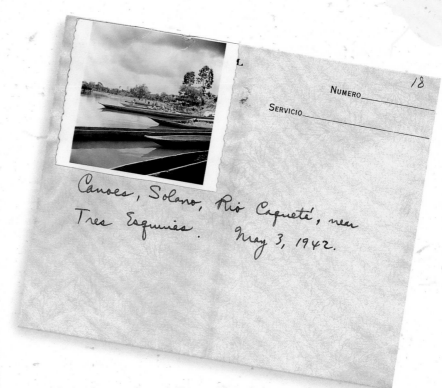

Canoes, Solano, Rio Caquetá, near Tres Esquinas. May 3, 1942.

time with the drums, this solitary student of plants took *yagé* with, as he would recall fifty years later, "the whole damn village."

The next morning, his face still painted and his mind swirling with the sounds of chants—*ya-jé, ya-jé, ya-ya-ya, ya-jé, ya-jé, ya-ya-ya*—Schultes paddled up the Sucumbíos in a dugout canoe to continue his explorations. His head throbbed. Unbeknownst to him, the preparation had contained the bark of *tsontinb"k'o,* the cold fever tree, together with *su-tim-ba-che,* a root said by the Cofán to cause a "drunk worse than *yagé*." Indeed, it had. Despite his discomfort, Schultes made a note to investigate the admixtures at length. Thirty years later he did, by dispatching his best graduate student to the Putumayo. After fifteen months in the field, Tim Plowman emerged with the definitive study, which included descriptions of several new species and varieties. The plant that Schultes drank at Conejo, and which gave him such a headache, is now known botanically as *Brunfelsia grandiflora* subsp. *Schultesii.*

Adapted from *One River: Explorations and Discoveries in the Amazon Rain Forest.*

among the cofan

TIKUNA WOMAN, RÍO AMACAYACU, COLOMBIAN AMAZON, 1944

In the homeland of the Tikuna, Schultes found rare specimens of *Hevea brasiliensis* that were both high yielding in latex and resistant to the South American leaf blight. He made his base there for three years, on a small farm carved from the forest at the mouth of the Río Loretoyacu. During that time he twice ascended the Amacayacu and walked overland fifty miles to descend the Río Cotuhé. In this way he explored all the land that lay between the Amazon and the Río Putumayo. On one occasion, in a pounding rainstorm, he took a step and stumbled, and his foot landed on what felt like a large rubber hose. Coiled on the ground was an enormous anaconda. The Tikuna, who believed in the sacredness of the snake, spoke often of his narrow escape.

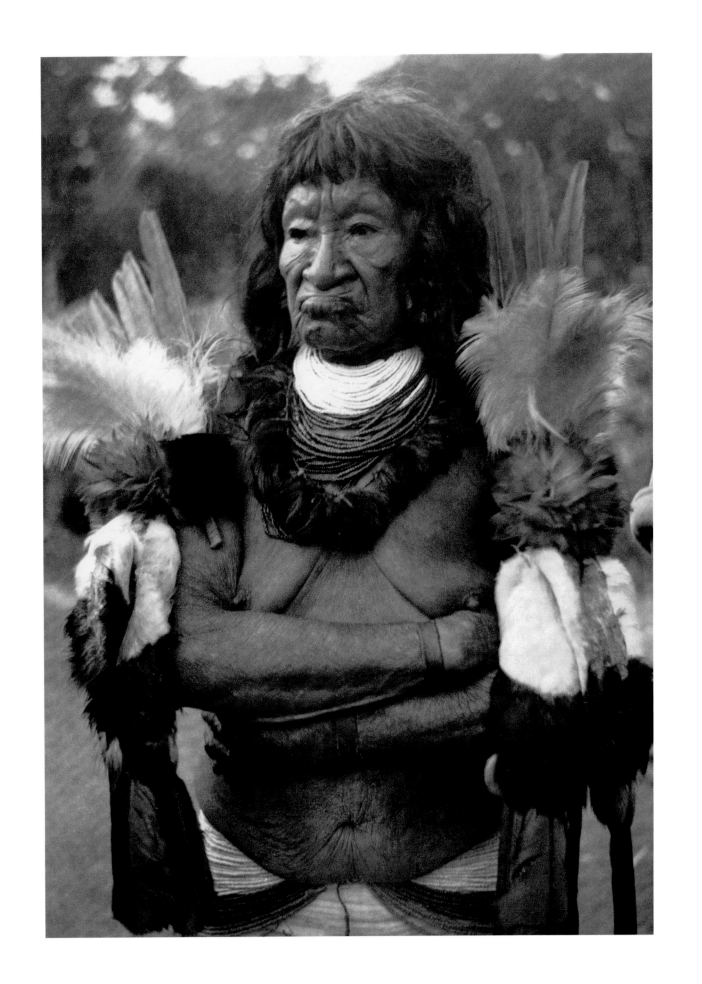

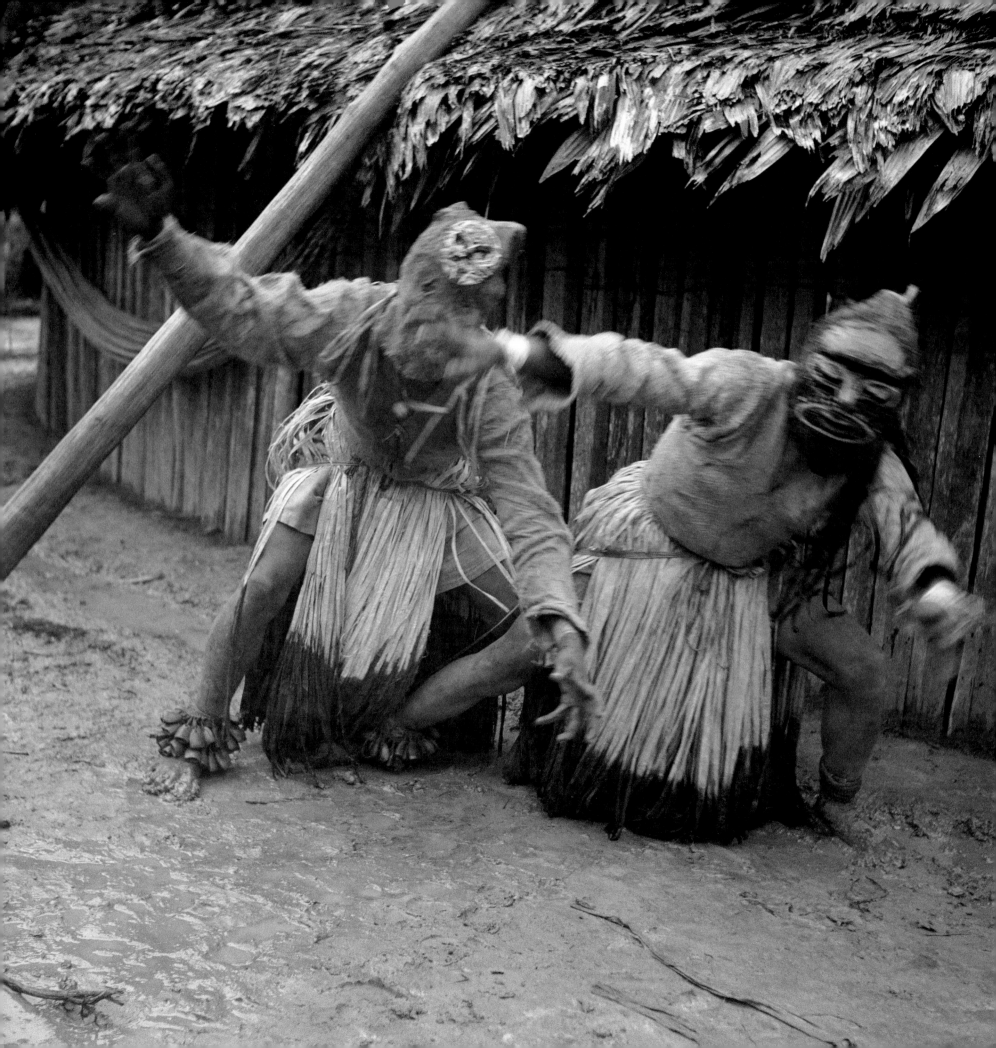

CAÑO GUACAYÁ, RÍO MIRITIPARANÁ, APRIL 1952

The masks of the Kai-ya-ree personify all the forces of nature. The human being within the mask is transformed and, through dance, enters into a direct dialogue with the supernatural realm. In this instance the spirit invoked is Wagti, a trickster who moves between good and evil, light and darkness. The Yukuna believe that Wagti must be placated to ensure the fertility of the forest, the fields, and the people. ᧁ

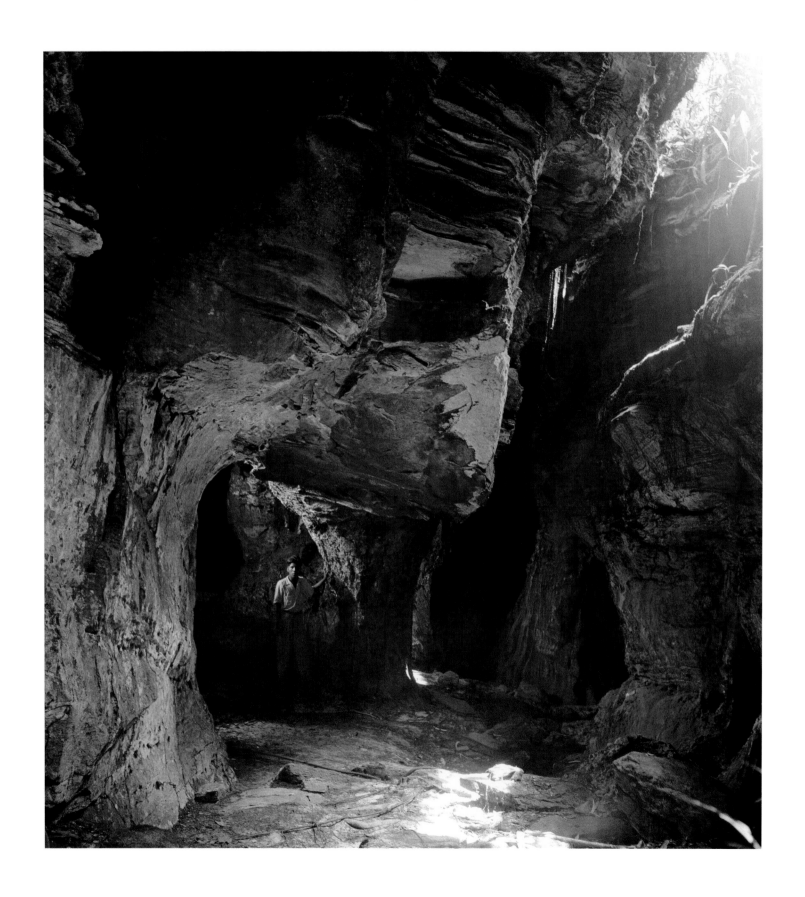

THE SANDSTONE CAVES OF THE SAVANNAH OF YAPOBODÁ, RÍO KUDUYARI, VAUPÉS

Like the sandstone mountains of Chiribiquete, the savannahs of the Northwest Amazon are remnants of the ancient uplands that once stretched continuously across the northern face of the continent. They are like desert islands in a sea of forest. There is almost no soil, and the ground is so porous that even torrential rains leave little mark. Only plants adapted to conditions of severe drought can survive. Thus the savannahs have become through time repositories of species found nowhere else in nature. ᴄ꒰

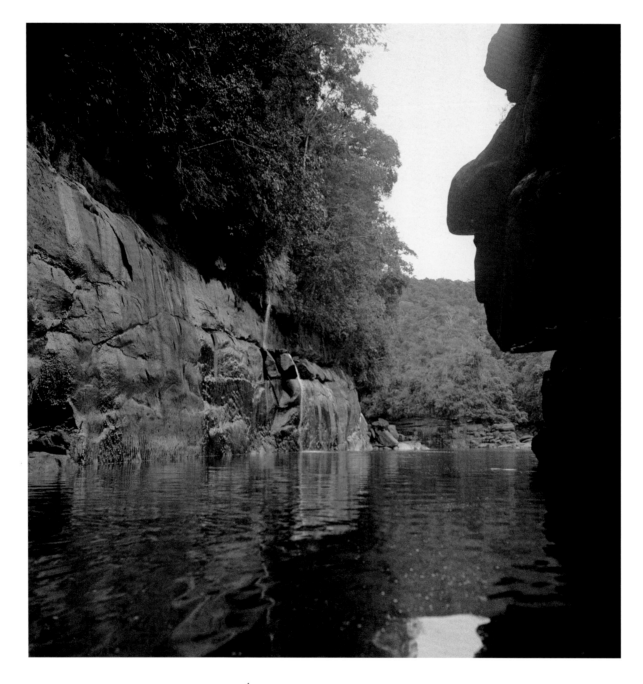

JIRIJIRIMO, RÍO APAPORIS, SEPTEMBER 1943

Below the falls the river enters a chasm several miles long, with towering rock walls on either side. "Our native paddlers," Schultes later wrote, "preferred to meet us with all our baggage at the end of the canyon because their Taiwano payé told them never to look upon the face of the god who lived below the waterfall. We paddled down the canyon alone; the boys met us at the end."

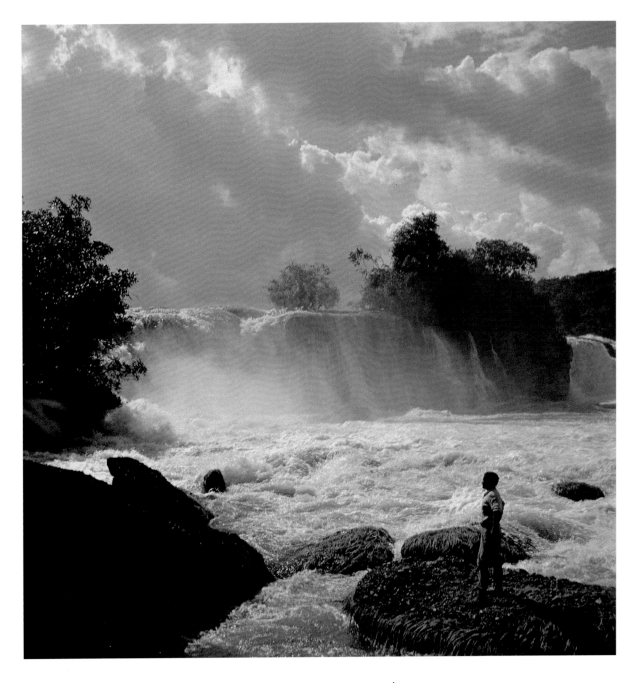

THE FALLS OF YAYACOPI, RÍO APAPORIS

PÁRAMO, NORTHERN ANDES

Silenced by rain and mist, the *páramo* is an exotic and mysterious ecological formation unique to the northern Andes. Further south, in Peru and Bolivia, the plateaus and valleys lying above eleven thousand feet are arid, barren, windswept, and cold, a highland desert useful only for the grazing of alpaca and vicuña. Nearer the equator, the same elevation is equally forbidding yet is constantly wet. The result is an otherworldly landscape that seems on first impression eerily like an English moor grafted onto the spine of the Andes. In the mist and the blowing rain, there are only the *espeletias,* tall and whimsical relatives of the daisy, spreading in waves, to remind you that you are still in South America. With bright-yellow flowers that burst from a rosette crown of long, silver, furry leaves, *espeletias* look like plants belonging in a children's book. The Colombians call the plant *frailejón,* the friar's shadow, because, seen from a distance, it can be mistaken for the silhouette of a man, a wandering monk lost in the swirling clouds and fog. ✑

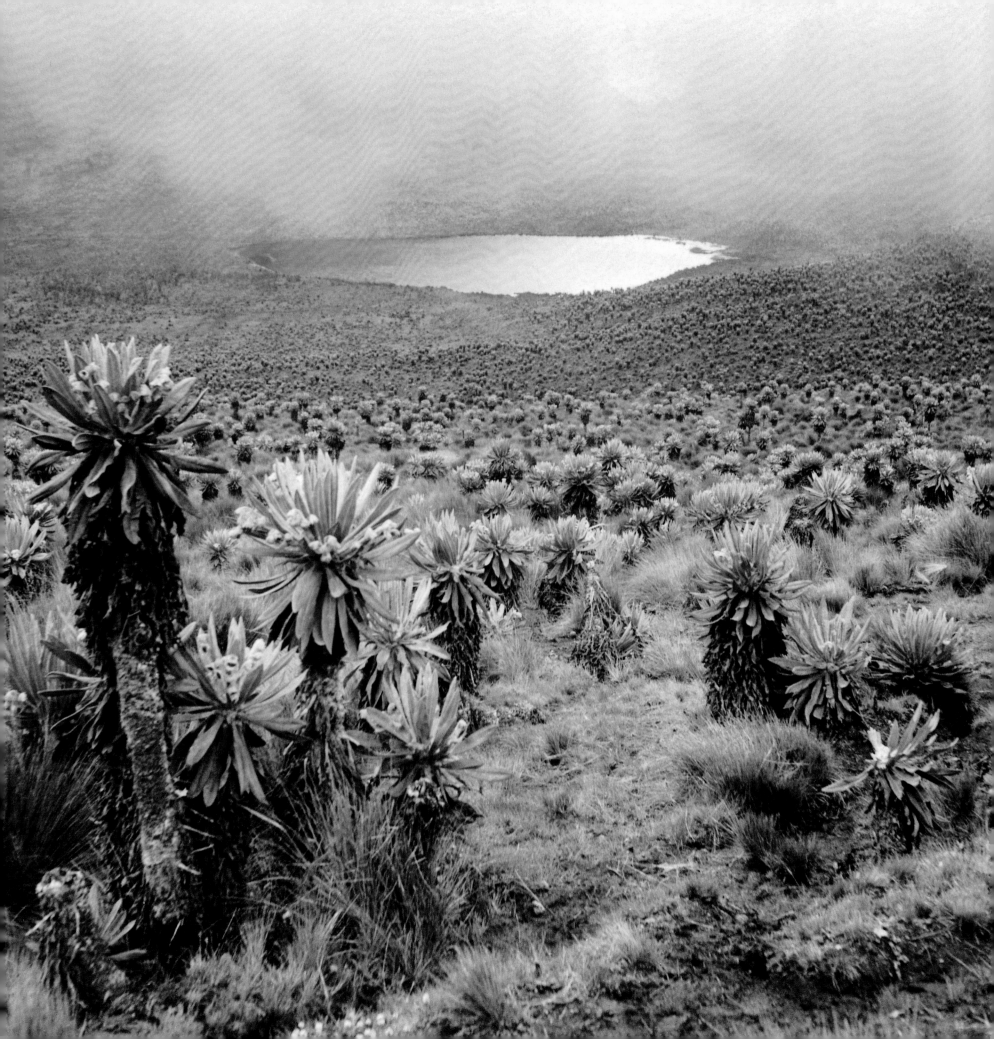

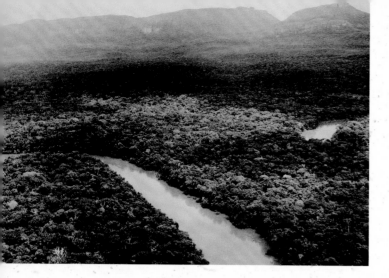

The Mountains *of* Chiribiquete

The rubber crisis propelled Schultes into the forest, and he spent much of 1943 exploring the remote Apaporis drainage. It was both an inspiring and deeply frustrating passage. Consumed by logistics and the desperate quest for latex, in four months he would collect only thirty specimens. Such a hiatus was, for him, not just unusual but profoundly unsettling. He was the first botanist ever to enter this part of the Amazon. Every day he walked past plants unknown to science. There were moments on the trail when he buried his face in his hands just to avoid seeing yet another new species that he was unable to collect.

His release came on the morning of May 14 when he began a slow climb across the flank of Cerro Comejen, now known as Cerro Chiribiquete, one of the sandstone mountains that had teased him for so many weeks. These upland formations stretch in a great arc, dividing the Macaya from the Ajaju and continuing south a hundred miles as far as Araracuara on the Caquetá. Known collectively as the Sierra de Chiribiquete, they are, in fact, isolated relics that from the ground appear to emerge randomly from the midst of the forest. Some are immense flat-topped ridges with one side sloping gently toward the forest floor, and the other a thousand-foot wall of yellow stone surmounted by jutting strata draped in vegetation. Others are dome-shaped, with perpendicular cliffs on all sides dropping to a series of broad and flat sandstone shelves. Massive and remote, veiled in mist and often grotesquely eroded, the mountains seemed to Schultes

to echo the dawn of time, rising like giant sculptures left over from God's first workshop. It was from these first tentative experiments, Schultes mused, that God had gone out and built a world.

As Schultes moved slowly across the sandstone ledges, working his way up the narrow draws, he observed in the flora a gradual transition as the lowland elements fell away and were replaced by rare and novel plants, many of them endemic and adapted specifically to the peculiar conditions of the uplands. There were, to be sure, isolated pockets where sand and soil had lodged and a low, scrubby vegetation had taken hold. But for the most part, on the exposed rock, especially across the summits, the conditions were those of a desert. In the dry season, when no rain may fall for a month,

the hot sun bakes the sandstone. When the rains do come, they pour off the surface in great sheets, forming waterfalls and torrents that rage for a few hours and then are gone. In the evening, throughout much of the year, a curtain of mist drops over the hills, but by dawn it is dispersed and the plants are once again exposed to the intense heat and radiation of the equatorial sun.

When he reached the summit, Schultes found a grassland interspersed with a dense brush of low gnarled shrubs—an island of savannah perched a thousand feet above a tropical rain forest. Adapted to the dry conditions, the plants were reduced in size, and many bore glossy, leathery leaves, often coated with heavy waxes or dense pubescence. Their bark was either thick and corky or thin and coated with wax. Epiphytes had exaggerated pseudobulbs for water storage. Many plants grew low to the ground, with dense rosettes of leaves. The roots were especially well developed, penetrating the cracks and fissures in the rock, reaching like veins across the face of cliffs. The growth forms were exceedingly strange; the overall aspect of the flora elfin and bizarre. Something of the magic of the place is revealed in the names chosen months later by Schultes for two new species of low trees and shrubs discovered that day, *Graffenrieda fantastica* and *Vellozia phantasmagoria*.

Many of the plants produced resins or latex. In fact, as Schultes slashed his way across the ledges of the mountain, he found himself completely covered with white, sticky

Vellozia phantasmagoria, a new species discovered May 14, 1943, and later named by Schultes. Chiribiquete, Río Apaporis.

latex that, mixed with the heat and sweat, made the climb thoroughly miserable. That is, until he realized that the stand he was cutting through, which had a density of some five thousand individual shrubs per acre, was made up of only two plants, both new to science. One species, which was closely related to balata, he later named after the mountain, *Senefelderopsis chiribiquetensis*. The other was a new variety of rubber, *Hevea nitida* var. *toxicondendroides*. Thus Schultes ended his first foray on the mountains, perched above an open cliff, listening as the wind rustled the leaves of these two rubber plants that had never before been seen by a botanist.

Adapted from *One River: Explorations and Discoveries in the Amazon Rain Forest*.

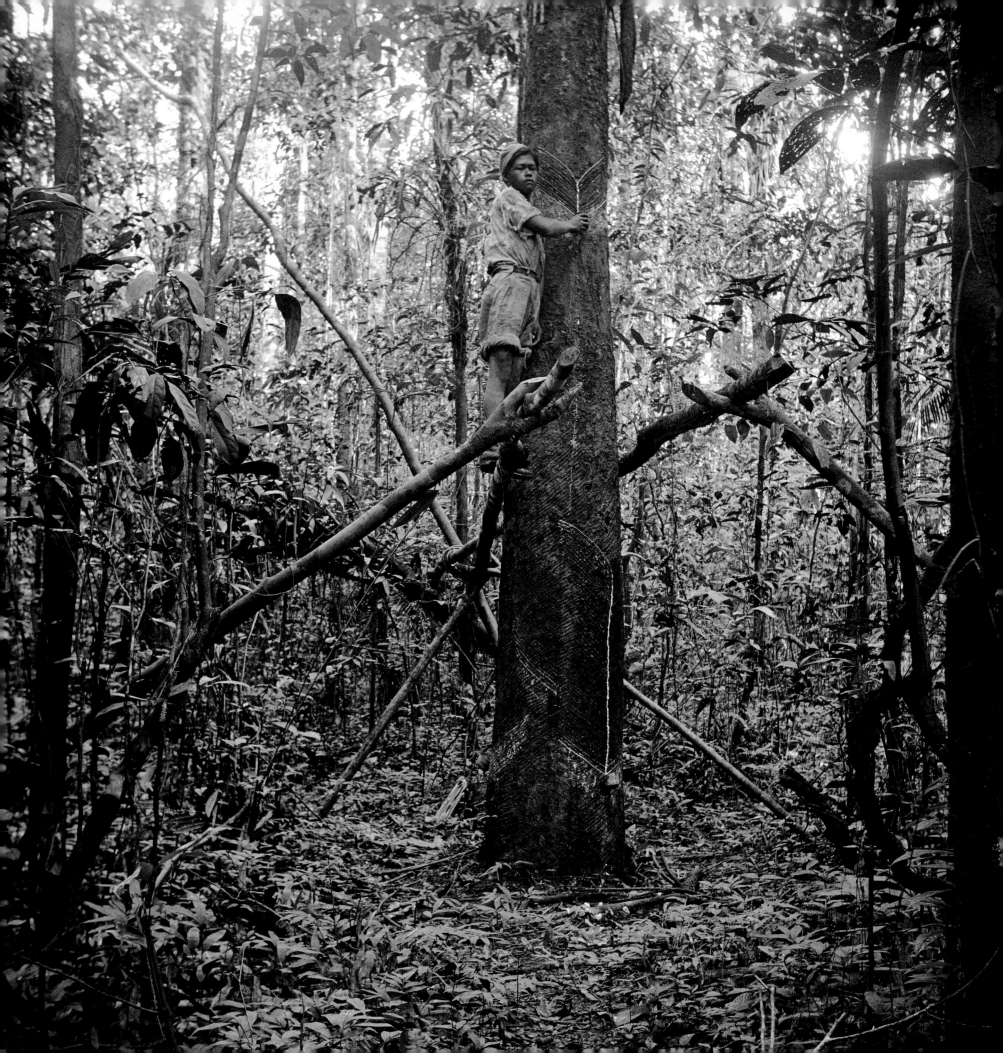

A YOUNG SERINGUERO, RÍO LORETOYACU, COLOMBIAN AMAZON

Throughout the fall of 1944, and during the subsequent tapping seasons of 1945 and 1946, Schultes came to know the natural history of rubber trees through the eyes of the *seringueros,* the rubber tappers who entered the forest at dawn to begin the arduous task of gathering latex from hundreds of widely scattered trees. Schultes surveyed some 120,000 individual trees, monitoring the yields of 6,000 of the best, and from these selected 120 clones to be dispatched as budwood for propagation at research stations in Costa Rica. ৎ৴

COFÁN SHAMAN, CONEJO, RÍO SUCUMBÍOS, APRIL 1942

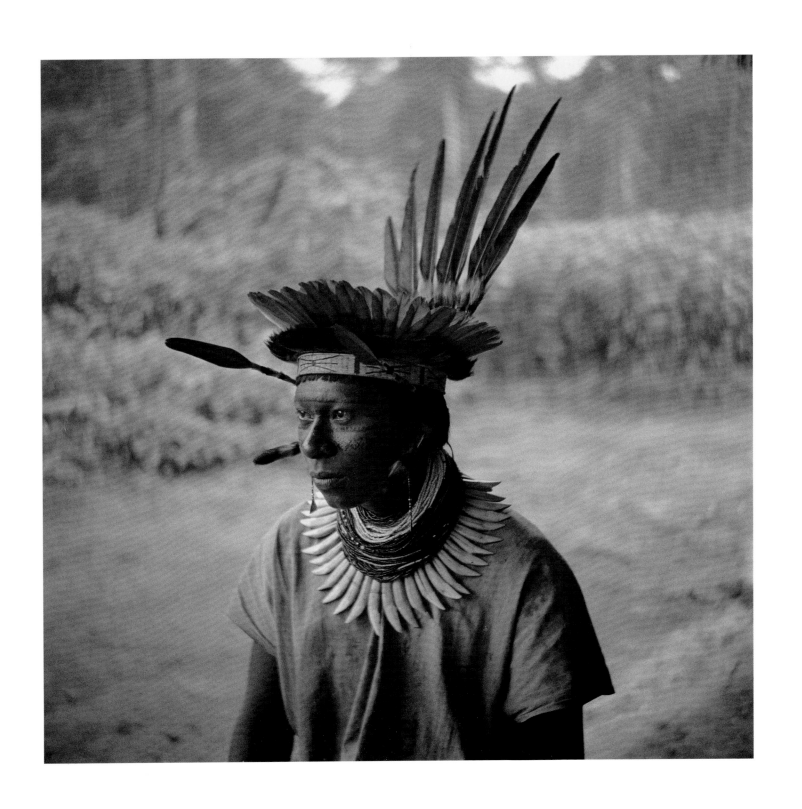

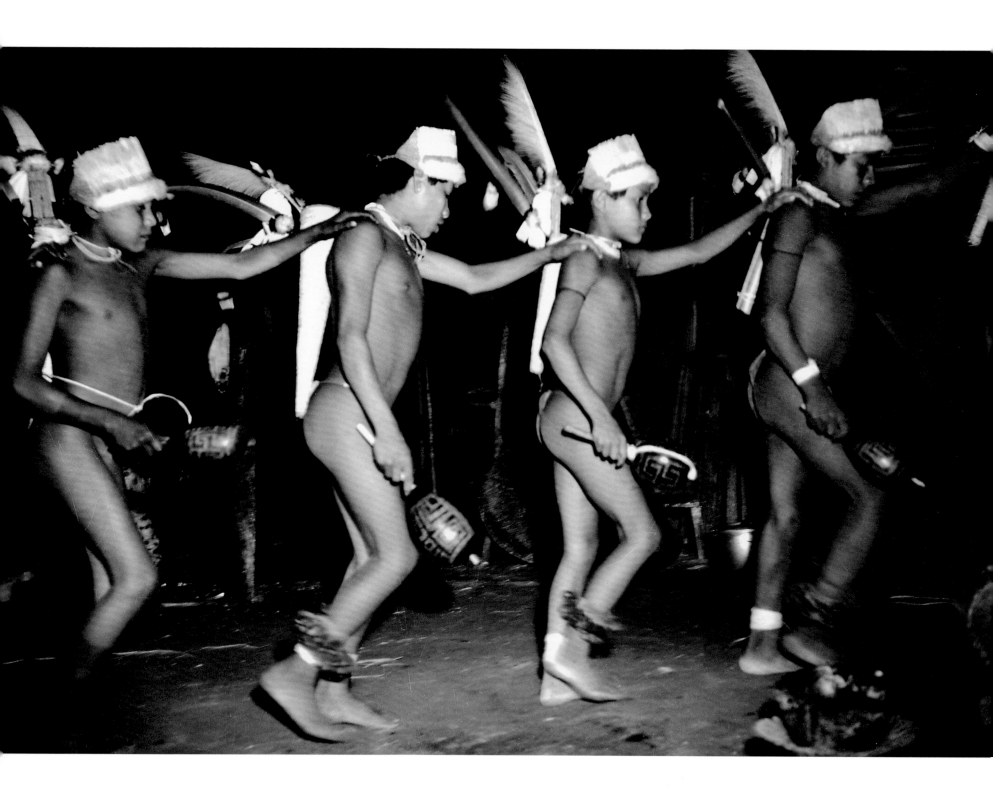

MAKUNA BOYS, RÍO PIRAPARANÁ, SEPTEMBER 1952

During his time among the Makuna and Barasana, Schultes collected a number of plants employed as admixtures to the yagé preparations. One of these was Sabicea amazonensis, known to the Barasana as kana. Usually found growing around the malocas, it is a scandent vine with opposite leaves and small pink berries that are said to sweeten the brew. Stephen Hugh-Jones, an anthropologist and acolyte of Schultes, observed its use during the Yuruparí, the sacred rites of male initiation. He likened the fruits to hearts on a string, each a symbol of a generation, all linked together by the vine, an umbilicus running away from the longhouse into the rivers and from there to the source of all humanity, the place in the east where the Sun is born. In driking yagé for the first time, in eating this fruit, the young boys remember the ancestral origins of life. The shaman's rattle, itself a heart, contains seeds of the fruit, and thus by blowing over the rattle the shaman transforms the heart and soul of the initiate. ᐁ

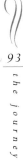

TRADITIONAL HEALER SALVADOR CHINDOY

Schultes's main informant in Sibundoy was a traditional healer named Salvador Chindoy. In photographs, Salvador is almost always singing or leaning over a patient as he sweeps away illness with a fan of jungle leaves. He wears a black *cushma* tied at the waist, a necklace of jaguar teeth, pounds of glass beads, a magnificent corona with a halo of erect macaw feathers, and a long cape of parrot feathers that hangs down his back to the waist. His ears are pierced by the tail feathers of a scarlet macaw, and his wrists are often decorated with leaves. The entire costume is a walking vision. The beads and feathers, the sweet leaves on his arms, and the delicate motifs painted onto his face are a conscious and deliberate attempt to emulate the elegant dress of the spirit people who the shaman meets when he ingests *yagé*. ❧

HEADING UPSTREAM THROUGH THE RAPIDS OF TATÚ, WACARICUARA, RÍO VAUPÉS

For the Indians of the Vaupés, rivers are not just routes of communication. They are the veins of the earth, the link between the living and the dead, and the paths along which the ancestors traveled at the beginning of time. Their origin myths vary but always speak of a great journey from the east, of sacred canoes brought up the Milk River by enormous anacondas. Within the canoes were the first people, together with the three most important plants—coca, manioc, and *yagé,* gifts of Father Sun. On the heads of the anacondas were blinding lights, and in the canoes sat the mythical heroes in hierarchical order: chiefs, wisdom keepers who were dancers and chanters, warriors, shamans, and, finally, in the tail, servants. All were brothers, children of the sun. When the serpents reached the center of the world, they lay over the land, outstretched as rivers, their powerful heads forming river mouths, their tails winding away to remote headwaters, the ripples in their skin giving rise to rapids and waterfalls. ༄

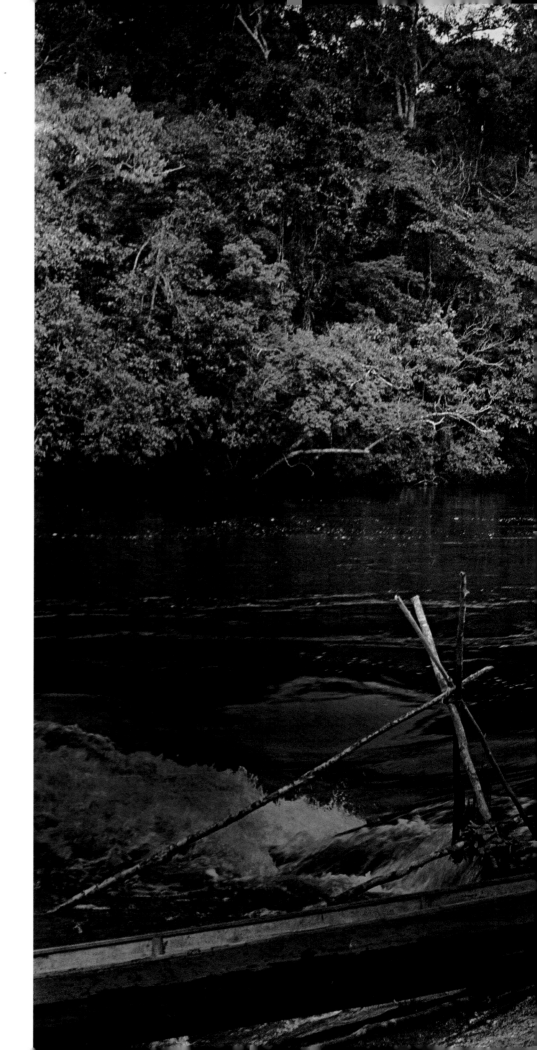

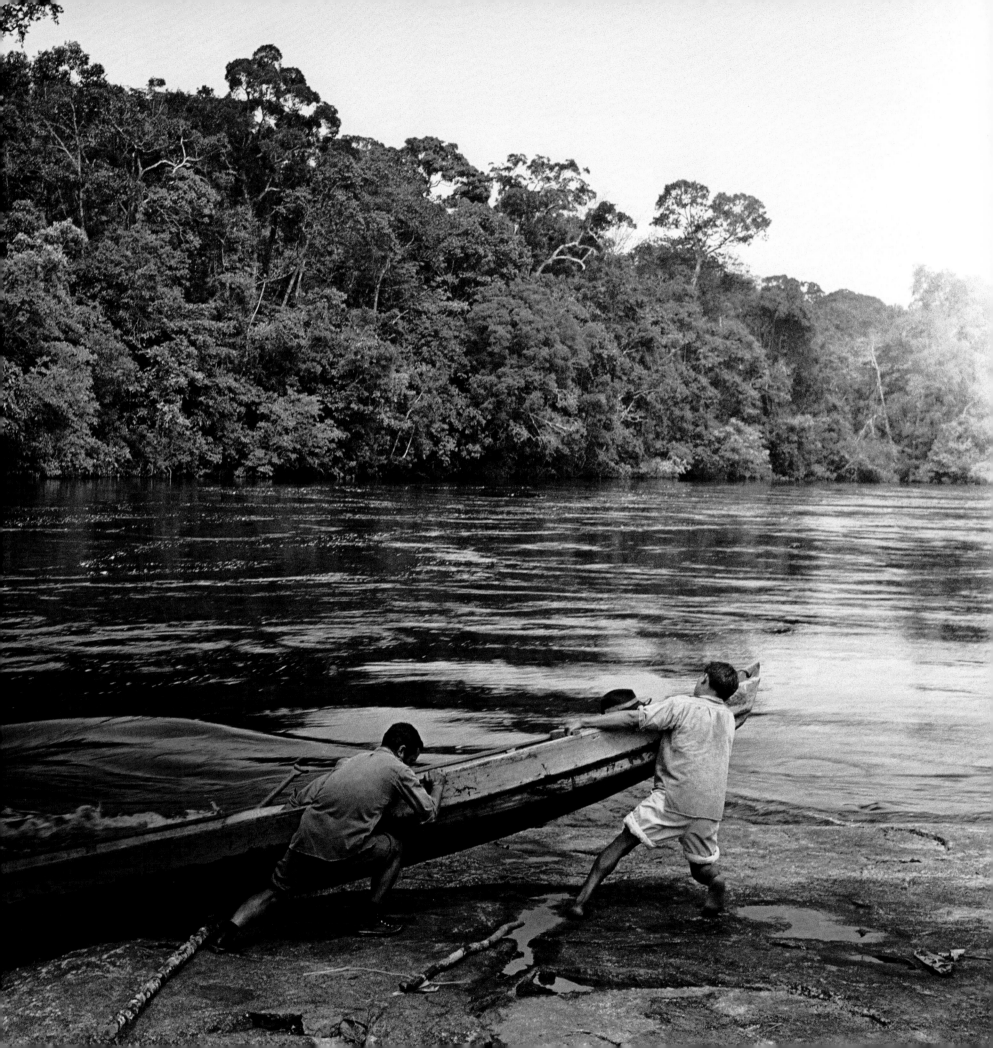

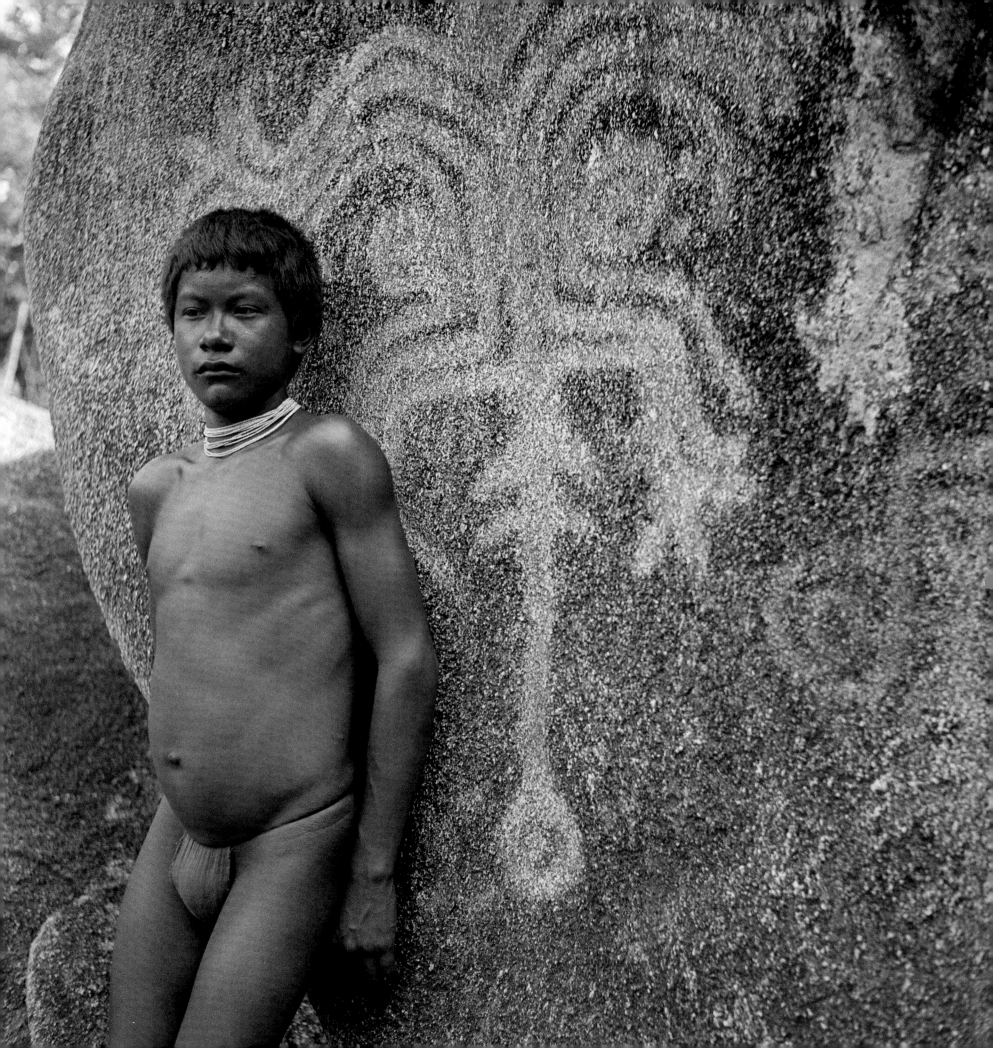

THE ROCK OF NYI, RÍO PIRAPARANÁ

In October 1943, during his descent and exploration of the Río Apaporis, Schultes paddled up the Río Piraparaná, a north-bank affluent, as far as the rock of Nyi, a petroglyph carved into a boulder of granite sitting precisely on the equator. Long sacred to the Makuna, Barasana, Tatuyo. and Taiwano, the image commemorates the visit of Father Sun when he first gave *yagé* to the people. Tragically, some thirty years later the petroglyph was irrevocably damaged by a Protestant missionary who claimed that it was the work of the devil. ～

CUBEO MOTHER BATHING CHILD AT SORATAMA, RÍO APAPORIS

In early 1951, at the behest of a Colombian merchant, Schultes established a trading post on a stretch of the Río Apaporis where nearly a decade earlier he had identified the highest concentration of rubber in all the drainage. Located three hours by paddle above the falls of Jirijirimo, Soratama served as his wilderness base for three years. It was an extraordinary opportunity. The lure of employment, good wages, and fair treatment attracted Indians from all over the Vaupés. With logistical support guaranteed and transport assured, he returned to his beloved Apaporis and entered the most productive phase of his career as an ethnobotanist. In three years he would collect over two thousand medicinal plants. Within a month he made one of his most important contributions to the study of hallucinogenic plants: the discovery of the identity of *yá-kee,* the intoxicating snuff known to the Indians as the Semen of the Sun. ᠔

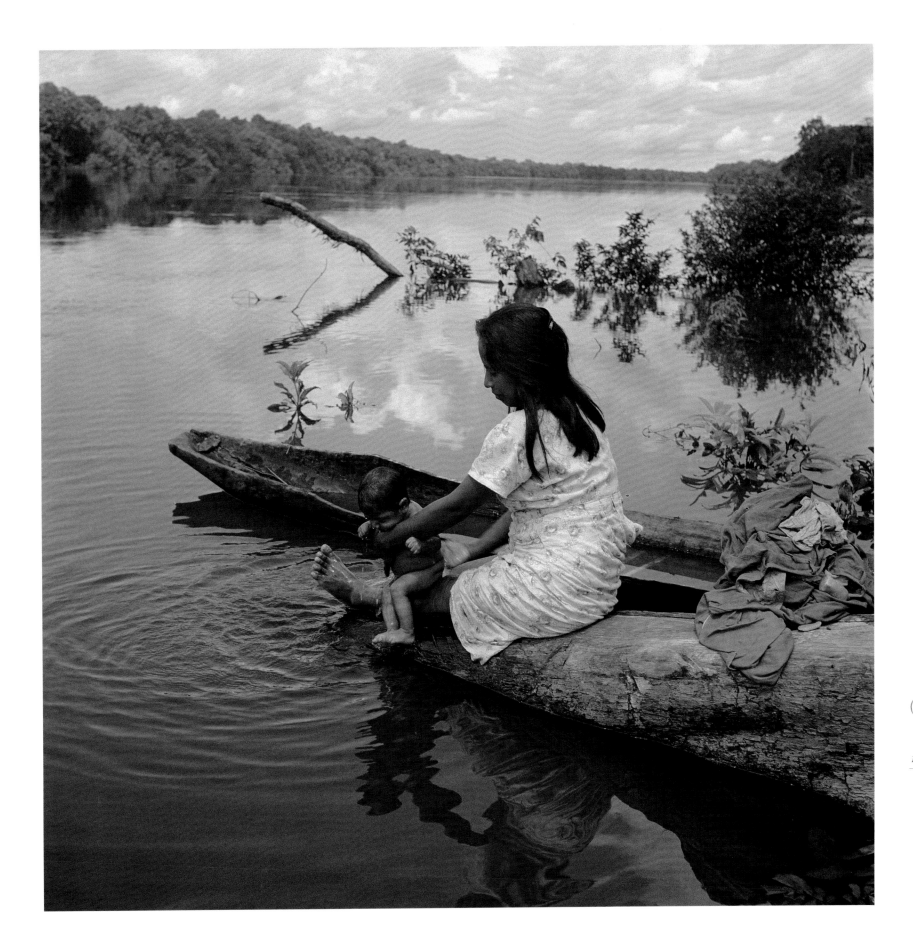

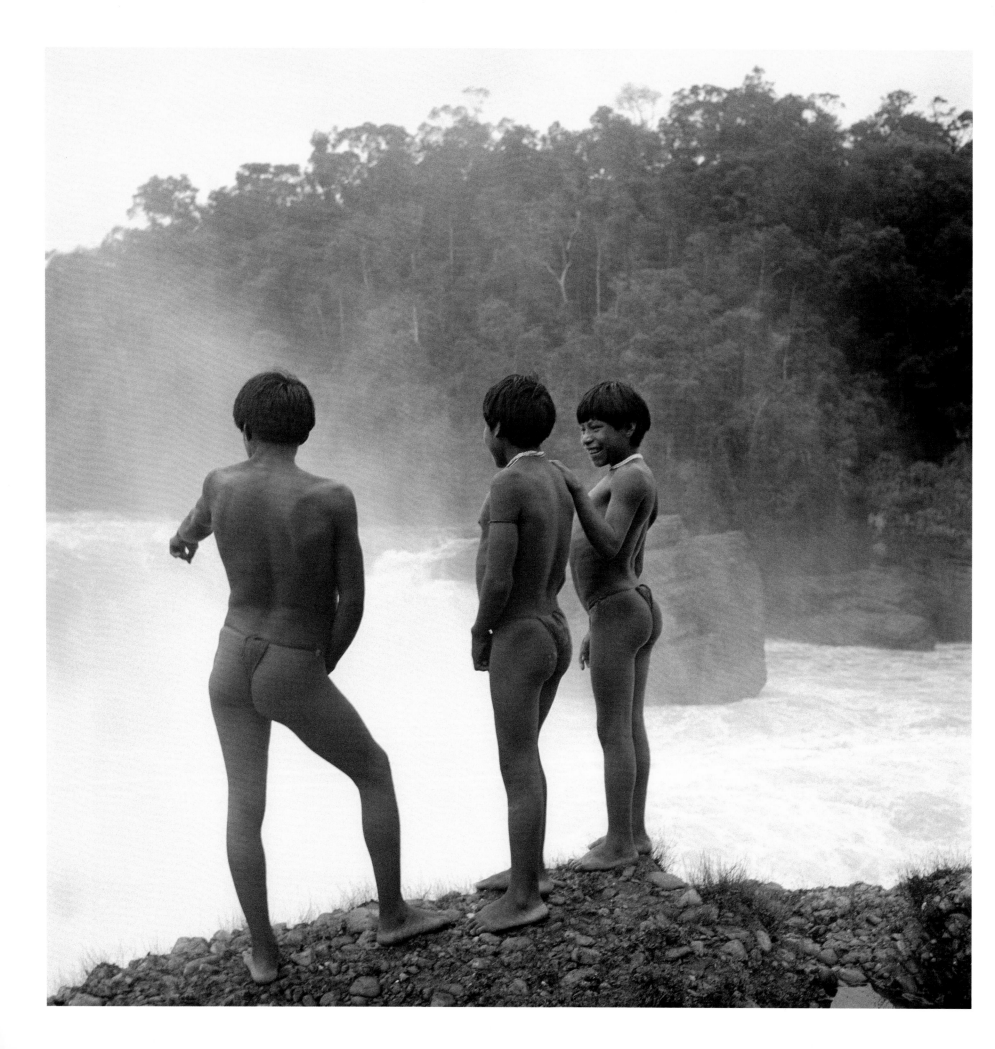

THE FALLS OF YAYACOPI, RÍO APAPORIS, FEBRUARY 1952

According to the Makuna Indians who live up several of the tributaries of the lower Apaporis, the falls at Yayacopi, like all the rapids of the river, were breathed into being by a primordial shaman who struck a deal with the gods. For generations the Makuna had been attacked, and once nearly annihilated, by a ruthless tribe of cannibals who dwelt at the headwaters of the river. Seeking an end to the terror, the shaman drank *yagé* for seven days, and in the course of his visions, the spirits agreed to transform the land, creating mountains and impassable cataracts that would forever separate the Makuna from their pitiless enemies. Since that time the Makuna have never traveled above Yayacopi, and the banks of the upper Apaporis have remained uninhabited. ♋︎

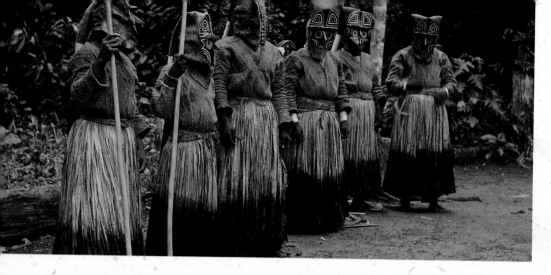

The Dance *of* Kai-ya-ree

At the end of February 1952, Schultes and his field assistant, Isidoro Cabrera, walked from the Apaporis overland, nine hours of arduous portage, to reach the headwaters of the Guacayá. There they spent a week among Tanimuka Indians, close allies of the Yukuna, and encountered the last surviving Matapies, a people whose language had been lost a generation before. Of the Yukuna, Schultes learned of two clans, the People of the Eagle, who numbered perhaps 250, and the People of the Boar, of whom only 40 remained alive. It was the fruiting season, the time of the great annual celebrations, and Schultes and Cabrera were dazzled by the power of the Yukuna wrestlers, men who consumed pounds of coca a day as they squared off and jousted with clubs of knotted wood.

Unprepared for an extended stay, Schultes and Cabrera were forced to retreat to the Apaporis and the rubber station of Soratama. Schultes flew to Bogotá but returned on April 4, eager to reach the Río Miritiparaná. With Cabrera sick with malaria, their departure for the Guacayá was delayed until April 21. They finally were back among the Tanimuka on the eve of the Kai-ya-ree, the annual festival celebrating the maturation of the *pupunha* palm. For a month the Indians had accumulated vast stores of dried meat and coca, sacred snuffs and fermented brews for the dancers. Emissaries of the *capitán,* or chief, of the longhouse had scattered through the forest, inviting all families of the Yukuna, Matapies, and Tanimuka to begin their movement toward the *maloca.* The

guests had gathered in a dozen places, all within a day's walk of the ritual site, to await the sound of signal drums announcing that all was in readiness. When Schultes and Cabrera entered the village, they were greeted by the chief, who offered them coca and tobacco, as well as the ritual salutation, a song recalling the events of the previous year.

The dancing began at midnight, and by then Schultes had been dressed as an animal, with a shirt of coarse brown cloth hammered from the inner bark of the *llanchama* tree, anklets of hollow seeds, and a long skirt made of strips of bark that rustled like grass as he moved. His mask was also of bark cloth, painted with black pitch and decorated with yellow and white designs. The opening dance was the Cha-vee-nai-yo, an offering to the spirit of evil. Sixteen men in four groups wound in and out among one another, movements that climaxed in an intense flurry before ending on a note of calm, a line dance with a simple, repetitive rhythm.

"The mask for the *Cha-vee-nai-yo,*" Schultes later recalled, "is weird: a human face fashioned of blackened pitch, with eye holes through which the dancer peers, a wedge-shaped wooden nose and a leering, toothless mouth. The eerie sight of so many hideously unreal devil-masks and the weirdly monotonous minor chant with its far-off, hollow sound as it is sung through the mask and hood had an almost hypnotic effect upon me. And, as I took part in this dance and joined in the chant myself, it was not hard for me to imagine that such an unearthly ritual must be placating some unearthly force."

In turn, through dance, the Tanimuka saluted each animal of creation. First, young boys adorned as monkeys and carrying leafy branches mimicked the lithe movement of primates scattering through the canopy. The Tapir dance was slow and lumbering, the one dedicated to Anteater startling in its costume's realistic depiction of the animal. The movements of the Deer dance were graceful and rapid, darting steps that perfectly captured the frightened and nervous character of the animal. The dance of the Wild Bee was accompanied by a low, buzzing drone. That of the Fruit Bat was accompanied by a song of unexpected beauty, a high chant, squeaky and shrill like the voices that emerge from caves. The most powerful dance of all, the one heard by Schultes just as he took a dose of hallucinogenic snuff, was that of the Jaguar. As he watched the nimble dancers pouncing and whining and snarling like cats, he saw the masks of wooden teeth, glass eyes, and whiskers of black pitch come alive, move toward him, and disappear in a pool of colored light.

The festival lasted four days, with Schultes dancing throughout. Only years later would he understand what he had lived and experienced through movement. For the Yukuna, the dances of the Kai-ya-ree tell the story of life, expressing all that they believe about the origins and evolution of the natural world. In taking on the images of supernatural beings and wild creatures, in balancing the forces of good and evil, the dancers ensure the health and fertility not only of their people, but also of the earth itself.

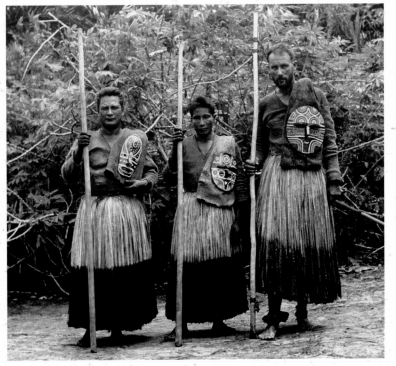

Schultes and two Tanimuka dancers at the Kai-ya-ree, Caño Guacayá, Río Miritiparaná, April 1952.

Adapted from One River: Explorations and Discoveries in the Amazon Rain Forest.

CAÑO GUACAYÁ, RÍO MIRITIPARANÁ, APRIL 1952

Overleaf: THE DANCE OF THE KAI-YA-REE, GUACAYÁ, RÍO MIRITIPARANÁ, APRIL 1952

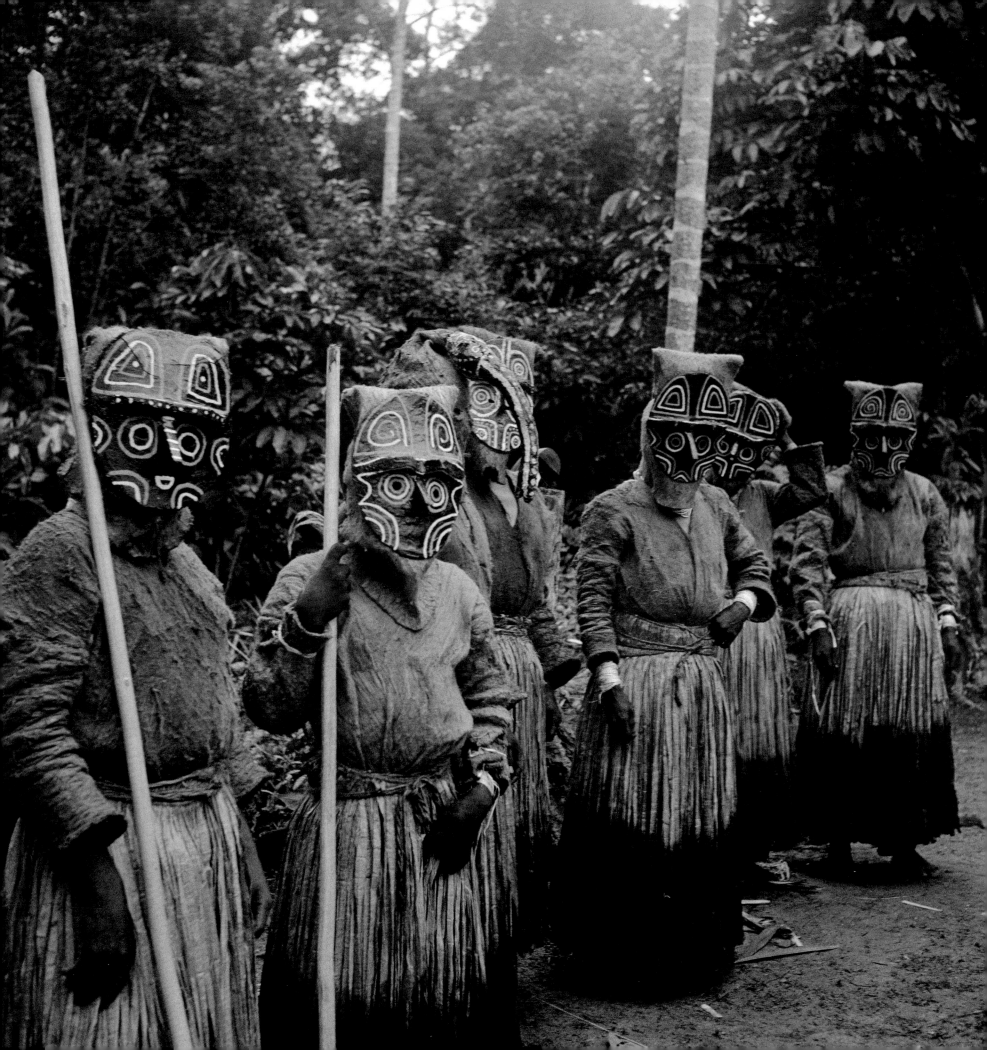

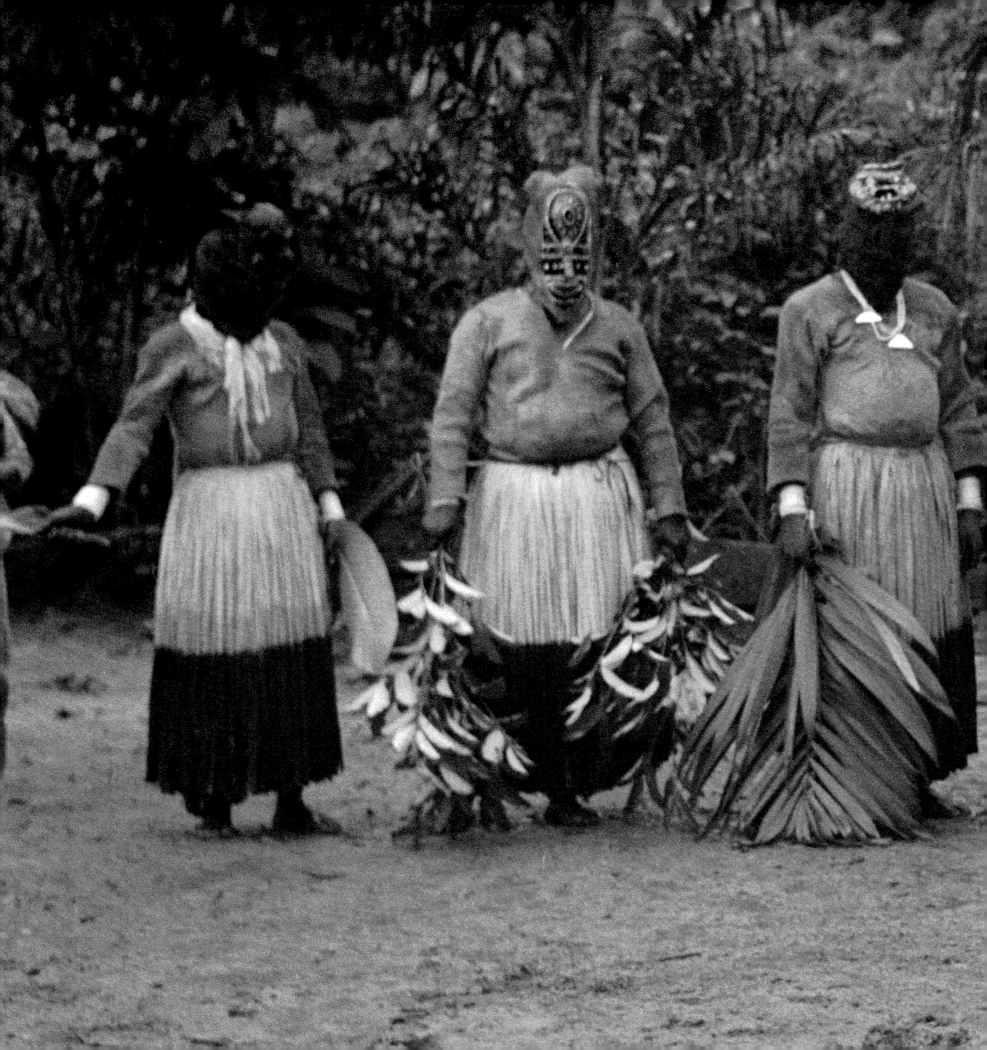

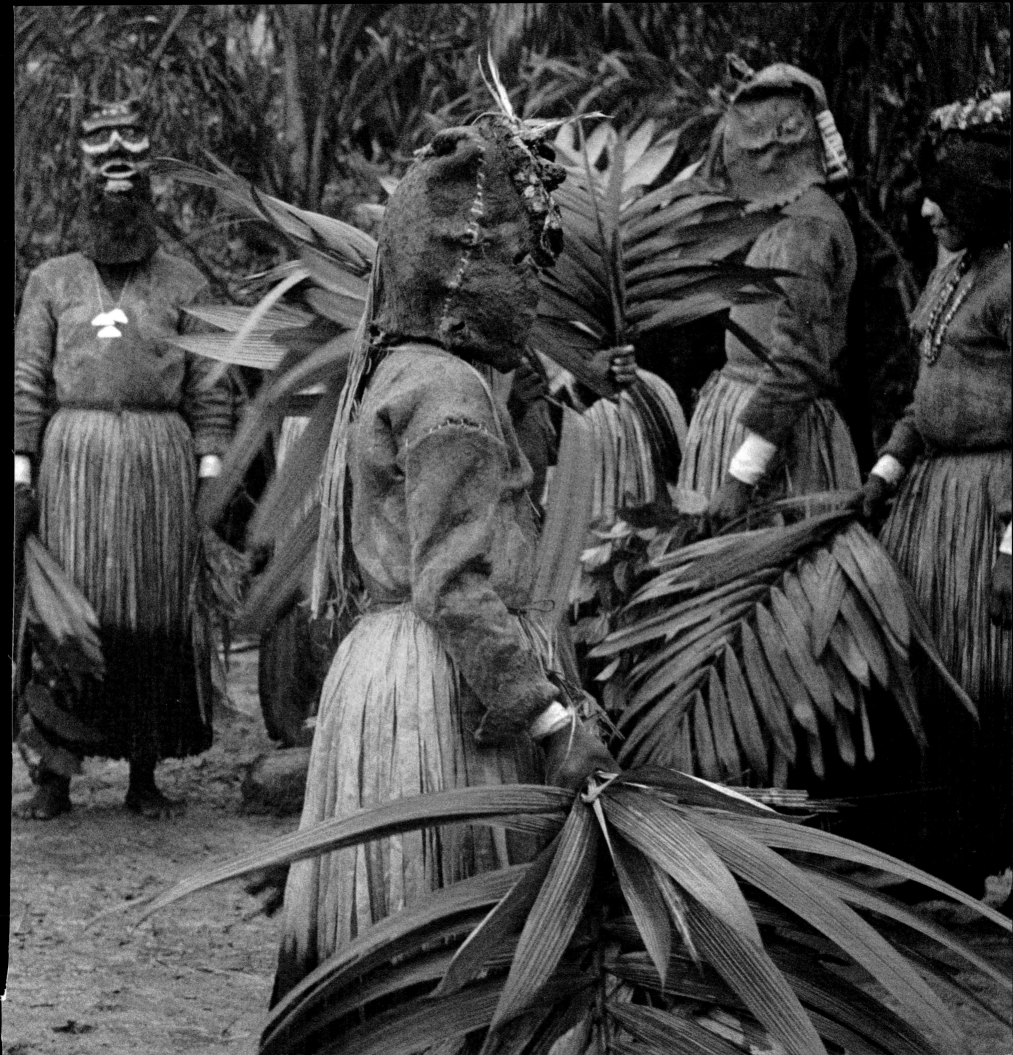

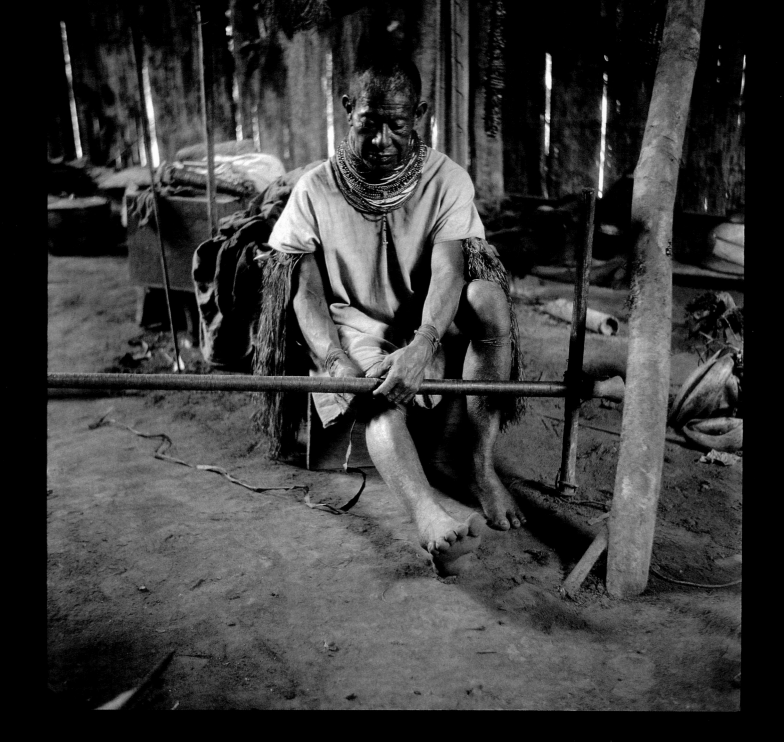

COFÁN ELDER MAKING A BLOWGUN, RÍO SUCUMBÍOS, APRIL 1942

By the time Schultes began his Amazonian explorations, the biological action of curare had been understood for a century. Medical experiments in 1942 revealed that the poison acted as a powerful muscle relaxant, promising to revolutionize modern surgery. Botanical knowledge, by contrast, was still embryonic. Not until 1943 would Harvard researchers produce the active compound d-tubocurarine from a properly identified botanical specimen. At this point no one had any idea how many plants contained the drug. Thus, as Schultes made his way to the Cofán, a journey that would yield no fewer than fourteen sources of curare, he did so charged with the excitement and anticipation of a scientist poised on the edge of discovery. ‿

THE COFÁN FAMILY THAT MET SCHULTES AT CONEJO,
RÍO SUCUMBÍOS, APRIL 1942

Before the arrival of the Spaniards, the Cofán were a powerful tribe, a small nation in effect, strong enough to incur the wrath of Inca Huayna Capac, who made war against them as he attempted to expand his empire to the north. By the time the Jesuits appeared in 1602, the conquistadors had stripped the gold-bearing sands of the upper Aguarico and Sucumbíos, and enslavement and disease had reduced the population to twenty thousand. By the mid-nineteenth century, when Colombia and Ecuador first mapped their eastern lowlands, geographers described the Cofán as a warlike tribe of perhaps two thousand, a figure that remained more or less constant until 1899, when, after a hiatus of more than two centuries, missionaries returned. The latest blow had come in 1923, when a measles epidemic, introduced by the Capuchin missionaries, had killed half the tribe.

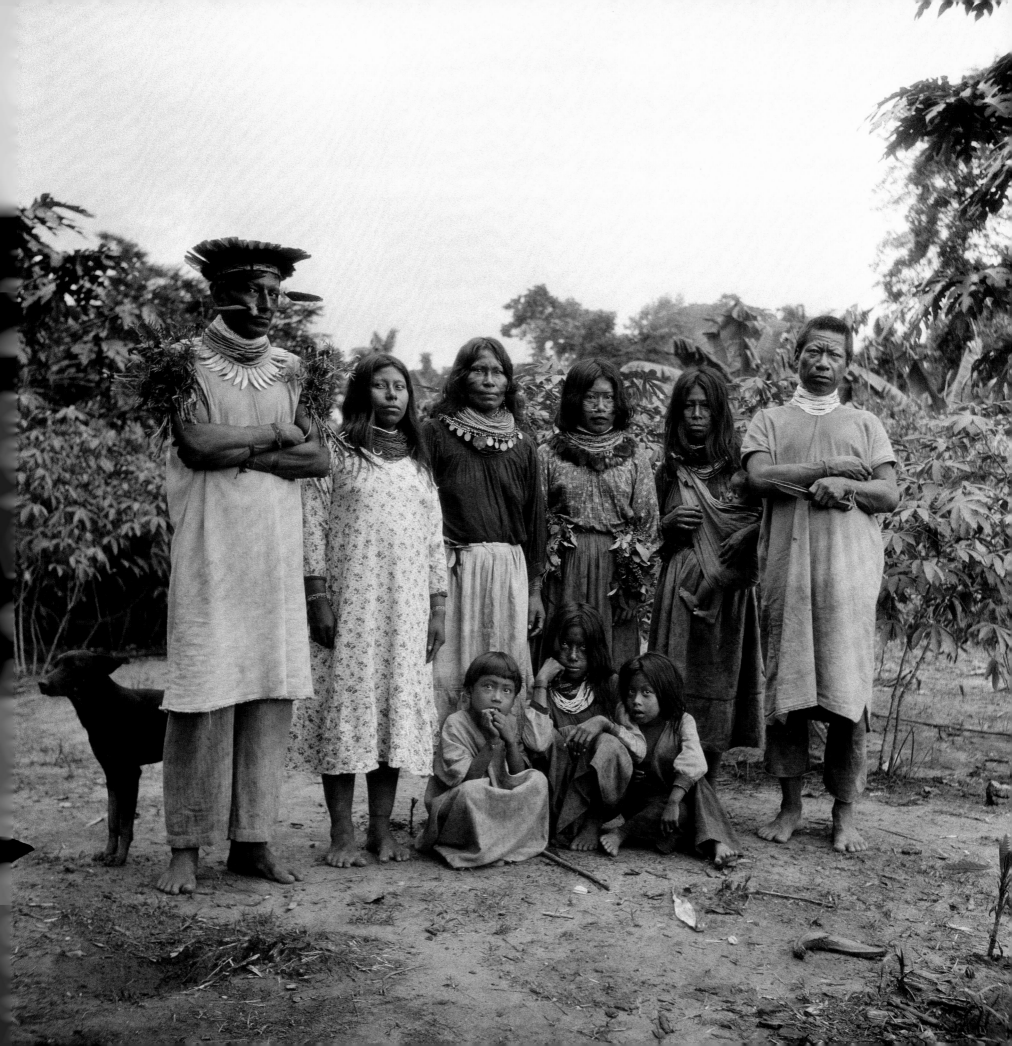

MAKUNA BOYS, RÍO POPEYACÁ, JUNE 1952

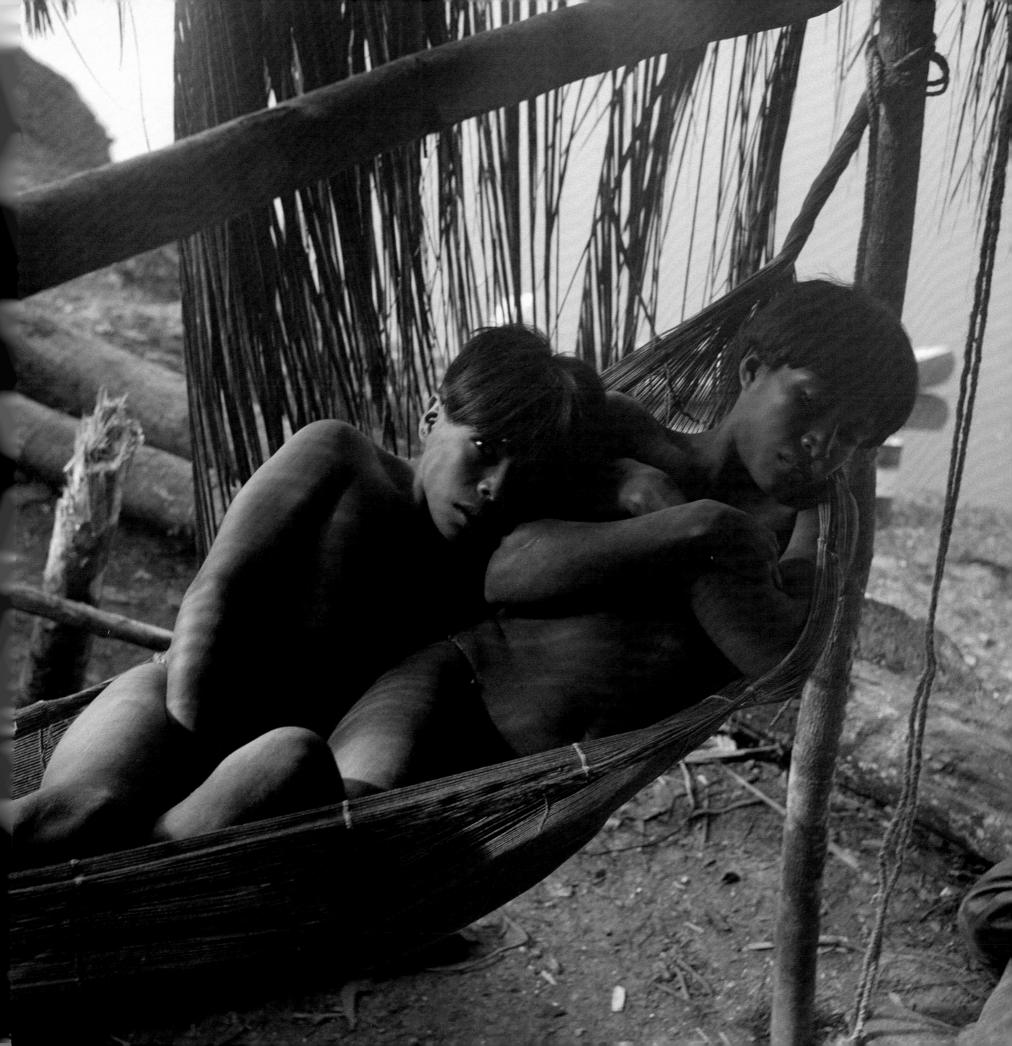

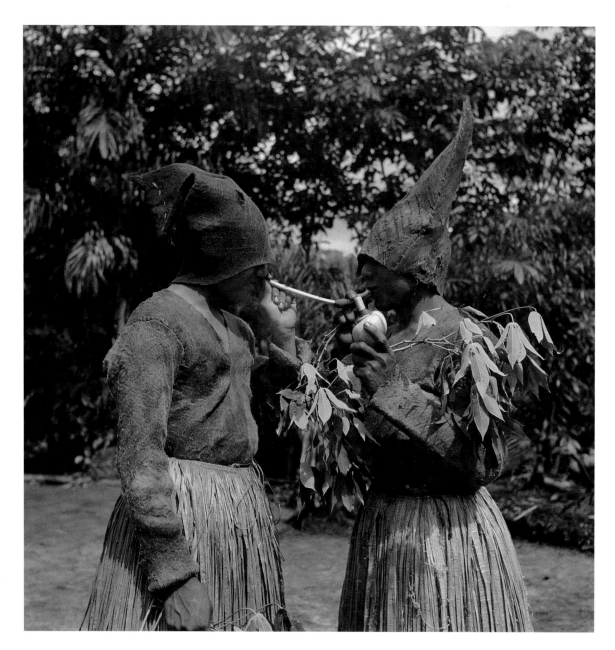

CAÑO GUACAYÁ, RÍO MIRITIPARANÁ, APRIL 1952

Two young dancers pause during the celebration of the Kai-ya-ree to take tobacco snuff, a sacred powder deemed
by the Yukuna to be an essential mediator with the spirit realm and a source of curative energy.

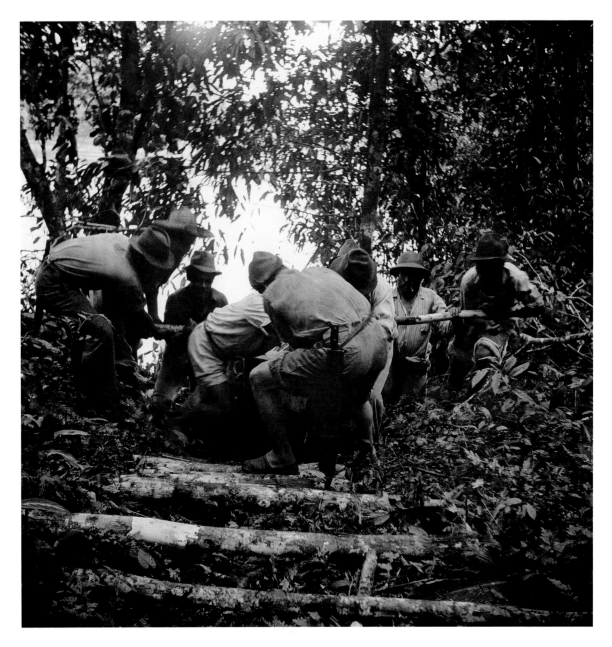

EXPEDITION, RÍO MIRITIPARANÁ, SEPTEMBER 1943

To explore the Apaporis, Schultes and his men hauled a 3,000-pound boat 36 miles overland from the Río Vaupés. It took 14 days, and the passage was horrendous. The soil was thick clay, and the rains fell every afternoon and evening, turning it into a muddy slough. They had to cross 120 creeks, inching the boat down each embankment and dragging it across the ground on rollers of wood cut from the forest. By the time they reached the Apaporis on September 17, 1943, the men were worn and weary and had little of the spark of those embarking on a long journey. It was no way to begin an expedition. ᴄ᷎

MAKUNA YOUTHS FISHING, RÍO POPEYACÁ, JUNE 1952

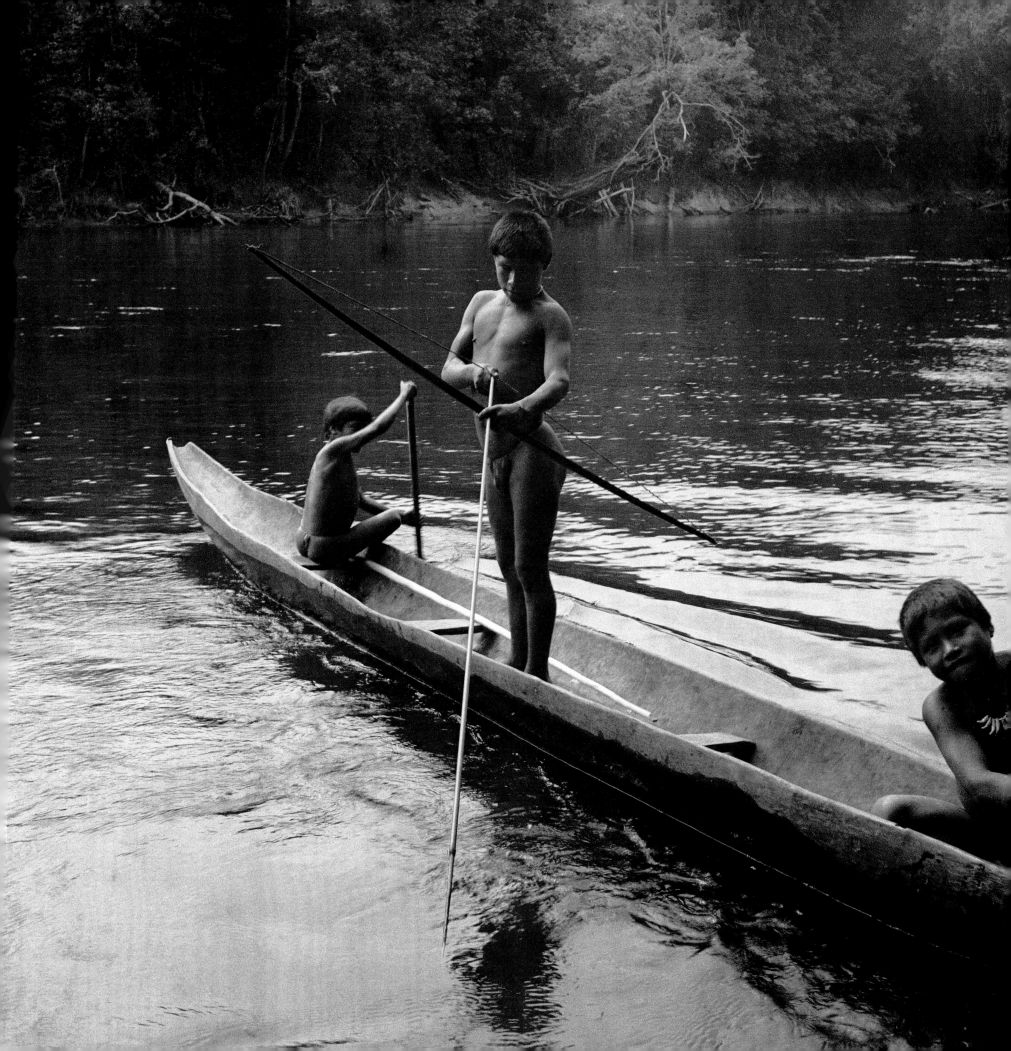

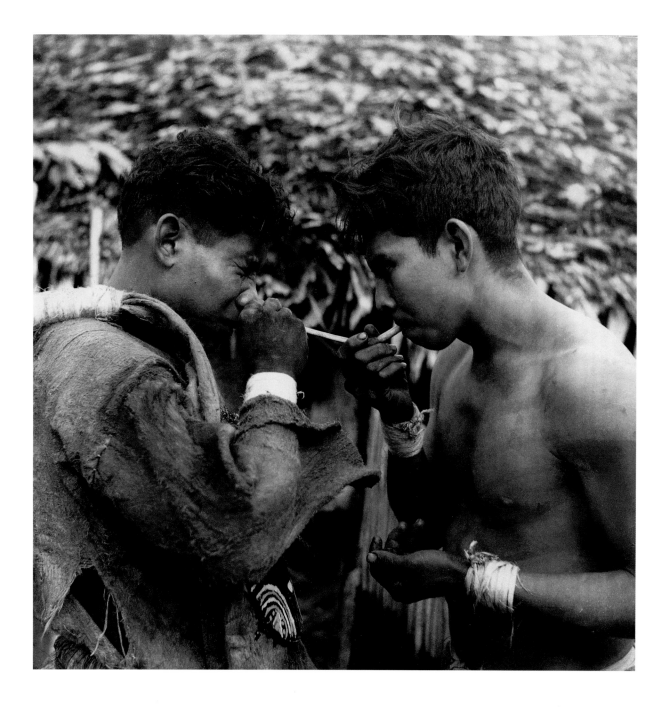

YUKUNA ADMINISTERING SNUFF, CAÑO GUACAYÁ,
RÍO MIRITIPARANÁ, APRIL 1952

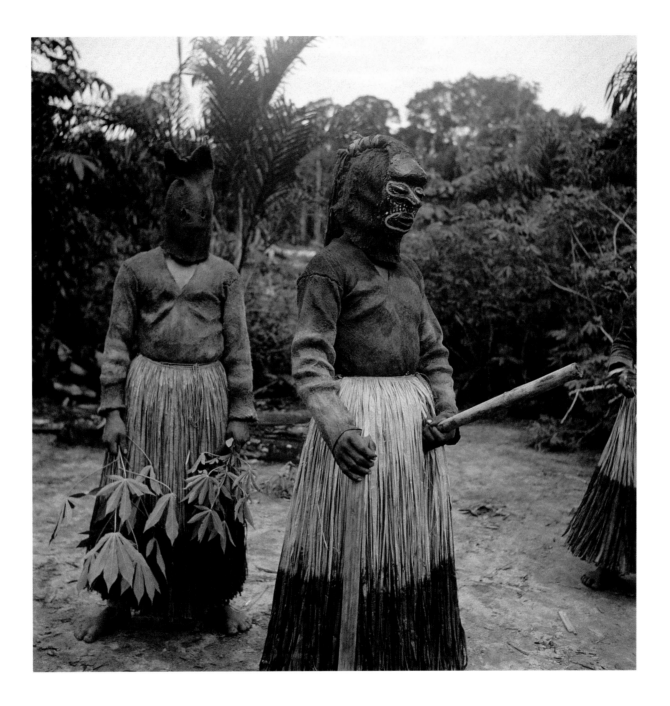

CAÑO GUACAYÁ, RÍO MIRITIPARANÁ, APRIL 1952

The dance of Wagti is a homage to fertility of people, fields, and the wild, with the wooden poles as phalluses, the movements those of copulation and procreation. ⌐⌐

A WILD ORCHID, SORATAMA, RÍO APAPORIS, 1952

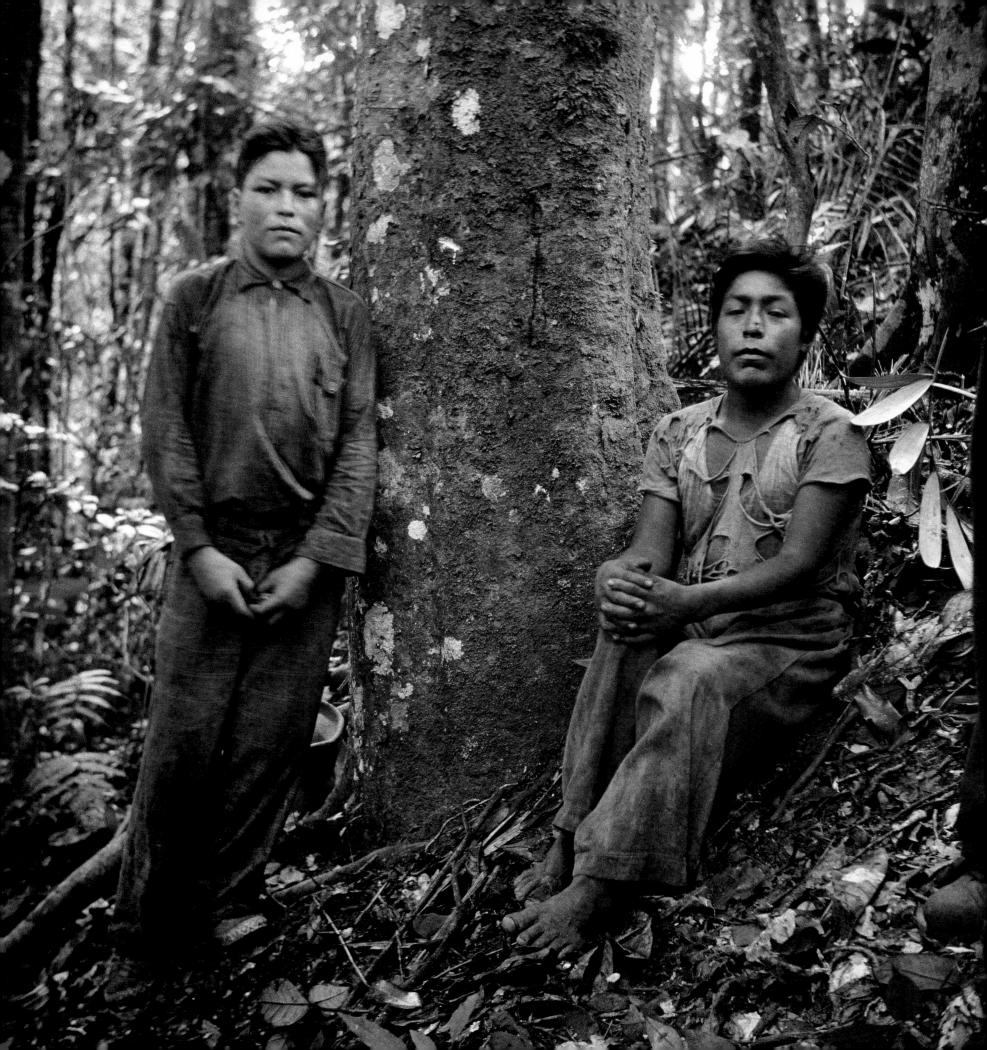

YOUNG RUBBER WORKERS, TINGO MARIA, PERU

In April 1945, Schultes's explorations took him south to Peru. At Tingo Maria on the upper Huallaga, he joined a party to descend the Río Tulumayo to visit a remote rubber station. Taken by the current, the canoe overturned in a rapid and was swept beneath a logjam. Most of the supplies were lost. Returning to Tingo Maria, he continued south and eventually reached the forests of Acre, where the borders of Peru, Bolivia, and Brazil come together. There he made an extraordinary discovery: a rare ecotype of *Hevea brasiliensis* that was high yielding, resistant to the blight, and the source of a latex whose quality was unsurpassed in the entire Amazon basin.

CLIFFS AT CERRO TAPIACA, RÍO VAUPÉS

Unlike the sandstone massifs encountered in the upper Apaporis, the isolated uplands in the eastern Colombian Amazon are granitic remnants of the Brazilian Shield. Schultes found them to be beautiful, but botanically of less interest, as they proved to have few endemic species.

Schultes relished any opportunity to explore the isolated uplands that soar above the Amazonian forest. It was exhilarating, after days in the jungle, to climb above the canopy and stand beneath an open sky. His ultimate goal on these expeditions was to understand the relationship between the flora of the Andes and that of the ancient highlands of the Guiana Shield, and thus reconstruct the geological and evolutionary history of the entire Northwest Amazon. The key was plant exploration, securing enough collections in enough places to begin to fill in the botanical map.

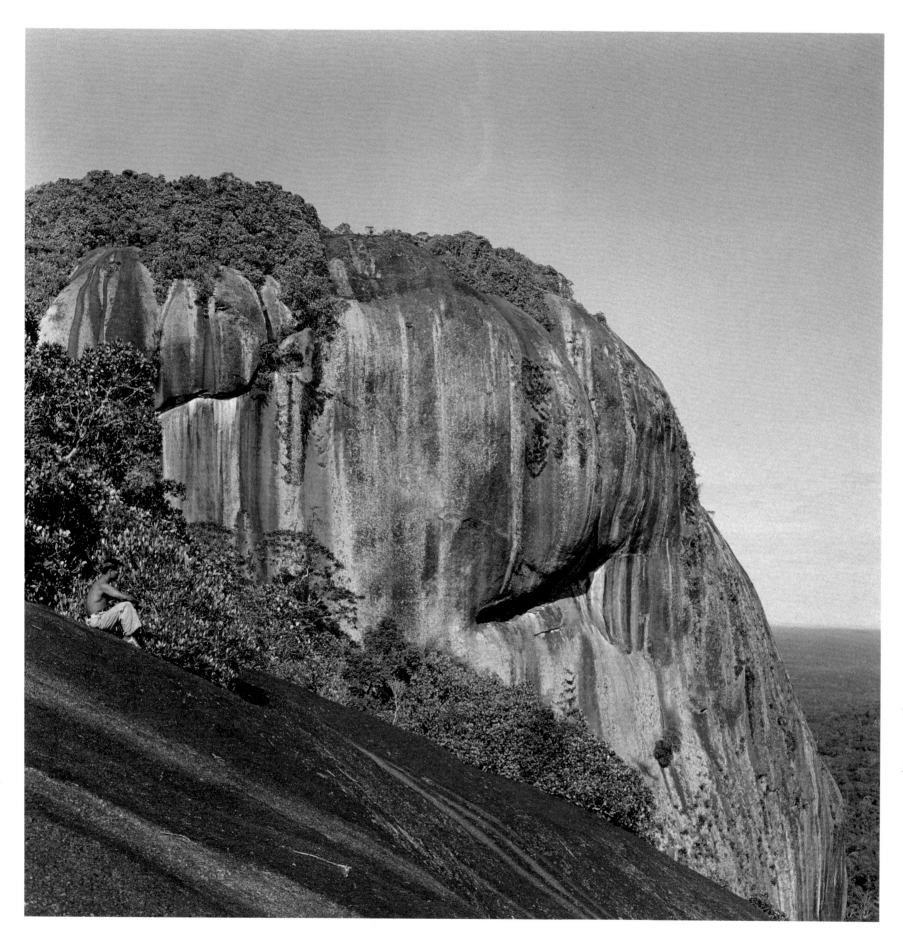

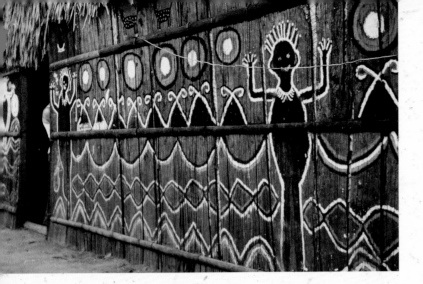

The Yagé Letters

In the early 1950s, William Burroughs traveled to South America in search of *yagé, ayahuasca,* the vision vine, the most powerful psychoactive preparation of the shaman's repertoire. His misadventures are chronicled in *The Yagé Letters,* a thin volume of correspondence between himself and Allen Ginsberg. Early in the text, Schultes makes an improbable appearance as "Dr. Schindler."

The last week of January 1953 finds Burroughs in Bogotá, riding a trolley toward the university and thanking God that he hadn't arrived junk sick in the cold and gloomy capital. He wants information on *yagé* and hopes to find it at the Instituto de Ciencias Naturales. He describes the place to Ginsberg:

"This is a red brick building, dusty corridors, unlabelled offices mostly locked. I climbed over crates and stuffed animals and botanical presses. These articles are continually being moved from one room to another for no discernible reason. The porters sit around on crates smoking and greeting everybody as 'Doctor.'

"In a vast dusty room full of plant specimens and the smell of formaldehyde, I saw a man with an air of refined annoyance. He caught my eye.

"'Now what have they done with my cocoa specimens? It was a new species of wild cocoa. And what is this stuffed condor doing here on my table?'

"The man had a thin refined face, steel rimmed glasses, tweed coat and dark flannel trousers. Boston and Harvard unmistakably. He introduced himself as Dr. Schindler.

"I asked about yagé. 'Oh yes,' he said, 'we have specimens here. Come along and I'll show you,' he said taking one last look for his cocoa. He showed me a dried specimen of the yagé vine which looked like a very undistinguished sort of plant. Yes, he had taken it.

"He told me exactly what I would need for the trip, where to go and who to contact. He suggested the Putumayo as being the most readily accessible area where I could find yagé."

At the end of January, following Schultes's advice, Burroughs heads for the Putumayo. A month later, with nothing accomplished, he is back in Bogotá. Having been conned by medicine men, jailed by the police, rolled by a

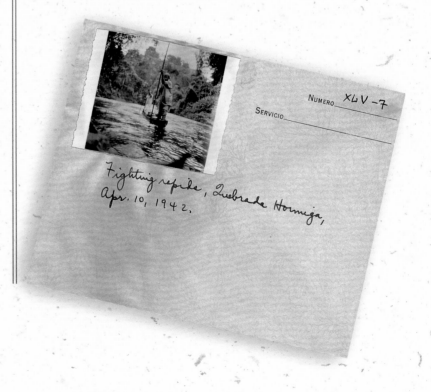

Fighting reptile, Quebrada Hormiga, Apr. 10, 1942.

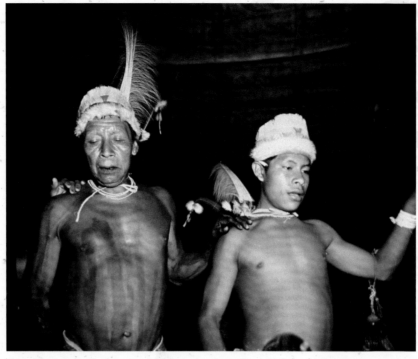

Makuna shaman with student apprentice dancing under the influence of yagé, Río Piraparaná, September 1952.

local hustler, and laid prostrate by malaria, he decides to stick close to "Doc Schindler" on his next foray into the jungle. "I have," he writes Ginsberg on March 3, "attached myself to an expedition, in a somewhat vague capacity to be sure, consisting of Doc Schindler, two Colombian botanists and two English Broom rot specialists from the Cocoa Commission."

Six weeks later, Burroughs writes once more from Bogotá. This time, thanks to Schultes, he's had better luck. Within a day of reaching the lowlands, Schultes has introduced him to an old friend, a German farmer and former gold prospector who, within half an hour, provides Burroughs with twenty pounds of *yagé* and an appointment to take the drug with a local *brujo,* or witch doctor. That night finds him on the dirt floor of a hut, sitting before a crude altar as the *brujo* chants over a red plastic bowl containing a brown liquid, oily and phosphorescent. Burroughs drank it "straight down." It had, he noted wryly, the "bitter foretaste of nausea."

Two minutes later, a wave of dizziness swept over him and the hut began to spin. Hit by a sudden, violent urge to throw up, he stumbled outside, flung himself against a tree, vomited six times, and fell down to the ground "in helpless misery." His numb body swathed in imaginary layers of cotton, his feet transformed into blocks of wood, his eyes lost in a blue haze of larval beings, this veteran of a thousand strange scenes had one cardinal thought. "All I want," he said to himself again and again, "is out of here." Fumbling with an emergency bottle of downers, he managed to pop six Nembutals. He spent the rest of the night on the floor of the hut, fighting off malaria-like chills and the crazed, obsessive thought that this *brujo,* alone among all *brujos,* made a specialty out of poisoning gringos. In the morning he attempted to compare notes with Schultes, who by this point in his career had taken *yagé* on more than twenty occasions.

"I never get sick," Schultes told him. Burroughs mentioned that at one point he felt himself change into a black woman, then a black man, then a man and a woman at the same time, with everything writhing as in a van Gogh painting. He had achieved pure bisexuality, becoming a man or a woman at will, awash with wild convulsions of lust.

"I only get colors, no visions," Schultes replied.

Adapted from *One River: Explorations and Discoveries in the Amazon Rain Forest.*

the yagé letters

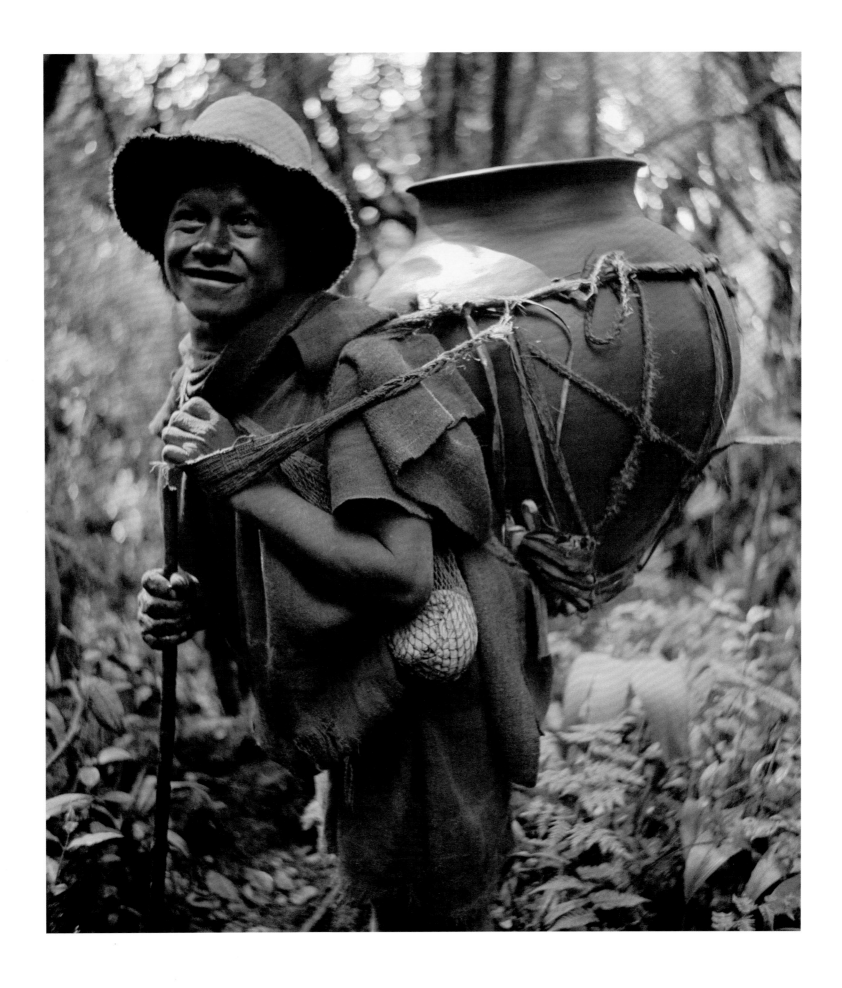

INGA MAN WITH CLAY POT, TAMBILLO, DECEMBER 13, 1941

The valley of Sibundoy was the land of the Kamsá, an isolated culture with a language related to no other. But it was also home for the Inga, a Quechua-speaking people who were closely related to the Ingano of the adjacent lowlands, and most likely descendants of populations moved into the valley by the Inca in pre-Columbian times. Schultes took this photograph on December 13, 1941. The Inga man was from Tambillo and heading to Santiago to sell his ceramic pot. Schultes was heading back to Bogotá to embrace his destiny. War had broken out just six days before at Pearl Harbor. ✑

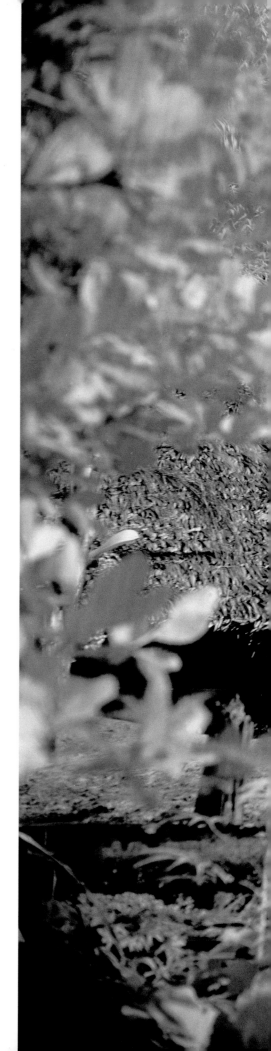

MAKUNA BOYS, RÍO PIRAPARANÁ, SEPTEMBER 1952

Throughout the Northwest Amazon the Indians live in beautiful structures that are both eminently practical and highly symbolic. Among the Barasana, for example, the longhouse or *maloca* is a model of the cosmos, with each architectural element charged with meaning. The roof is the sky, the house beams the stone pillars and mountains that support it. The mountains, in turn, are the petrified remains of ancestral beings, the Mythical Heroes who created the world. The smaller posts represent the descendants of the original Anaconda. The floor is the earth. The long ridgepole overhead represents the path of the sun that separates the living from the limits of the universe.

Beneath the ground runs the River of the Underworld, the destiny of the dead. The Barasana bury their people in the floor of the *maloca,* in coffins made of broken canoes. As they go about their daily lives, living within a space explicitly perceived as the womb of their lineage, the Indians walk above the physical remains of their ancestors. Yet the spirits of the dead drift away, and to facilitate their departure, the longhouse is always built close to water. And since all rivers, including the River of the Underworld, are believed to run east, each structure must be oriented along an east-west axis, with a door at each end, one for the men and one for the women. Thus the placement of the *maloca* adjacent to running streams is not just a matter of convenience. It is a way of symbolically acknowledging the cycle of life and death. The water both recalls the primordial act of creation, the riverine journey of the Anaconda and Mythical Heroes, and foreshadows the inevitable moment of decay and rebirth.

Outside the longhouse is a world apart, the place of nature and disarray. The owners of the forest are the jaguar and the demon spirits that have been transformed into animals that eat without thought and copulate without restraint. White people are like the animals, the Indians maintain, dwelling at the margins of the world, reproducing with such abandon that their numbers swell, spilling over into the lands reserved from the beginning of time for the Barasana, the Makuna, and the other peoples of the Anaconda. The world of the wild is a place of danger, the origin of disease and sorcery, the realm where shamans go in dreams and hunters walk each time they leave the protective confines of the *maloca* and surrounding gardens. ∾

Photo by Guillermo Cabo.

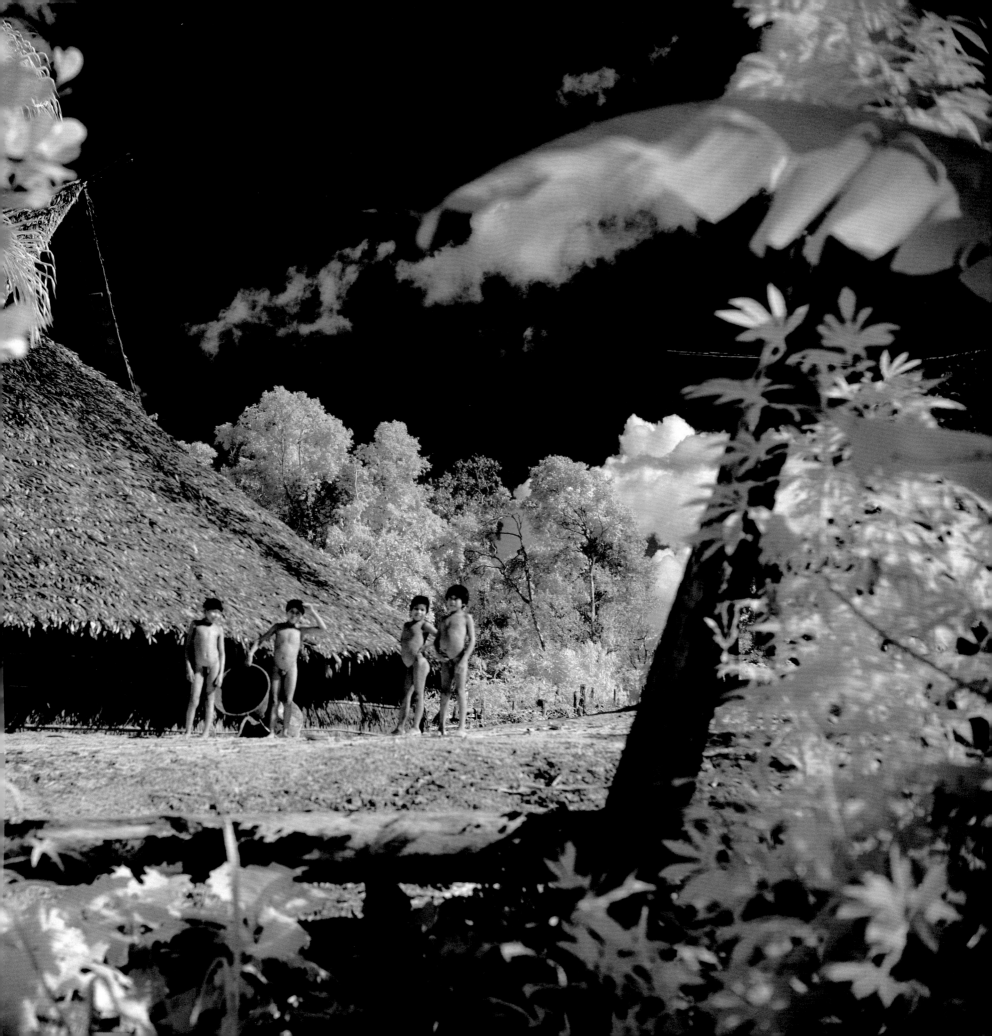

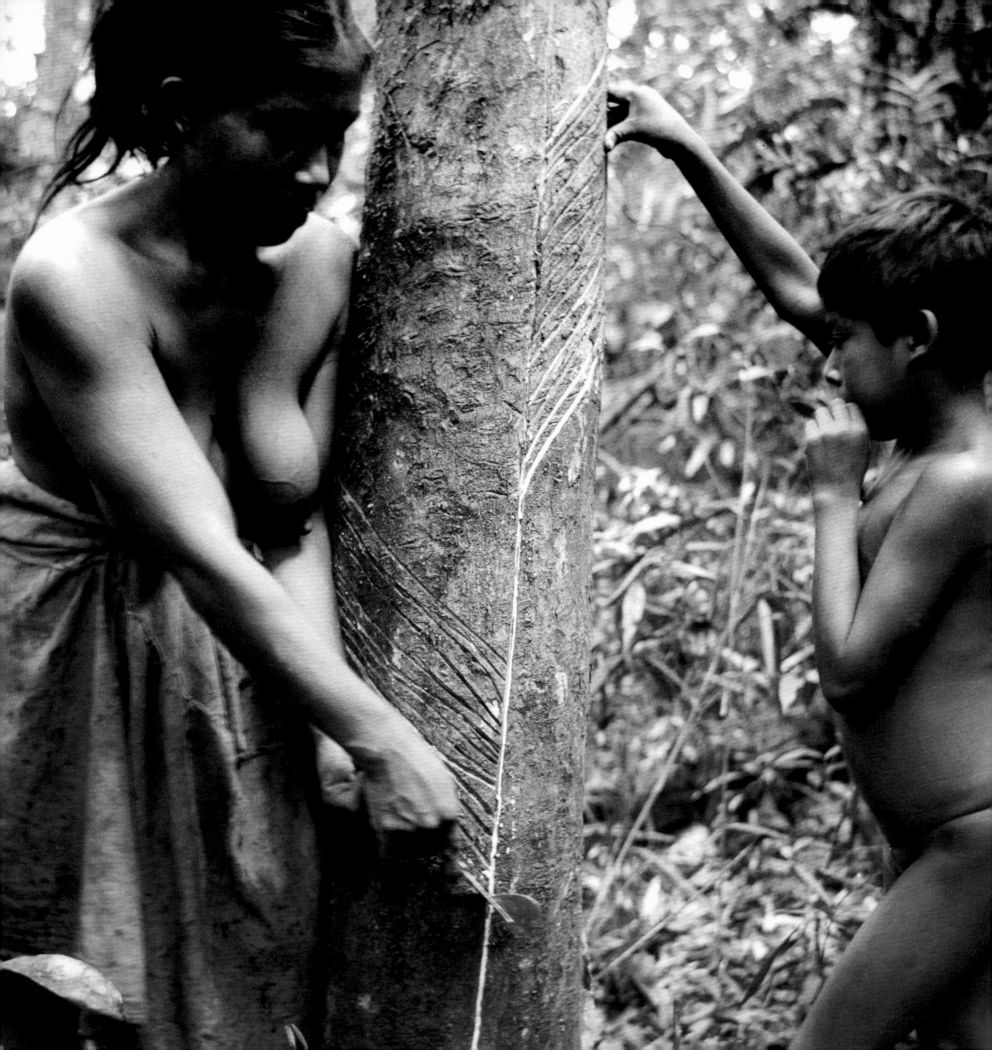

CUBEO MOTHER AND HER SON TAPPING RUBBER, RÍO TUY, VAUPÉS

During the height of the rubber terror, some forty years before Schultes arrived in the Amazon, the atrocities committed against Indians defied imagination. Women were treated particularly cruelly. Rafael Calderón, a twenty-two-year-old bandit who tethered Indians for target practice and once gave a Witoto child fifty lashes for stealing a loaf of bread, lived by the motto "Kill the fathers first, enjoy the virgins afterward." When a woman refused to sleep with one of his men, the trader Armando Norman wrapped her in a kerosene-soaked Peruvian flag and lit it on fire. When the stationmaster at Atenas discovered that a young Indian girl he had raped had venereal disease, he tied her to the ground and flogged her while a burning firebrand was inserted into her vagina. A priest who had lived in the Putumayo during those dark years told Schultes that the best that could be said of a white man in that era was that he did not kill Indians out of boredom. ❧

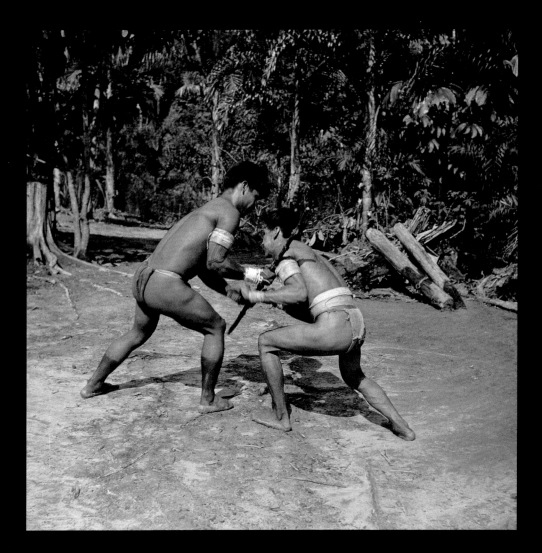

RÍO MIRITIPARANÁ, APRIL 1952

Infused with prodigious amounts of coca, Yukuna men test their strength as they joust with clubs of knotted wood. Schultes described it as a form of wrestling that had the potential to turn violent as the competitors became antagonists, pounding each other, as he wrote, with the "gnarled protuberances at critical locations on the muscles." ᴑ

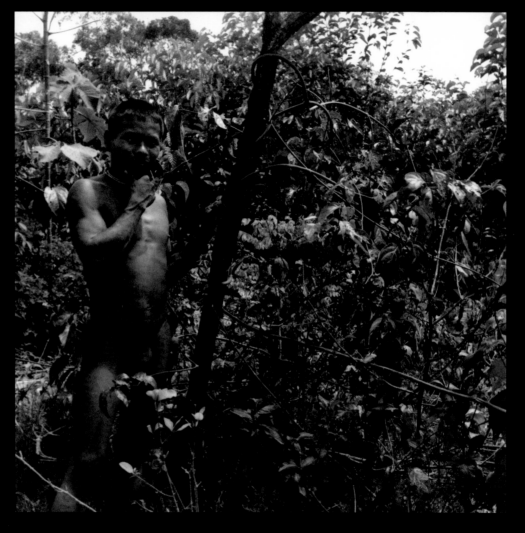

MAKUNA YOUTH IN A GARDEN OF YAGÉ, RÍO PIRAPARANÁ, VAUPÉS, OCTOBER 1943

Yagé is many things, but pleasant is not among them. As Schultes once wrote, "The beverage is extremely, sometimes nauseatingly, bitter and vomiting usually accompanies the first draught. It almost always causes diarrhea." Still, the psychic effects are astonishing. The world dissolves into a new reality. By the Indians the vine is likened to a snake, a sinuous thread that reaches back to the dawn of time, like an umbilicus linking the human being to the mysteries of the mythical past. ᐒ

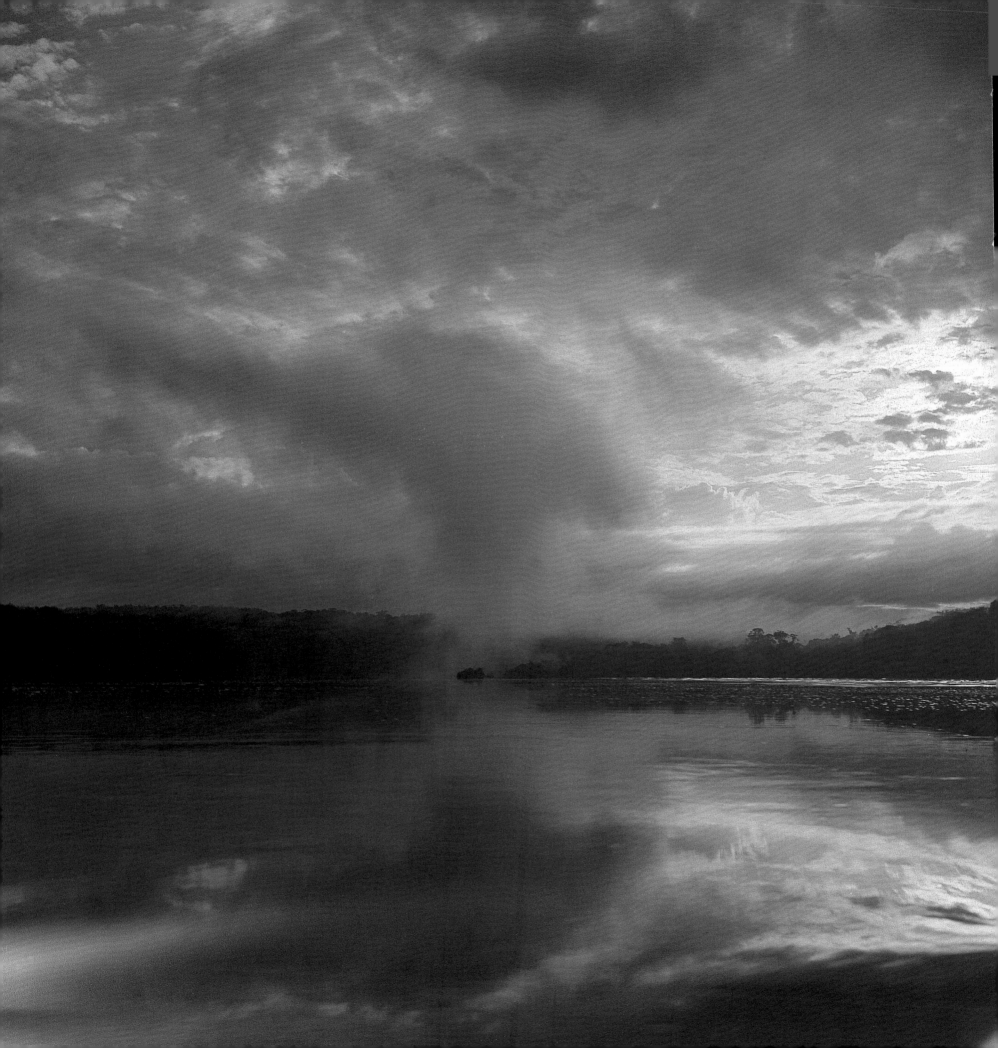

APPROACHING THE ENTRY FALLS OF JIRIJIRIMO, OCTOBER 1943

Located just below the mouth of the Río Kananarí, Jirijirimo is the most dangerous of the rapids on the Río Apaporis. Schultes and his men approached the entry falls at dawn. In the stillness of the morning, with the slow, steady movement of the river beneath the boat and the dark bands of vegetation on the distant shores, he witnessed for the first time the great plume of mist that rises from the water and hangs ominously above the cataracts, as if to conceal the wild beauty of the river from the sun. As the river narrowed, funneling half a mile of water toward a chasm sixty feet across, Schultes heard the dull thunder of the entry falls, a hundred-foot wall of water leading to the gorge.

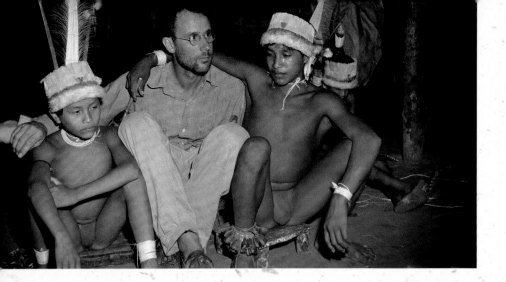

The Semen *of the* Sun

For years Schultes was aware of conflicting reports describing the use of hallucinogenic snuffs in lowland South America. The English botanist Richard Spruce had found a powder known as *yopo* on the Orinoco in June 1854 and identified the source as the tree *Anadenanthera peregrina*. The famous German ethnologist Theodor Koch-Grünberg, traveling in the Northwest Amazon between 1903 and 1905, had told of a "magical snuff...prepared from the bark of a certain tree...the sorcerer blows a little through a reed into the air. Next he snuffs, whilst he absorbs the powder into each nostril...immediately the witch doctor begins singing and yelling wildly, all the while pitching the upper part of his body backwards and forwards."

In 1945, when the Smithsonian Institution published the seminal five-volume *Handbook of South American Indians,* an anthropologist had produced a map showing *yopo* distributed among tribes throughout the Northwest Amazon. This map left Schultes utterly perplexed. In his years in the field, he had consumed copious amounts of tobacco snuff and had taken *yagé* more times than he could remember. He had never come upon *yopo,* and he knew that the source tree grew only on the open savannahs of the Guaviare and Orinoco, with scattered populations thriving at the mouth of the Rio Branco on the lower Madeira in Brazil. It was never found in the rain forest. What's more, Koch-Grünberg, who wrote exclusively of the wet tropics, had mentioned a bark that was employed to make the drug, whereas Richard Spruce had quite specifically identified seeds as the source of *yopo*.

The mystery was very much with him on the morning of June 26, 1951. For a week he and a group of rubber workers had been surveying the forest on the north bank of the Apaporis between the mouth of the Río Pacoa and the Kananarí. Among them was a young Puinave Indian, the son of a shaman who had been flown in from the Río Inírida, the highest Colombian affluent of the Orinoco. As they moved through the forest, they happened upon a small flowering tree, which Schultes recognized as *Virola calophylla*. The lad examined its bark and innocently turned to Schultes.

"This is the tree that gives *yá-kee*. My father uses it when he wants to talk with the little people."

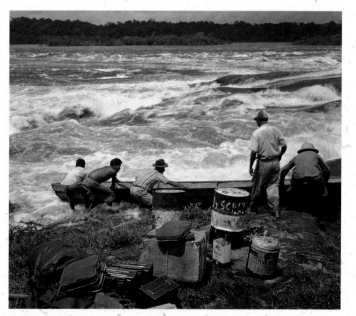

The descent of the Río Vaupés, April 1953.

Schultes froze, momentarily stunned. He knew that the homeland of the Puinave was one of the regions where *yopo* did grow, and no doubt the boy's father employed the hallucinogen in shamanic rites. But what on earth was *yá-kee?*

"Does he use the seeds?" Schultes asked, thinking that *yá-kee* might just be another name for *yopo*.

"No," the boy answered, "just the bark."

Schultes quietly led him away from the others, to a clearing on the riverbank where they could be alone.

"Do you know how to make it?" he asked.

"Of course."

The next morning, they left their encampment early and returned to the tree they had found the day before. The Puinave youth insisted that the bark had to be removed at first light, before the sun penetrated the canopy and warmed the trunk. With a quick slash of the machete, Schultes found that it came off easily in long strips. Within minutes a thick red liquid oozed from the inner surface.

The Puinave youth soaked the bark for thirty minutes and then rasped it, placing the shavings in an earthen pot. He added a small amount of water and then kneaded and squeezed the material, straining it several times through a piece of cloth into a second and smaller vessel. Once satisfied, he discarded the shavings and placed the liquid over a low fire, allowing it to simmer for several hours. When the preparation had been reduced to a thick, dark syrup, he removed the pot from the heat and set it in the sun so that the residue would solidify slowly into a dry crust. With a pestle of polished stone, he ground this deposit into a fine powder, mixing in equal amounts of ash derived from the bark of wild cacao. The final product was sifted and placed in a large snail shell. Attached to the shell were two bird-bone tubes, each plugged with a stopper of bright feathers. The Puinave then handed the

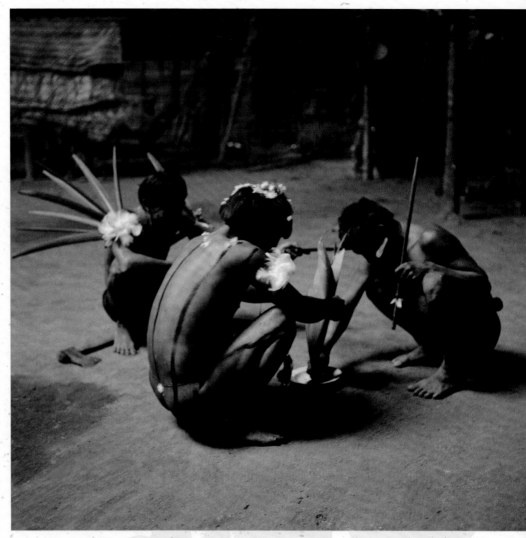

Yanomami taking ebéna *snuff. Totorobí, upper Río Negro, Brazil, August 1967.*

works to Schultes. By then it was afternoon, and Schultes had been waiting all day to try the snuff. Following his young companion's instructions, he put the end of one tube in his nostril, placed his lips on the other, and blew hard through his mouth.

"It may be of interest," he wrote the following day, "to append a few observations which I was able to make personally after taking *yá-kee*. I took about one-third of a level teaspoonful of the drug in two inhalations using the characteristic V-shaped bird-bone apparatus by means

of which the natives blow the powder into the nostrils. This represents about one-quarter the dose usually absorbed… Within fifteen minutes a drawing sensation over the eyes was felt, followed very shortly by a strong tingling in the fingers and toes. The drawing sensation in the forehead rapidly gave way to a strong and constant headache. Within one half hour, there was a numbness of the feet and hands and an almost complete disappearance of sensitivity of the finger-tip; walking was possible with difficulty, as in the case of beri-beri. Nausea was felt until about eight o'clock, accompanied by a general feeling of lassitude and uneasiness. Shortly after eight, I lay down in my hammock, overcome with a heavy drowsiness which, however, seemed to be accompanied by a mus-

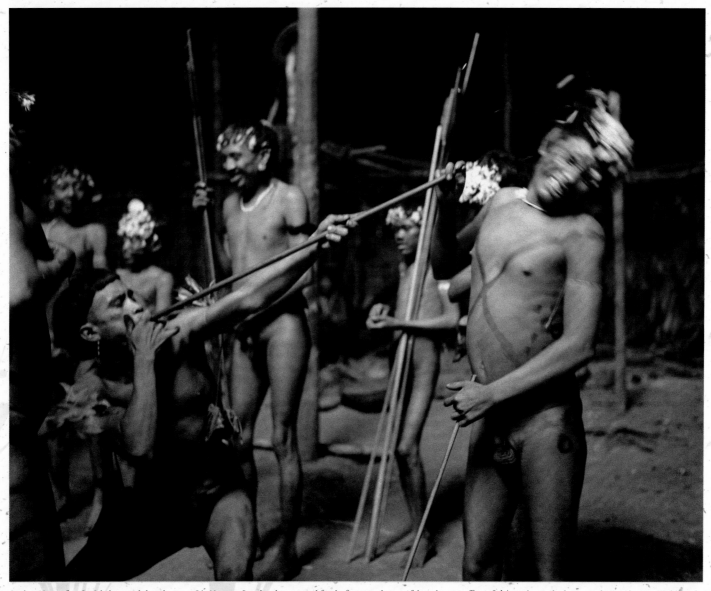

In the summer of 1967, Schultes traveled to the upper Río Negro in Brazil and experienced for the first time the powerful psychoactive effects of ebena, the powder known to the Yanomami, or Waiká, as the Semen of the Sun. The powder induced not the distortion of reality, but rather its dissolution. In that suspended state of consciousness, the healers worked their deeds of mystical and medical rescue.

cular excitation, except in the extremities of the hands and feet. About 9:30, probably, I fell into a fitful sleep which continued, with frequent awakenings, until morning. The strong headache over the eyes lasted until noon. A profuse and uncomfortable sweating, especially of the armpits, and what might have been a slight fever lasted from about six o'clock all through the night. There was a strong dilation of the pupils during the first few hours of the experiment. No food was taken and no tobacco was smoked from the time the experiment began until one o'clock in the afternoon, that is, for twenty hours during the course of the experiment.

"Since this experiment was performed under primitive conditions in the jungle, all observations had to be made by myself. In spite of its many and serious shortcomings, the experiment indicates the narcotic strength of the snuff. The witch doctors see visions in color, but I was able to experience neither visual hallucinations nor color sensations. The large dose used by the witch doctor is enough to put him into a deep but disturbed sleep, during which he sees visions and has dreams which, through the wild shouts emitted in his delirium, are interpreted by an assistant."

For Schultes, this innocent discovery was both a culmination and a beginning. He had, in fact, stumbled upon *yá-kee* in the early spring of 1942 in the Putumayo while walking from El Encanto to La Chorrera. His field notes for May 31, 1942, record the collection of a small, unidentified tree known to the Witoto as *oo-koo'-na,* with "red resin in bark. Intoxicating." But the significance of the collection was lost on him at the time, and the specimen soon forgotten. Now, after nine years, with a positive identification in hand and certain knowledge of the efficacy of the snuff, any number of curious leads presented themselves.

Within a week he had found a second psychoactive species, *Virola calophylloidea.* A month later, while working among Taiwano on the Río Kananarí, he came up with a third, *Virola elongata.* Over the next months he was able to document the preparation of the snuff among the Cubeo and Tukano on the Vaupés, the Barasana and Makuna on the Piraparaná, and the Kuripako far to the north on the Río Guainía. Then, in 1953, a report reached him from an American missionary working in Venezuela among the Waiká, or Yanomami, at the headwaters of the Orinoco.

According to this account, the Waiká used a snuff called *ebéna* to contact the *hekula,* spirits of rocks and waterfalls. For the next decade, tantalizing but indefinite reports suggested that *ebéna* was derived from *Anadenanthera,* the source of *yopo.* Schultes had his doubts. Finally, in the summer of 1967, he journeyed to two widely separated Waiká villages on the remote upper reaches of the Río Negro in Brazil. At the Salesian mission of Maturacá, he found something he had never seen in thirty years of studying hallucinogenic plants: the casual, essentially recreational use of drugs. In every house hung a large bamboo tube of snuff. The Indians took it formally during rituals and festivals, but any man was free to dip into the stash if he felt the urge. It was not uncommon to see an individual high on *ebéna,* dancing and singing alone, while the rest of the village went about the daily round. Schultes confirmed that the source of *ebéna* was, as he had always suspected, a virola, in this case *Virola theiodora.*

At the second village, he arrived by chance during the annual festival of the dead. Sitting on the ground, he watched as a shaman lifted a four-foot grass tube to his mouth and placed the other end into Schultes's nostril. He endured the blast of snuff that ripped into his sinus and transformed the world before his eyes. But he was not prepared for what came next. At the height of the feast, the Indians ran out of snuff. Schultes waited

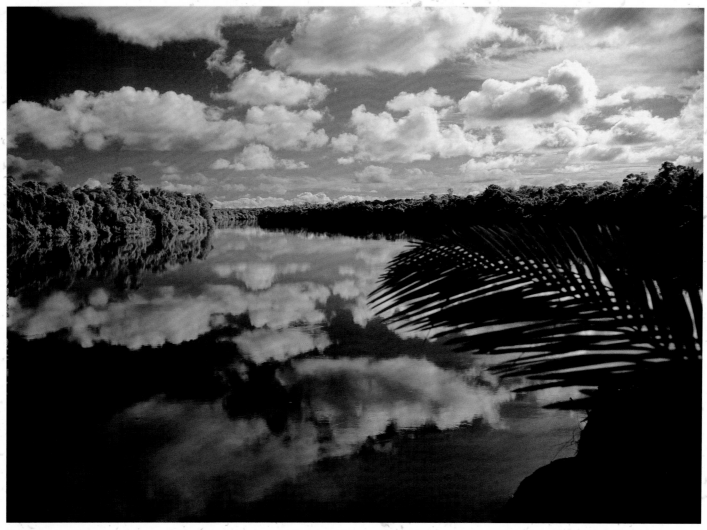

Photo by Guillermo Cabo.

expectantly, anxiously, as they opened several bamboo quivers and removed dozens of poisoned arrows. Having scraped off the venom and ground it into dust, they placed the powder into the blowing tube. Before Schultes could say anything, the shaman drove the venom into his nose. What amazed him was that nothing changed. He felt the same surge, the same magnetic release from the world. Poison and hallucinogen were one. It was something he would never understand, and never forget.

This was not the end of the virola story. Upon his return from the field, Schultes had several samples of *ebéna* analyzed. An astonishing 11 percent of the snuff's dry weight was composed of a series of potent tryptamines, including 5-methoxy-N,N-dimethytryptamine, arguably the most powerful hallucinogen known in nature. More curious than the strength of the snuff was the fact that the chemical constituents were both in kind and concentration almost identical to what had been found in *yopo*. The source trees were botanically unre-

lated. One drug was derived from seeds, the other from inner bark. Yet somehow the Indians had recognized both plants and discovered ways to exploit their remarkable chemical properties.

Two years after the Brazilian expedition, Schultes's work with virola took yet another serendipitous turn, again sparked by a unexpected encounter in the forest. The unusual chemical properties of the virola resin had shown considerable promise as an anti-inflammatory drug. Commissioned by one of the major pharmaceutical companies to gather a hundred kilograms of bark, Schultes found himself in February 1969 on the banks of the Río Loretoyacu, near Leticia. His assistant was Rafael Witoto, a native of El Encanto on the Karaparaná. As they stripped the bark from the trees, the young man turned to Schultes.

"This tree," he said, "is the one my father made little pellets from. He ate them when he wanted to speak with the little people."

The remark startled Schultes, who had been down this path before.

"You say he *ate* it."

"Yes."

It was impossible. Schultes understood the pharmacology of the drug. He knew that tryptamines had to be absorbed through the nose or injected. Taken orally, they are rendered inert by monoamine oxidase, a naturally occurring enzyme in the stomach. Yet experience had taught him that no information could be dismissed out of hand.

"What do you call it?" he asked.

"*Oo-koo'-na,*" Rafael said. Witoto was one of two indigenous languages Schultes spoke fluently, yet the word had no meaning to him. He did not remember that he had recorded it in his field notes twenty-seven years earlier.

"Can you make it?"

The boy could, and the next morning the work began. The procedure was familiar: the inner bark scraped away, the liquid boiled off until a dark brown syrup remained. But rather than allowing it to dry, Rafael formed the paste into small pellets and then rolled them in a vegetable salt derived from the bark of a tall forest tree. There were no other admixtures. Schultes ate four pellets. The effect was unmistakable. The mystery was how it had happened. Schultes assumed there had to be another compound in the paste that inhibited monoamine oxidase. No chemist believed him until one working in Sweden found trace amounts of beta-carbolines, compounds known to block the action of the enzyme. Once again, Schultes was vindicated by his faith in the word of his informants.

Adapted from *One River: Explorations and Discoveries in the Amazon Rain Forest*.

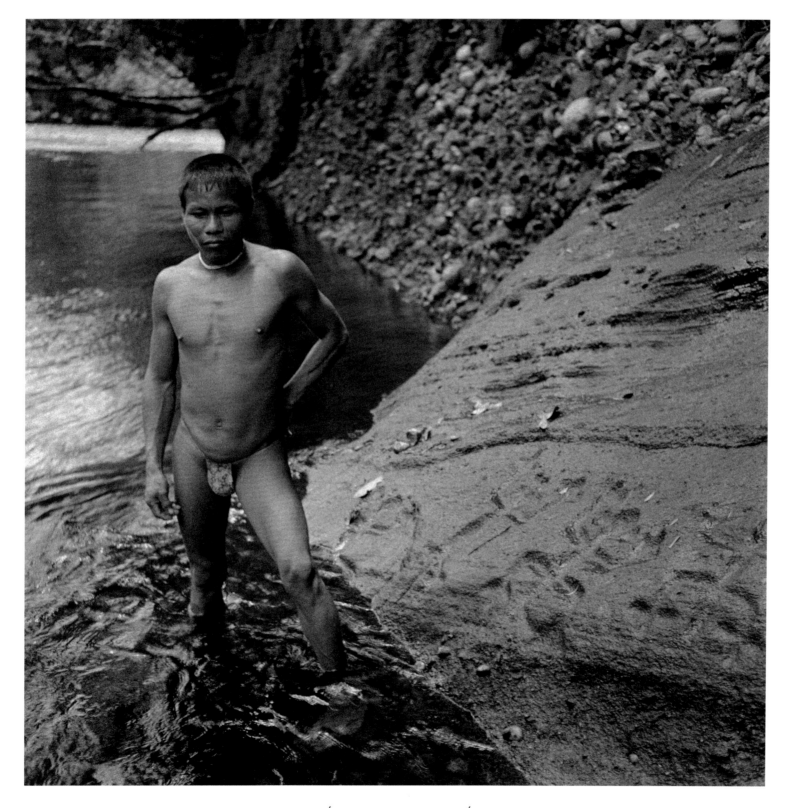

PETROGLYPHS, RÍO PIRAPARANÁ, OCTOBER 1943

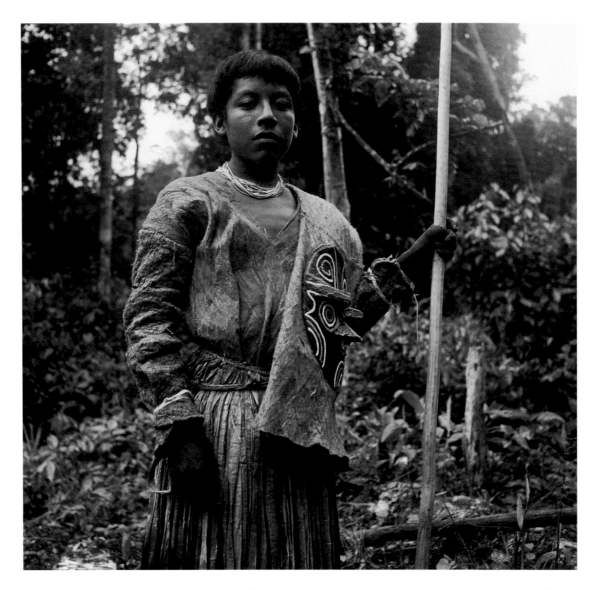

A TANIMUKA SHAMAN'S APPRENTICE, CAÑO GUACAYÁ,
RÍO MIRITIPARANÁ, APRIL 1952

Becoming a shaman takes months, if not years, of hard work. First one has to master the basic visions. You have to be able to bring forth specific visions when you take certain medicines. You have to learn to bend the visions with song. And then there is the terror. The master shaman conjures up snakes wrapped in fire, thousands of angry claws tearing at the sky. The apprentice has to face them upright, without hesitation, with only power. He must suck at the breast of the jaguar woman. Just as he is getting comfortable, she flings him away into a pit of vipers. One of the snakes carries him away to heaven, where the *yagé* people introduce him to the spirits of the dead. Only after many such terrible journeys does the initiate meet God. He stands before a solitary tree and a door that opens into nothingness. The initiate has to walk into that emptiness. Only then, when he realizes what lies beyond the door, can he receive his staff and the summons from God to be the protector of his people. ∽

CUBEO SHAMAN UNDER THE INFLUENCE OF YAGÉ,
MITÚ, JUNE 1953

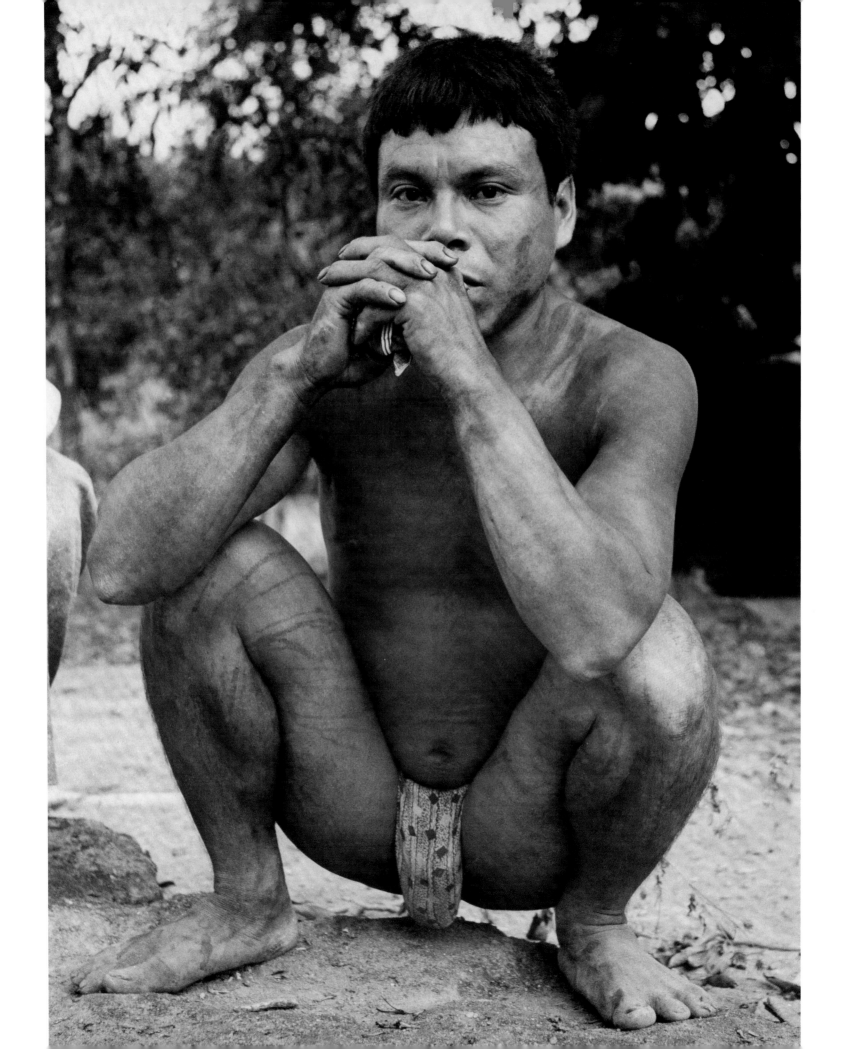

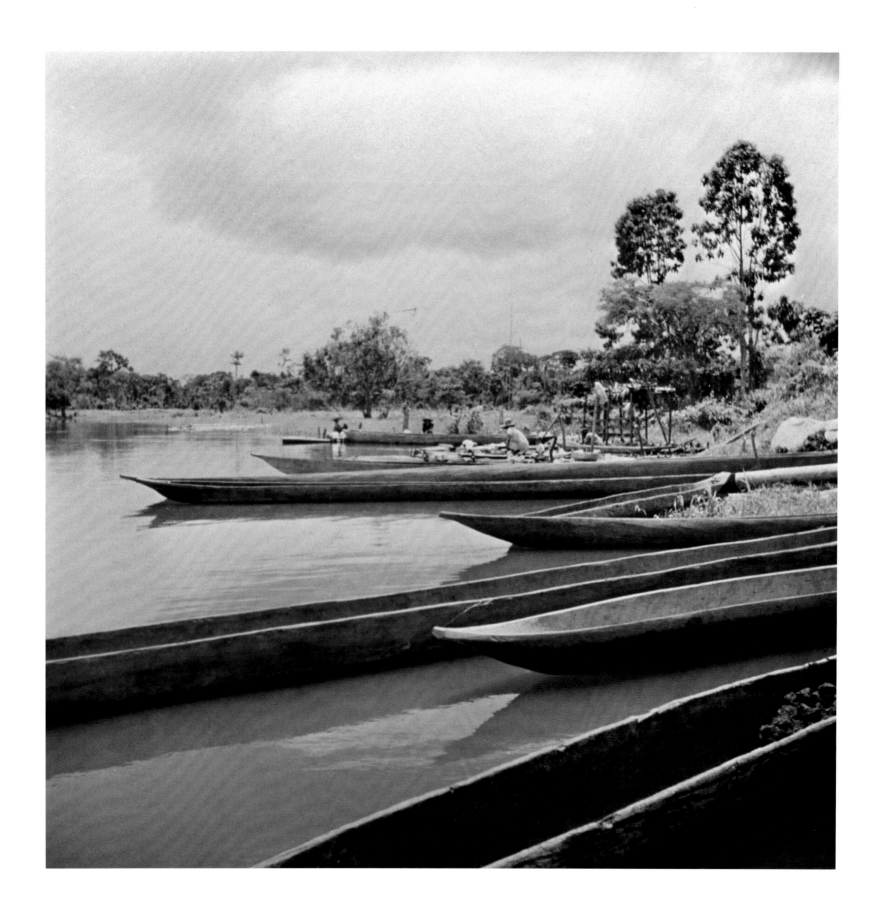

DUGOUT CANOES ALONG THE RIVERBANK AT SOLANO, RÍO CAQUETÁ, NEAR TRES ESQUINAS, MAY 3, 1942

In late April 1942, Schultes's plans to descend the Río Putumayo were interrupted by the unscheduled arrival of a military plane at Ospina. It was a tri-motor Fokker destined for Tres Esquinas, an army post and Indian settlement one hundred miles to the northeast at the confluence of the Río Orteguaza and the Caquetá. Military flights periodically left Tres Esquinas for Bogotá. Schultes leaped at the opportunity to get his curare and *yoco* specimens, particularly the live material collected when he was with the Cofán, back to the capital before he began his long journey down the Putumayo. Thus, quite unexpectedly, he spent the first days of May on the banks of the Caquetá, living in the longhouses of the Koreguaje, waiting for the Bogotá plane, and enjoying for the first time the smoky taste of Amazonian coca. ᴄ᷒

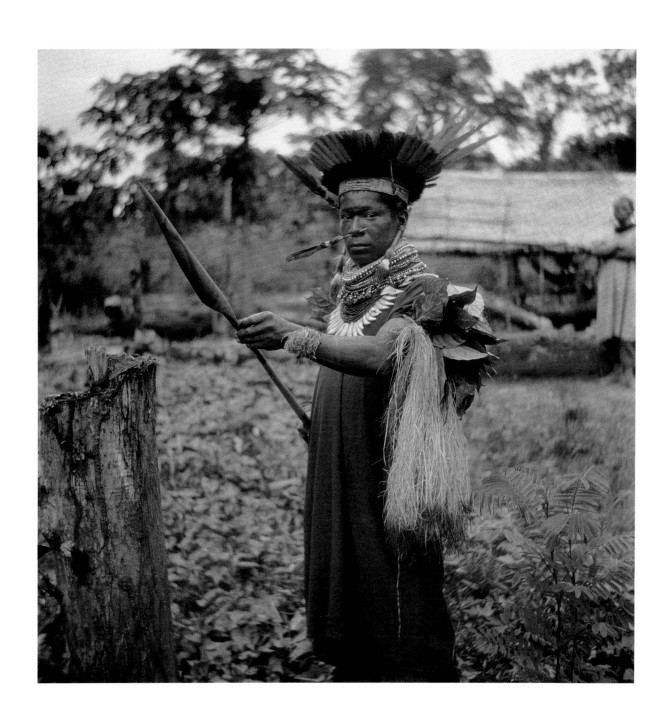

COFÁN SHAMAN, RÍO SUCUMBÍOS, APRIL 1942

Schultes described the Cofán as the finest poison makers in the Amazon. They exploited the common species of *Chondrodendron* and *Strychnos,* but augmented their repertoire with dozens of plants that only they employed. The result was botanical wizardry, complex combinations that brought together ingredients gathered both locally and from afar. Trade routes reaching for hundreds of miles existed purely for the delivery of admixtures for the poisons. The actual formulas were secret, and the preparation of the poisons enveloped in ritual. The men had to fast for days, perform ritual devotions, and sing the proper songs to invoke the essence of the plants. The results were elaborate, a dozen or more preparations specifically designed for particular species of prey.

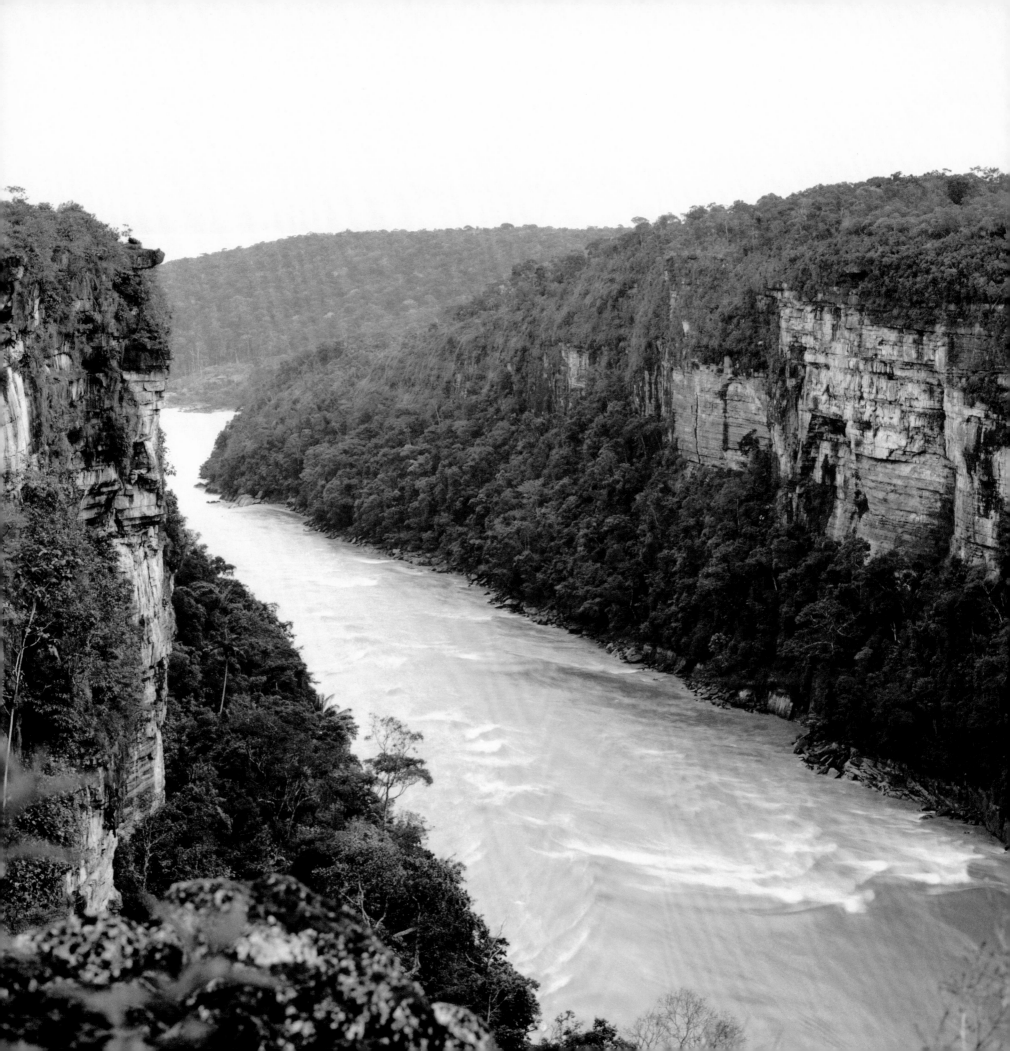

THE CATARACTS AND CLIFFS OF ARARACUARA, RÍO CAQUETÁ

Though named for the scarlet macaw, Araracuara had a reputation that was decidedly dark. Colombia had no death penalty. Araracuara was a penal colony, home to a hundred of the worst criminals and murderers in the country. With rapids on all sides and a boundless forest, escape was impossible, and the convicts were free to wander as they pleased. It was the only place that Schultes ever carried a gun as he worked. On the last day of his expedition, as he waited to leave, the warden informed him the pilot had been obliged to pick up a sick nun, and that there would be room on the plane for Schultes or his specimens, but not both. Either he or his plants would have to wait for the next plane, which was due within the month. Schultes dispatched his specimens. The plane carrying the nun and the specimens got as far as the headwaters of the Caquetá before falling into the forest, killing all on board. ∽

COFÁN SHAMAN, CONEJO, RÍO SUCUMBÍOS, APRIL 1942

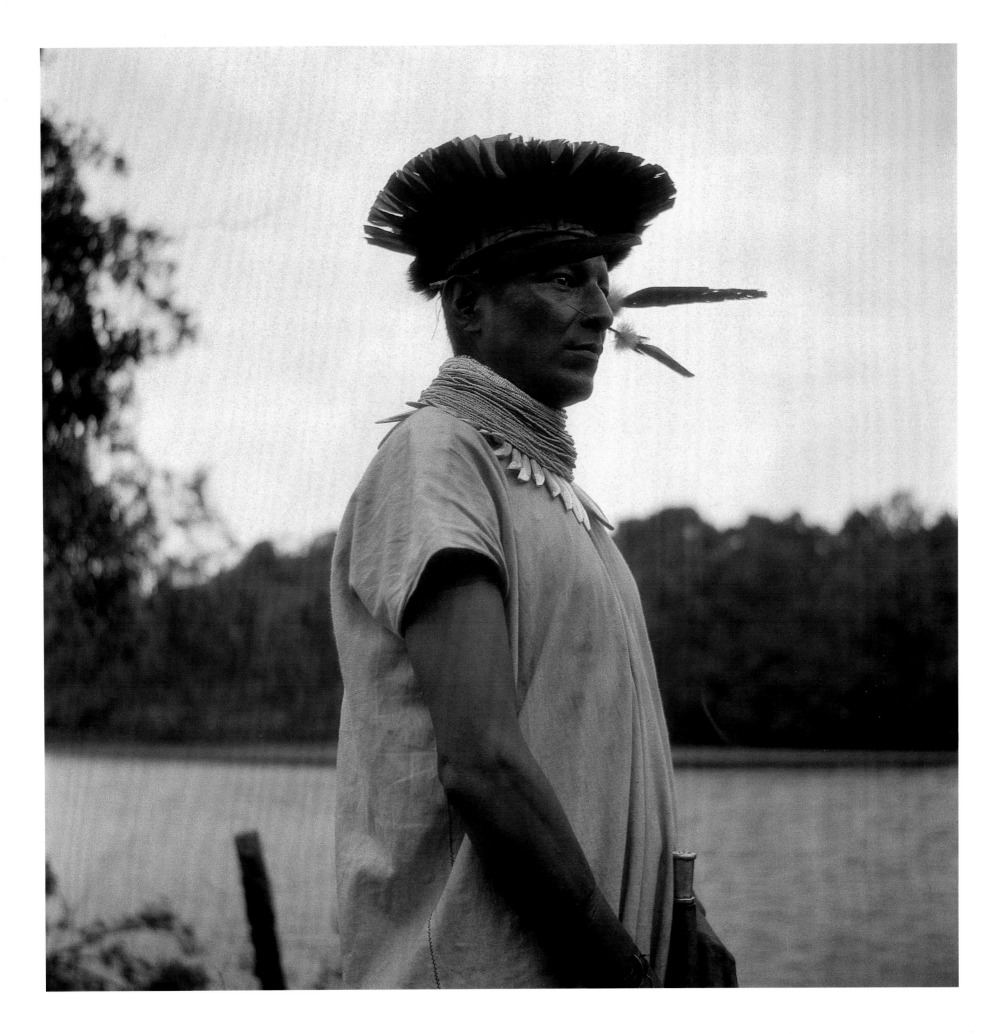

AFTERWORD

By CHRIS MURRAY

I remember first hearing about Richard Evans Schultes and his amazing photographic legacy from my friend Wade Davis. While telling me tales of Schultes's incredible adventures in the Amazon, Wade shared with me some of the photographs Schultes had taken. I was drawn in and fascinated by what I saw in the vintage material. The few photographs I saw that day were different from any I had seen, not only because they depicted a culture that was new to me, but because of their intrinsic beauty, clarity and singular vision. I couldn't believe that many of these photos hadn't been shared with the general public, and the idea emerged of editing a book that would present Schultes's photographs showcasing their aesthetic qualities as well as their scientific value.

It was a great day when I was finally introduced to Professor Schultes by Wade, and given the thrilling chance to explore his photographic archives at his home in Boston. Beginning with that first visit, Wade and I chose the photographs we knew would give this book its scope and depth. Schultes's work as an ethnobotanist and plant explorer was monumental—we wanted to share with the world his extraordinary work as a photographer. From that first day in the archives throughout the course of our research I marveled at the way in which Schultes had organized his original photographs in envelopes containing the negatives and small work prints, each still bearing notations in his elegant handwriting. Just holding these old envelopes from over a half-century ago, transported me back to a lost time. I think that you'll feel the same when you see Schultes's camerawork, much of which is reproduced for the first time in this book.

The *Lost Amazon* collects the legendary ethnobotanist's beautiful and enduring images of exceptional rarity and importance. Here Schultes honors the soul of the Amazonian Indian culture through his photographs which are, perhaps, altogether the single most compelling visual record of the period.

Anyone who sees these photos will be thankful that Schultes, thought by many to be the greatest Amazonian explorer of the twentieth century, considered his Rolleiflex camera an essential piece of equipment on his extraordinary journeys. His field expeditions brought him places no one with a camera had gone before, into the path of medicine men, ceremonial practices, ornate masks, shamans and their dances, sacred waterfalls and rivers, austere mountains, stone engravings, and of course, exotic plants. Schultes's powers of observation were highly tuned and served him well as both photographer and scientist. In this medium he passed along his observations to us, revealing much with his particular photographer's eye.

Schultes's landscapes deal with a heroic subject: the majesty and beauty of the Amazon. Communicating the wonders of nature, Schultes's images of mountains, rivers, waterfalls, and forests are infused with the visual and emotional resonance of this sacred territory. And his portraits themselves are a paean to great spirits past. Invoking a sense of the timelessness of humanity, courage, and cultural exploration they provide us with a window into the character and qualities of the people of the Amazon.

His photographs of the ceremonies and rituals in these pages demonstrate a deep trust between the photographer and his subjects. He did it by becoming an insider, partaking in the rituals and ingesting the hallucinogenic plants central to the ceremonies of the people he was photographing. As a result, his photos document a sacred part of Amazonian life that most of us would never see.

I would like to acknowledge my dear friend and publisher Nion McEvoy, Wade Davis, and most of all Richard and Dorothy Schultes with deep gratitude and affection.

Overleaf: SERRANIA DE LA MACARENA, JANUARY 1951

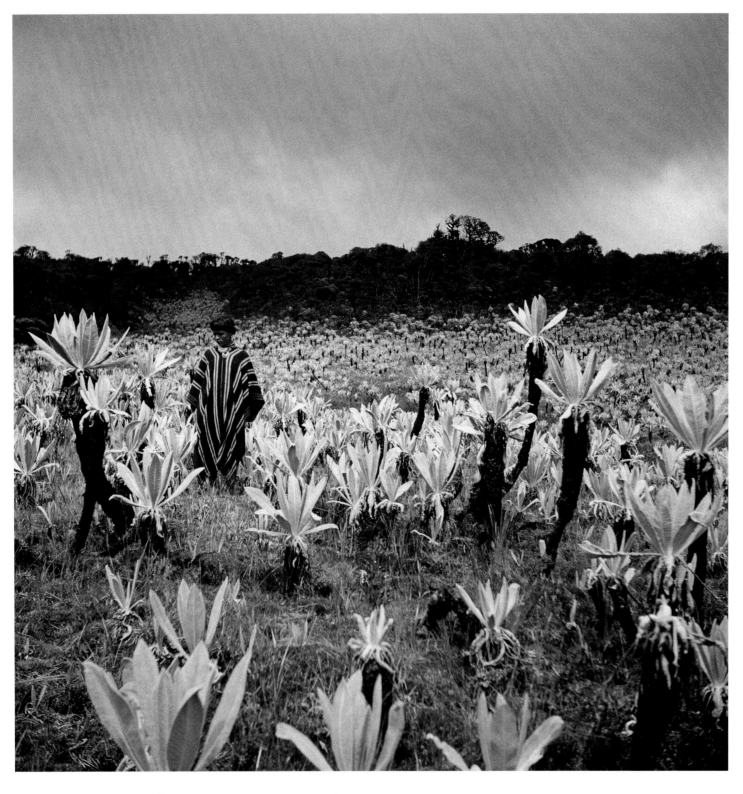

A KAMSÁ YOUTH ON THE PÁRAMO OF SAN ANTONIO ABOVE THE
VALLEY OF SIBUNDOY, NOVEMBER 1941

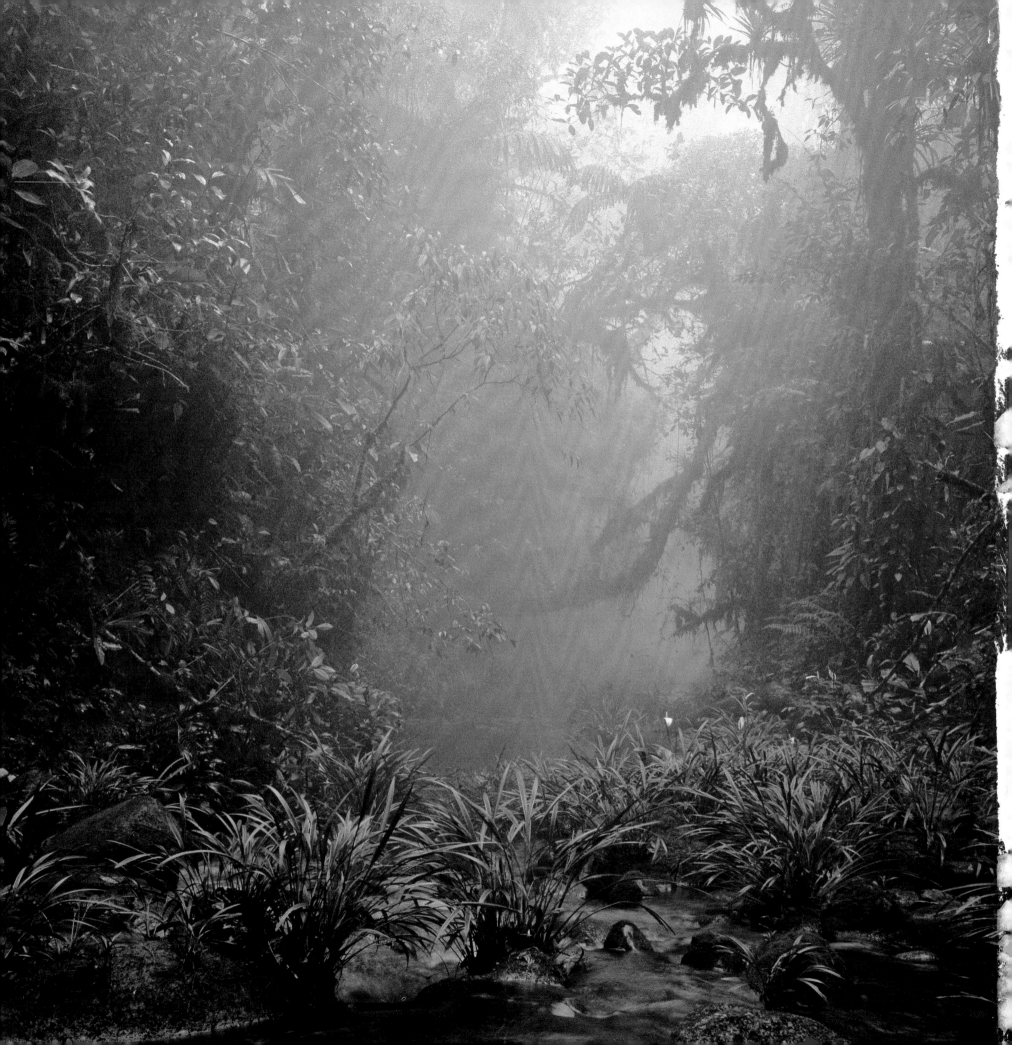

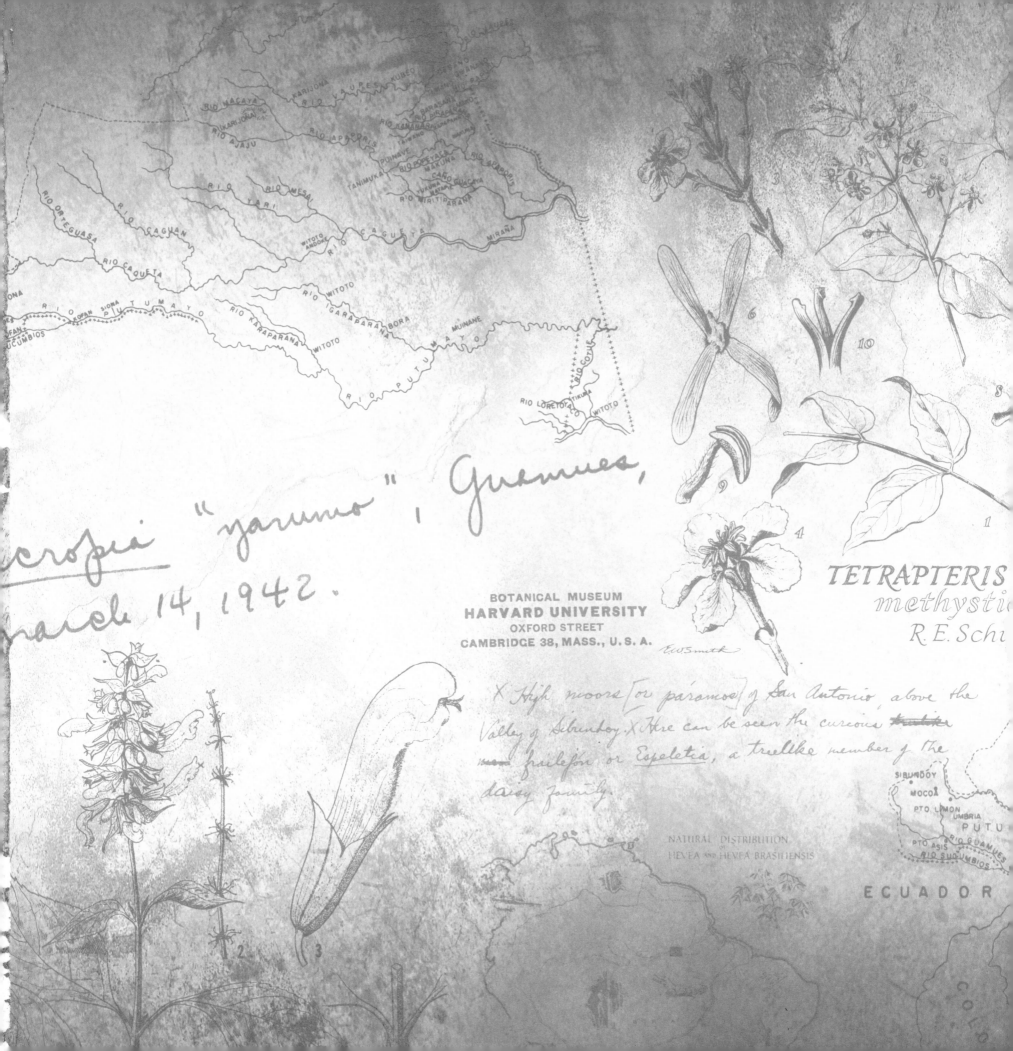

...cropia "yarumo", Guamues,
...arch 14, 1942.

BOTANICAL MUSEUM
HARVARD UNIVERSITY
OXFORD STREET
CAMBRIDGE 38, MASS., U.S.A.

E.W.Smith

TETRAPTERIS
methystic
R.E.Sch

X High moors [or páramos] of San Antonio, above the
Valley of Sibundoy. X Here can be seen the curious ~~tree like~~
~~moor~~ frailejón or Espeletia, a treelike member of the
daisy family.

ROUPALA
colombiana
R. E. Schultes

GRAY HERBARIUM
HARVARD
UNIVERSITY

Cecropia "yarumo" *Guarumo*
march 14 1942.

BOTANICAL MUSE
HARVARD UNIVE
OXFORD STREE
CAMBRIDGE 38, MASS.